THE
FINE ARTIST'S
GUIDE TO
MARKETING AND
SELF-PROMOTION

Julius Vitali

ALLWORTH PRESS

Published by Allworth Press
an imprint of Allworth Communications, Inc.
10 East 23rd Street, New York, NY 10010

Cover by Douglas Design Associates, New York, NY

Book design by Sharp Designs, Holt, MI

ISBN: 1-880559-35-8

Library of Congress Catalog Card Number: 95-76692

Printed in Canada

Contents

INTRODUCTION

The Benefits of Marketing and Self-Promotion

How do fine artists create a reputation and a career that will ultimately allow commercial galleries to sell their work? Persistence is certainly one of the keys to success; but many other factors contribute, such as: publicity, marketing, having an aesthetic foundation that can be articulated, networking, timeliness, and luck. In analyzing famous artists' careers, one sees a pattern emerge. The artists share an ability to find their way into the public eye through exhibitions, performances, commissions, and other means. Appearing in a public forum allows newspapers, magazines, radio, and television to comment, both formally and infor-

mally, on the artist and the work. The media creates reputations over time. This is a cumulative process that occurs via face/name recognition and through reproductions of the work.

If you look in the *Yellow Pages* under Public Relations, you will find listings of companies that use the media to help shape careers; but it is costly to hire professionals. They tend to use expensive methods, like advertising, to achieve success. This book is a complete guide to low-cost, low-tech ways to achieve the same success on your own—even on a small budget.

This book empowers fine artists by explaining promotional and marketing strategies that work, with an emphasis on the importance of documenting artwork through color slides and other photographic reproductions; maintaining copyrights; assembling proposals, grants, articles, and resumes; exhibiting and publishing work in the U.S. and Europe; attaining eligibility for Arts-in-Education residencies; and functioning as your own press agency.

Self-Sufficiency

Most artists want to have their work taken on by a good gallery that will give them solo shows, sell their work at hefty prices, and help them to develop a reputation. Many artists, however, cherish a sort of "Paris in the 1930s" dream in which they will be discovered by chance, without making too much of an effort. At the same time, sensing how unrealistic this is, they claim they "just want to do their work."

This book offers a method whereby artists can realistically increase their chances of being taken on by a good gallery. This method focuses on building a resume and a reputation through ones own efforts. In fact, even a good gallery will not necessarily guarantee income. Artists need ways of creating income from their work without depending on a gallery to sell it and without selling the actual work. I have found that it is possible to construct a parallel forum to the established art-world market. However, any fringe activity relies on inventive tactics, sometimes ingenious and uncommon, to achieve both short- and long-term goals, and it has been through trial and error that I have found some "guerrilla" approaches to success.

One way to create a reputation and generate income is through the use of slides and other photographic reproductions. Reproductions, not the

work itself, are the medium through which art is generally judged and publicized. By taking control of this aspect of the art market and ensuring the quality of the reproductions and minimizing the costs, the artist can reap important benefits.

This book also stresses the importance of being able to articulate what one's art is about. By doing so, one can make the work more marketable, accessible, and interesting to a wider audience—including some audiences and markets artists normally wouldn't consider open to them.

Artists are, by their very nature, creative and critical thinkers. They critique their own and other people's work and utilize critical thinking whenever a new project is started. Any project they undertake is a form of creative problem-solving with a beginning, middle, and end. If artists put their minds to it, they are able to accomplish many different goals. Why, then, do they need a book on marketing and self-promotion? Artists want to be successful, but they need to learn how to employ their creative and critical abilities to market their work.

Publicity and Marketing

Picasso was not born famous. He had the same concerns as you regarding success. Media and technology were more limited during his time than they are today, but that did not diminish the work that was involved; photographs had to be taken; press releases had to be written and mailed. This is still part of the process of becoming established as an artist.

There is an accepted standard for the use of press releases and accompanying materials. The artist sends color slides, black-and-white photographs, audio tapes, videotapes, and other previously published material (if available) to publications and galleries. Follow-up happens through phone calls, faxes, appointments, or additional mailings.

For example: imagine you are having your first solo exhibition. You mail press releases and other supporting materials to magazines, newspapers, and local television. This results in the publication of some of these materials and a television news clip. You should obtain as many copies of the publications as possible and videotape the news clip.

In this scenario, the publicity both supports the current exhibition and serves as marketing because of the other possibilities that may result from the exposure. Appearances in public forums like magazines and television can result in name recognition, sales of the work, additional media interest

in the work, or talk shows appearances for the artist. If this exposure generates interest, other parties may contact you directly or through the gallery. You will perhaps be invited to exhibit again and elsewhere.

Any published materials, including reviews, should be sent to other galleries and publications, and the video news clip can be sent to other television stations. This will help you to obtain future exhibits, receive more publicity, and be reviewed repeatedly.

Rather than doing an enormous and expensive mailing, it is often better to think strategically about what kind of publicity in which specific venues will be most effective. Sending out material blindly results in a low percentage of success. A single item published in a magazine or newspaper with a national audience can result in a significant response, due to the circulation of the publication.

Whenever you or your work appear in a public forum—newspapers, magazines, billboards, posters, on television or the radio—you have received publicity. Having control over how you and your work appear in these public media is the art of marketing.

The Art of Marketing

The Dadaist Tristan Tzara was a master of publicity and marketing. There is probably, in all the history of art, no clearer example of publicity making an art movement than that of Dada. It is notable that an art movement which produced a small amount of actual artwork, with little stylistic consistency, should have become one of the most influential art movements of the early twentieth century.

The Dada artists were so radical and controversial for their time, that traditional art world venues (galleries, art magazines, awards, competitions) ignored them. The Dada artists, however, set up an alternate system, a parallel path of their own exhibitions, magazines, and performances, centered at the Cabaret Voltaire in Zurich, Switzerland. They published manifestos and held exhibitions that were perceived as shocking—like one where visitors had to walk through a men's bathroom to arrive in the gallery. The Dadaists broke down the traditional way to achieve artistic recognition and success. They literally caused a scandal via the news item. These scandalous news items helped the Dadaists gain a reputation but not reviews of their work. The art critics were aghast.

Tzara documented everything and acted as the spokesperson via press releases and correspondence out of Zurich.

Judging by the amount of literature about Dada and the Cabaret Voltaire, it would appear that the cabaret was a large hall. This is not so; it only held fifty people. However, the Cabaret Voltaire was in a city where the international press was located. This helped the Dadaists receive worldwide editorial coverage as a "news item." If the art world hadn't eventually recognized its value, Dada would have faded into oblivion like any other news scandal. The Dada artists created this parallel market in order to survive.

We can learn from the history of art movements like Dada; they provide a model which can be applied today. Dada achieved recognition because Tzara knew how to use the media to carry its message. That is, in part, why Dada is where it is in the annals of art today.

Persistence

For the last fifteen years, the demystification of the media and its relationship to art has been my obsession. This book describes techniques and goals that have been a way of life for myself and my work. I have been an artist living off my wits for more than fifteen years. My approach to publicity and marketing offers artists a method for getting their work into the public eye and increases their chances of building a successful career; it also gives them the opportunity to make a living from their art at the same time.

There are many different types of fine artists: watercolorists, collagists, painters, printmakers, performance artists, conceptual artists, photographers, sculptors, combinations of these, and many others. No one approach will work for all. You may not want to follow my methods exactly. Instead, modify them to meet your needs; take what you want and apply it to the type of artwork you are creating. Persistence is the surest way to achieve the long-term goal.

❧

CHAPTER 1

The Importance of Writing and Photography

In later chapters we will discuss how to get publicity, but it is important to be prepared beforehand to market yourself to your best advantage when you do receive publicity.

Unfortunately, in today's world too many people say, "its all been done before," "there's nothing new," or "it's just a restatement of an earlier idea." Because of this cultural jadedness, true value and originality in the arts are often overlooked. Newspaper and magazine editors, television and radio news directors are bombarded every day with press releases, faxes, phone calls, computer E-mail, and publicity stunts. Why shouldn't they

be leery? Look at all the hype that comes out of Hollywood, either through advertising, reviews, or pre-release publicity. This leeriness filters into the art world, and it is a bias that is hard to overcome.

As a result of this jaded attitude, fine artists who either call or write cold, are allowed an opportunity (out of politeness) of about thirty seconds (a sound bite) or approximately one hundred words (a word bite). If you can adequately describe what you do in thirty seconds, the window of opportunity remains open for as long as a dialogue is necessary. If not, the window closes and the response is "it's not for us," or "call us again when you have something new."

Therefore, I recommend developing a "rap" of about thirty seconds or one hundred words. It will help you exude confidence and persuasiveness. Then telephone calls (thirty seconds) and letters (one hundred words) can be successful tools. You need to be able to lead people into your work, to make it accessible, understandable, and likeable. Remember, there is always a chance that your art will appear boring, typical, or crazy to people who know nothing about you or why you do your work. It takes an effort to appreciate something new, and you can't expect that others will necessarily make this effort. It is up to you to help people appreciate your work.

The hundred-word rap should define the style of your art and the subject matter; indicate the medium; give a brief account of influences and/ or studies; mention major awards, exhibitions, and collections your work might be in; and explain your aesthetic, that is, what you are trying to accomplish in your work.

To be a successful artist, you will need to have a personal aesthetic philosophy. In order to write an artistic statement or define your art, you must come to terms with this. If you do not have one then it would be advisable to start thinking about it. Without this foundation, the art will be viewed as superficial. Reviewers, critics, curators, editors—the word bite people—want and need to know this information, and the better prepared you are for this, the easier it will be to advance your career through the various media.

It is unlikely that one artist will spend his or her whole career working in one particular style. Artists try different mediums, whether oil paints, ceramics, photography, or conceptual art. They can experiment freely as long as their aesthetic foundations allow them to choose the right venues for their ideas. Take Picasso as an example: despite the media used (oil

painting, collage, drawing, sculpture, ceramics), all of his work fell under an umbrella loosely defined as Cubism. However, he went through different phases. In the twenties he tried Realism and in the thirties, Surrealism. Then he went back to Cubism but in a form that was very different from his early work. He was able to translate his ideas in a multitude of ways. However, he defined his goals via an aesthetic, and since he knew the gallery scene better than most people, he created work that was exhibited on a regular basis.

Examples of Artists' Raps

The hair-sculpture artist Terry Niedzialek gives an example of an artist's rap that successfully introduces the artwork and the artist's aesthetic.

> Using human hair and the total person as my medium, I construct human hair sculptures with narrative themes that make environmental, political, and humanitarian statements. I use such materials as clay, gel, wire, and paint with different forms and objects built in.
>
> I explore the interrelationships between the head and the body, human and nature, self and world. These organic environments become an extension of the wearer and inner spirit. The sculptures reflect narrative coiffures of the eighteenth-century woman of the French Court and the Aboriginal tribal body art/decoration as ritual celebration. It is an interdisciplinary art form which crosses the boundaries between plastic art, performance art, and fashion, resulting in exhibitions, live events, performances, workshops, and thematic commissions.

If it is successful, the artist's rap will change the way the work is perceived. (It can be helpful to think about who the rap is directed at and to tailor it to the specific situation.) In the case of Terry Niedzialek, her rap may help someone looking at her work to appreciate that it is not simply an unusual hairstyle, but part of a thoughtful, ongoing, creative process.

The rap works the same way with any kind of art. Imagine a landscape painter who needs to distinguish his work so that it will be examined and judged fairly. The hundred-word rap for such a painter might say:

> My name is Mr. Neutral Palette, and I prefer working from nature. Though natural light gives me inspiration, I work both on location and in the studio

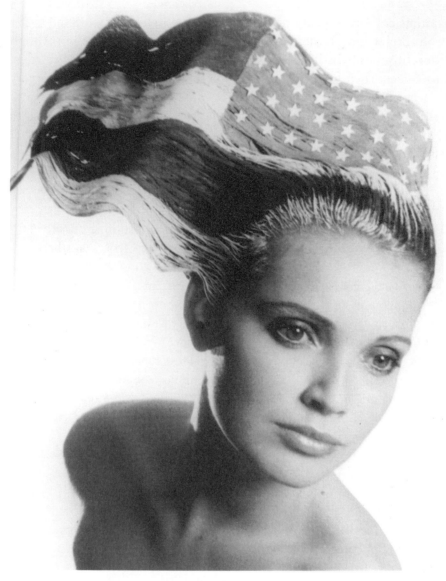

Figure 1: Hair sculpture, *America the Beautiful*

Hair Sculpture © Terry Niedzialek, photo © Julius Vitali

using oils and watercolors. I live in New England, and my work is
influenced by the Hudson River School and the American Impressionists,
but I have also studied and taken classes with many established masters
in New York City. The subject matter of my paintings ranges from pastoral

landscapes to moonlit seascapes, which are scraped in an illusion of deep space using the delicacy of the chiaroscuro style. Primary sketches on paper, made on location, are a necessary ingredient in my process. Each sketch is used as the foundation for a series of variations, and the sketches are often exhibited along with the finished work. My work has won many prizes and honors in respected competitions around the United States.

It is the artist's aesthetic, communicated through the rap, that helps the listener or reader to understand what is unique, distinctive, and of interest in the work. Mr. Palette draws attention to his peculiar style, "scraped in an illusion of deep space using the delicacy of the chiaroscuro style," as well as his interest in the artistic process and the relationship between the sketches and the finished product. He presents himself not as just another landscape painter, but as an artist with an individual style and process. The rap gives the listener something focused and particular to remember about the work.

Artists attending Art-in-Education workshops conduct mock telephone calls in order to learn and master this technique of the "art rap." Test your art rap. If it proves unsuccessful, then modify the information until it begins to work. Create a sample list of ten galleries or other sites to call or write. Determine what sort of positive and negative responses you receive. Based on this sample, adjust your rap to create a higher percentage of success.

A rap that succeeds in winning the ear of the listener will become the foundation for the other kinds of writing you will need to do, including press releases, artists' statements, grant proposals, and more. You may find that the time you put into developing your hundred-word rap is productive not only for marketing your work, but for the work itself. Having a clear aesthetic base can help your artwork become more articulate and forceful.

Fear of Writing

One concern for many artists is a fear of writing that stems from the fact that they are visual rather than verbal thinkers. In French there is a phrase "as stupid as a painter," which suggests that all a painter knows is art-related; all other knowledge of life is insignificant. This is an unfair stereotype, like that of the absent-minded professor who wears two different colored socks.

Everybody who goes through the educational system has a rudimentary knowledge of English grammar and composition. However, like any other technique, writing has to be practiced on a regular basis. Most artist's writing abilities are simply unpolished, raw, and neglected.

The first thing to remember is that the Great American Novel is not being asked of you. Press releases and artists' statements are normally one page, or about two-hundred-fifty words maximum. A typical grant application "Description of Proposed Project" is four-hundred typed single-spaced words or thirty-five lines. When filling out these grant application forms you are not required to fill up the whole application. If you can describe your project in fewer words and still be understood that is sufficient. The trick to this type of writing is to be as clear and concise as possible. No falsehoods or flowery language. Follow the instructions carefully and tell them what they want to know. Stick to writing about your technique, aesthetic, and the style of your project. The more clearly you describe your ideas, the more likely people will understand you and your work.

If you can't seem to refine your writing ability with practice, then get help. This can take the form of a ghost writer, a critic, or a cultural journalist. Even if you have to barter your work in return for someone's writing skills, do not neglect this. Too much is at stake career-wise, since press releases, artists' statements, grants for individuals or special projects, artist-in-residencies, artist-in-education, and corporate support all require writing ability.

You can also try buying a micro-cassette recorder. In this way, you can speak instead of writing your ideas. You can record your "art rap," interior monologues, or discussions with people about your work and just transcribe it later. You could also have someone interview you about your upbringing, work, and aesthetic. All reporters use tape recorders as a back-up for interviews and keeping notes. Why not do as these writing professionals do?

The more you understand about the kinds of writing necessary for an artists' career, the easier it becomes to tackle each writing chore. Breaking down each writing assignment into its components will help you to overcome this obstacle.

The Press Release

One of the most important writings you'll need to do is the press release. A press release always begins with the most important information. The first paragraph indicates the date, time, and location of the event; the nature of the event, whether it is an exhibition, workshop, or performance; the name of the artist or artists; and information that is of a practical nature (address and phone number of the site, admission cost if applicable, and the like).

Next, the press release should give a brief history of the artist's achievements. Basically, what you need to do is to expand your one-hundred word rap for this part of the press release. For example, a brief description of any grants received for this project and reviews and description of past exhibitions should be added. Include information about the specific works being displayed. Keep in mind the purpose of the press release: to inform the press of the public display of your work and to convince them of the newsworthiness of the event. Anything out of the ordinary, such as a site-specific installation, demonstration, workshop, or lecture in conjunction with the display, should be highlighted.

Finally a closing paragraph should include any pertinent information needed to explain technique or concepts that might be of interest to the press. (This can even be a how-to explanation that takes one through the steps to the finished artwork.) The press release should not be longer than three typed pages. A one-page or double-sided press release is usually sufficient.

Often a gallery will ask the artist to write preliminary information that they will rewrite into the actual press release. You will need to be familiar with the components of a press release in order to do this and to exercise control over the content of the press release the gallery prepares.

You need to be creative when sending out these press releases since newspapers and magazines get flooded with them. The writing should be straightforward, but you might want to incorporate an image as a heading. This breaks up the traditional release format and adds an artistic touch. The envelope can have a photocopied image on it to "grab" their attention, or you can include a small, one-of-a-kind artwork as part of the package to distinguish it from the deluge of press releases the media receive.

The press release can be faxed to the media, if time is short, or to television stations, on the day of the event. If you are sending out a video

AMOS ENO GALLERY

FOR IMMEDIATE RELEASE

CONTACT: ANNE YEARSLEY
(212) 226-5342

MICHAEL J. BERKOWITZ

RELIGIOUS IMAGES
PAINTINGS ON GLASS

APRIL 23 - MAY 12, 1994

Michael J. Berkowitz will present his most recent work in "Religious Images: Paintings on Glass" at the Amos Eno Gallery from April 23 to May 12, 1994. A reception for the artist will be held on April 23 between 4:00 and 7:00 PM at the gallery.

Mr. Berkowitz began working on this series of paintings on glass in 1987. After a decade and a half spent creating large scale environmental installations and performances, the artist felt a need for a new direction. Always interested in working in non-traditional materials Berkowitz first encountered paintings on glass while hitch-hiking across Central Asia. First in Iran, then later in India, Yugoslavia, Senegal, Burma, and Mexico he discovered different techniques and styles of painting on glass. Six years ago he began to adapt the techniques to his own end, his own vision, and the current paintings are the result.

To create these works, enamel sign paint is applied on the reverse side of pieces of glass. The pieces are then set into a wooden ground which both supports the glass and defines the design. The colors and patterns are seen through the glass which gives them a hard and shiny appearance. In addition, while the works are flat, the materials employed in the paintings impart to them feelings of weight and "object-ness" which are essential to their effect.

Though Mr. Berkowitz's education was firmly rooted in traditional Western Art, his work for the last twenty years has reflected a growing interest in and influence of less traditional sources: Islamic architecture and tilework, Chinese and Japanese ceramics, Hindu and Buddhist religious art, African sculpture and textiles, Contemporary "Outsider" Art, and religious rituals to name but a few. To date, he has travelled in some 70 countries worldwide in order to see, experience, and understand the many elements which have in turn enriched his art. His current work reflects all of this.

594 BROADWAY, #404, NEW YORK, NY 10012 (212) 226-5342

Figure 2: Press release

Courtesy Amos Eno Gallery

newsclip to television stations or magazines (if the video adequately explains the art), you should also include a written press release. More about press releases will be explained throughout the book.

Documenting Your Work

Along with developing your aesthetic philosophy and writing ability, you will need to document your artwork. Slides have become the unofficial standard for artistic evaluation, whether for grants, individual or special projects, competitions, artist-in-education residencies, magazine articles, or inquiries to galleries. This method of evaluating work via the slide projector, light table, or window, was not chosen by artists. The medium was created by a film manufacturer and adopted by editors, grant panels, and gallery owners. Like it or not, the decision has been made on a collective level that 35mm slides shall be the standard medium for submission of materials, be they drawings, oil paintings, photographs, sculpture, installations, multimedia works, or performance art.

Why? One reason is that the Kodak carousel slide projector has set a standard for the industry. Every business and school has one, and thus everybody brings a slide tray with them if they present portfolios, give lectures, or the like. However, this standardization has a Janus face. While slides are a convenient way of showing people your work, you must invest a significant amount of time to create superb slides that represent your artwork in the best light. Slides are an illusion as much as they are an image of the art object. Poor quality slides will give the impression of poor quality work. Although a visit to your studio or a gallery exhibit is preferred, most people will become familiar with your work first through reproductions.

During this century, the rapid growth of technology has produced a rapid change. The results are new breakthroughs in convenience but at a price. Artists must now rely not only on the actual objects they produce (oil paintings, sculpture), but must also consider the way those objects are reproduced: slides, photo CDs, computer graphics, faxes, photocopies, videotapes. This produces a dilemma—how to best represent your work and in what medium?

Unfortunately, in the art business, these illusionary means of representation are necessary in order to have a career. If a business can find a way to standardize, then your business has to match this in order to keep up or be left out. In order for a business to grow, prosper, and be creative,

it must seek out customers, keep them, and then find new customers and new markets on a continual basis. Initially this is daunting, since most artists do not think of themselves as being in business and therefore do not market and publicize their work in a business-like fashion.

Many artists believe that everything attributed to the art after it is created is just hype, advertizing, or commercialism. However, there is no way around the fact that artists need to have the absolute best quality color slides (and black-and-white prints) for presentation and reproduction. The competition for galleries, grants, and publicity is fierce. You do not want to make yourself ineligible due to poor quality images. Therefore you must know how to control the quality of the photographic reproductions of your work. This requires understanding the properties of color film, color temperature, and lighting, and having the tools—camera, tripod, lenses—to achieve superb results. The documenting of artwork is not difficult. Start thinking of photographic documentation as an integral part of the artistic process. The best way to maintain quality and reduce expenses is to do it yourself. You can be certain of getting high-quality originals for publication and for duplication. You can ensure the archival quality of the photographs; you do not want to reshoot your work every year, or even every few years, because the colors have faded. As the photographer of your own artwork, there is also no question of copyright ownership. You want to be the owner of the reproductions of your work, so that when they are published you will receive all residuals from the use of them.

Planning Ahead

Photography is a critical part of documentation, and, due to the impermanence of color paper and film, it is important for artists to know which films and papers deteriorate faster than others. Color photography needs more care than black-and-white, since relatively unstable organic dyes are used versus the essentially stable silver halide. Artists could have problems with their color images in later years, due to neglect or a misunderstanding of archival principles. Artwork might have to be reshot, due to the fading of the slide, which might be inconvenient or impossible. Do it right once, and it will always be available for future publishing or display.

The Permanence and Care of Color Photographs by Henry Wilhelm with Carol Brower, (1993 Preservation Publishing Co., $69.95. Sold only through mail order, $4.95 shipping for a total of $74.90. Call 1-800-335-

6647 or fax 1-515-236-0800.) is a must for artists. It provides an understanding of the permanence and archival stability of color photography and its standards. Mr. Wilhelm has taken twenty years to research portions of this book and he is well known as an expert on photographic films, papers, and equipment. I have done my own research and talked with many photographers over the years and I have come to similar conclusions as Mr. Wilhelm, though I did not do the exhaustive testing he did. Many of the film recommendations in the photography appendices are based on Mr. Wilhelm's book.

Artists need to send out duplicate slides for submissions unless many copies of the originals are made. If it is possible, shoot both color slides and black-and-white negatives at the same time. This is a prudent investment, as you will not have to convert from slides to black-and-white prints when the need arises, and the quality of the images will be superior. But, before attempting to shoot ten images of the same artwork to save duplicating costs, make tests and take notes. This is the only way to be sure of the results. Apparent shortcuts can result in the loss of money and time. If you miss a deadline because your slides did not turn out, you may have to wait a year before you can apply again (for grants), or you may have missed a unique opportunity (such as an exhibition).

Because great quality slides and black-and-white prints are a must, it is especially important to own or have access to a 35mm camera body, a normal lens with macro focusing, and a sturdy tripod. You will need the best tools to document your artwork. However, keep a perspective on the amount of money needed to purchase equipment. In my opinion, Nikon is the camera company with the best system. You must have an incredible amount of faith in your light meter and from my own experience, Nikon's lightmeters are superb. In addition, Nikon equipment holds its resale value over time. I do not recommend trading in your 35mm camera to go out and buy a Nikon. You might only need to buy a good light meter. When you take slides of your artwork the exposure should be exact. If the lens aperture is only half to one f/stop off, it can deepen the color (underexpose) or lighten the color (overexpose) of the artwork, yielding unsatisfactory results. This can be corrected when duplicate slides are made, but you will lose quality and time.

Another hint: if you own one manufacturer's camera body, then stick with that company's lenses. An example: some people by a Nikon camera body, then buy a non-Nikon lens. Nikon does not recommend this since

the camera might not perform as designed. This is especially true of electronic camera bodies. Nikon does license out its special bayonet mount to Tamaron and other manufacturers. The savings between the same lens, Nikon to non-Nikon, could be 30 percent. However, photographers buy a Nikon lens for its superb optics. Having the best quality optics ensures image quality of your work.

To document your artwork, you will need a fixed-focus lens like a fifty millimeter (50mm) with macro focusing capability. You should have this feature because it is sometimes necessary to shoot from closer than three feet and a macro focusing feature allows this. This is especially important for small works or fine details. This will be further explained in the photography appendices at the end of the book.

If your work is published (see chapter 4), you may be able to take advantage of a service called Nikon Professional Service (NPS). Once tearsheets of your published material are available, write to find out whether you qualify as a professional. As a professional and a member of NPS, you may be lent Nikon equipment free of charge. For information call or write to: NPS, 1300 Walt Whitman Rd., Melville, NY 11747; 1-516-547-4397. Customer service 1-800-Nikon-US.

For a detailed explanation of how to document your artwork by taking great quality black-and-white photographs and color slides, see the appendix.

Writing and Selling Articles

Color slides and black-and-white prints have several purposes: to include with applications for grants and exhibitions; to serve as publicity in newspapers and magazines; and to sell to publications for articles or other usages. Most artists do not realize the sales potential of their photography. For many years I made a living just selling articles about my work to magazines all over the world, whether or not it was in conjunction with a exhibition. This is also a way for artists to develop a reputation. The media picks up on your work because it is in a public forum. Even a small mention in a national magazine can be significant in terms of publicity.

Your hundred-word rap, together with slides and photos of your work, provide the foundation for a very brief article. A press release, together with photos, can also become a brief article. These are essentially press kits that can be mailed out as they are or expanded and tailored to fit the

needs of an article. Sometimes one thousand words is the maximum for a feature article (four typed pages or a five-minute conversation). You should provide information that could be published as is. Newspapers and magazines can take whatever they want out of it, rewrite if they want to; and if more specific information is necessary, they can contact you.

Once you have articles, reviews, or notices about your work published in newspapers or magazines, these can be sent out as the basis for other articles about yourself. I'd recommend this for two reasons. One, it provides an objective view; and two, it gets you off the hook about writing it yourself. Remember, this published text is just the base, which can be tailored to fit the article's needs. You may be able to interest a publication in doing a similar article, an expanded or updated version, or an entirely new article. Whenever you use published material, make sure you give the appropriate credit and clarify or update the information as necessary. If you read general interest publications like *Time, Newsweek, People, Rolling Stone,* or the *National Enquirer,* you can get a feeling for what needs to be included in such an article. If you are able to generate interest in your work, you will open channels for publicity outside of the very competitive art press.

The most easily written component of an article is your personal history. This includes any childhood stories pertinent to the art, your education, apprenticeships, private instruction, any evidence of achievement, influences, and travel that pertains to your artistic development. Any humorous situations or anecdotes which can make the article colorful should be included. Remember, it is important to show the inter-relatedness of your personal history, the development of your work, and your mastery of technique. This is especially true if you create a new art form or significantly add to an existing art form. The point is to give the reader an understanding of how you became interested in art and what attracted you to a particular medium.

The most difficult part to write, but one which can take up a major portion of the article, has to do with your aesthetic. Again, this is the philosophy behind the work, the reason it is being created. This foun-dation, can be drawn from your own personal techniques, experimen-tation, and/or from an established school of art. You can make this more interesting by relating it directly to the slides included with the article. Using the images, you can define explicitly the significance of the aesthetic as it relates to practice. This simplifies and grounds your writing, putting

the work in the context of the artistic journey, from the inception, through development, and into maturity.

The preceding information arms the fine artist with two media: writing and photography. Having control over these two marketing and publicity tools (reproductions and text) will allow for many professional opportunities in both the publishing and art world. The following chapters are structured to help you disseminate your text and reproductions and receive publicity.

➤

CHAPTER 2

Publicity: Newspapers and Magazines

What constitutes a significant art event and, therefore, the need for publicity? This depends upon whether a show is held in a major city, suburb, or rural area; and beyond that, in what type of location—whether a gallery, library, or restaurant. A solo or group show should always be publicized. Publicity is also necessary for art performances, artist-in-residencies, artist-in-education jobs, workshops, master classes, demonstrations, fundraisers, lectures, and commissions. A master plan has to be envisioned with a time table for implementation. This might require asking several people to work with you to complete the task, since

you want at your disposal all the various media options, including newspapers, magazines, both cable and broadcast television, and AM and FM radio. You might have to depend on friends, lovers, relatives, or assistants (see chapter 4) to coordinate these tasks. The first time you attempt to organize publicity, it will seem daunting! Do not get stressed from the anticipation; once you are involved in the process it becomes much easier to complete and modify the tasks. The techniques described in this chapter are specifically designed for fine art events, but many are also classic strategies that could be modified to publicize any activity.

Location

When you are contemplating having a solo exhibition, you should carefully consider the location of the gallery or other site where your work will be shown. If it is not in a city, defined in media terms as having either its own television stations or newspapers, then the likelihood of achieving any regional or national success will rest on how successful you are in placing national magazine articles. National magazines have no audience boundaries, but newspapers and television do have limitations in coverage area and in travel distance.

A solo or even a two-person show coordinated with an event offers the best potential for publicity success. However, there are many variations on this theme. You can receive significant publicity for your involvement in a group show or other art event or can fail to receive any publicity even for a high-profile solo exhibition. No plan of action is guaranteed, but many tips will be offered here to maximize your success.

Regardless of which stage of your career you are in, the best way to approach the media is by having previous and/or present materials such as articles, press releases, and photographs available to coordinate with an exhibit. If you are at an early stage in your career and are trying to solicit an exhibition via a general mailing or by visiting commercial galleries, National Association of Artist Organizations (see chapter 5 for address and information), or other sites, then you should usually accept any site. As your career advances, however, you will want to be more particular and choose to exhibit in locations where you will receive the kind of publicity that will best benefit your career.

I'll give you a general hierarchy of the importance of location for media exhibition coverage.

1. *New York City.* It is the U.S. publishing capital as well as fashion and art center for the world. The book publishing industry is located there; five major newspapers are published daily; many foreign correspondents cover the United Nations and New York City news. In addition, there are: feature syndication news services (both American and foreign), N.Y. correspondents, out-of-town newspapers, television network-broadcast stations, cable systems, and commercial and public radio. New York is a media heaven or hell, depending on whether you succeed or fail. In addition, the three major art magazines (*Artnews, Artforum, Art in America*) have editorial offices in New York, and the major museums and galleries are located there.

2. *Los Angeles.* The same can be said about Los Angeles as New York, except it is not as fiercely competitive. It lacks many foreign correspondents and does not have as many daily newspapers, but it still has major television and cable as well as galleries and museums.

3. *Washington, D.C.* Every major newspaper, both foreign and domestic, has a correspondent located in Washington, but they are usually politically oriented. This means that political/social/humanitarian art would have an edge in this city. Two newspapers, regional weeklies, and major museums are located there also.

4. *Other major cities.* These can be defined cities where the four broadcast networks—ABC, CBS, NBC, and FOX—have affiliate stations, or cities with one or two newspapers and a city magazine. Another way to determine whether a city is in this category is if a major sports team is located there. Examples are: Philadelphia, Chicago, San Francisco, Cincinnati, Miami, Dallas, and Seattle.

5. *State Capitals.* Due to regional, political importance of these cities, television and newspapers cover events and sometimes UPI or AP has a correspondent located there. Usually these towns are not cultural hotspots.

6. *Everywhere else.* This includes small cities, towns, suburbs, and rural areas. There might be a local television station which could be affiliated with CNN and newspapers with "Neighbors" sections. These are regional pullout sections devoted to news of that area. Unfortunately, these sections are seen only by that region—a limited market. There might be a local city magazine in color and lots of

free community newspapers that run small filler articles about art events.

If you have an exhibition in any of these locations except number six (there are exceptions), I would advise you to attempt to do a major publicity push for your exhibition or other art-related event.

After you have sent out slides or proposals for shows and have been accepted, you should know at least nine months or more in advance when the show is scheduled to occur. This gives you enough time to write an article (which can concentrate on either recent or past work), photograph the work, and make dupes and black-and-white prints.

There is no standardization to a publicity campaign. It ranges from a single-page press release without any supporting images, to a mega-release, an article with supporting materials including videotapes.

Preparing Press Releases

When the dates of the event are set, the first thing to do is to ask the exhibition site for a press release. This can take the form of a general (preliminary) or a specific (finished) release. If the site can't work that far ahead, then ask for their blank stationery and write your own press release. Many sites just do not understand the significance of publicity, and consequently, everything is done at the last minute. This is especially true of the nonprofit alternative spaces where there is little money, poor planning, and underpaid and overworked staff. These galleries tend to operate in a continual crisis situation. No event or exhibition has any more significance than the last or next one. This is democracy at its best and worst.

Every site will do a minimum of publicity. This usually consists of sending out press releases with accompanying photographs and maybe a follow-up phone call. But if everything rests on one or a few people who write grants, curate, hang work, deal with the daily issues of a gallery, and/ or cultivate patrons or collectors, not much else will be done.

Do not expect these people to contribute more than they are used to doing, unless something has been specifically arranged. If they do not follow through, it is usually because they are not aware of the necessity of timetables for publicity. Under these conditions, you must direct the publicity yourself. This is why you ask for a press release as soon as you

know the show is on a calendar and the date will not change. Then you will have enough time to formulate and implement an effective media plan with the least amount of stress.

In formulating your plan, you will have to weigh the options we have discussed so far and determine where you are most likely to be successful in receiving coverage—whether the exhibit is at a nonprofit space, commercial space, or museum, and in a city, suburb, or rural area. Sometimes it is best to wait until you are ready for a major publicity effort. You should weigh all the exhibiting circumstances before you make a decision. If you start planning many months in advance, you will have the time to research and understand the media options available in a particular area.

It is important to know how to receive national coverage by utilizing certain cities within each state. While state capitals are often not cultural centers, they do have Associated Press offices. To illustrate, if you exhibit in Harrisburg, the Pennsylvania state capital, it is possible to have national success, but you have to understand the market. Because Harrisburg has an Associated Press office, it is possible that an Associated Press article written there will be syndicated nationwide. In addition, Harrisburg has the local *Patriot* newspaper and two television stations, either of which could do a news spot, which, again, might be syndicated on national television. This is not as unlikely as it seems and has happened to artists before.

At least six months before the exhibit, you need to have a clear idea what artwork will be used for press releases and what work has to be photographed and duplicated. This will save rush service costs. Slides have to be captioned and a decision made as to which magazines should be sent material.

Three to four months before the exhibit you should have shot the work to be exhibited, made duplicate slides, and written text about you, your aesthetic, and the artwork. Magazines are often prepared several months in advance, so you will want to be ready to approach them well before your show opens.

Images on Press Releases

I like to create my own press release (with the approval of the site), since it becomes a little art piece itself. It is a very good idea to have a black-

AMOS ENO GALLERY

For Immediate Release Contact: Anne Yearsley (212) 226-5342

SHARON A. LOPER: KINESICS IN BRONZE

The subject of Sharon Loper's current body of work is Kinesics: The power of silent command.

The recently completed work, consisting of 12 bronze male and female figures, will be on view at the Amos Eno gallery from January 27 to February 15, 1996. A reception for the artist will be held on January 27 between 6:00 and 8:00 PM at the Gallery.

The sculptures, neither literal nor abstracted, are impressions of expressionism.
Loper's work goes beyond the obvious and reaches into the depth of the unspoken ... of body language.
Body language is the communication of psycho-spiritual messages through gesture, stance, expression ... it is a silent solicitation of response.
A solicitation that rarely goes unheeded.

Sharon Loper researches her subject thoroughly.
She lives with it and studies it, until she perceives its very essence.
Loper then becomes the subject she is creating, and by doing so, is able to explore it from the inside out.

Then ... and only then does she lay her hand to clay, allowing her intuitive creativity to bound free.

The art unfolds and grows spontaneously, viscerally, without preconception.
There is, from the very beginning, a spiritual connection between sculptor and sculpture.
The work builds and forms in visual poetry ... and she is its evolution.
Not the least of her talent is knowing when the piece has reached its zenith ... when to release it.

The result is a powerful, tactile communication.
People are drawn to experience it ...
to touch it ... to be part of it.
And the sculpture, in turn, becomes a living thing.

She is not only a superb artist, but a fine craftsman. Having studied with such classic artists as Joseph Martineck and Joseph Mugnaini, she knows her craft and the time honored responsibility of the artist to posterity. She works in only the purest materials and with the finest artisans to replicate her work.

Loper maintains her studio in Los Angeles, and has exhibited in many solo and group shows throughout the United States. Her work is recognized by critics and collectors and is included in numerous public and private collections, both here and abroad.

594 BROADWAY, #404, NEW YORK, NY 10012 (212) 226-5342

Figure 3: Press release with image

Courtesy Amos Eno Gallery; design by Veronica McLaughlin

and-white, screened photo, or line drawing as part of the composition of the press release. A screened photo photocopies much better (the grey scale has more contrast due to the dot matrix of the screen). A screened photo can come from previously published newspaper or magazine article, and it can be reduced to fit the size of the press release. This creates a generation loss if reduced, but it will be fine for this purpose.

If you do not have a screened image, you can have a photograph scanned at a service bureau via a computer. Some copy shops offer this service. If you are using a computer, you can get the image scanned onto a disk and create a press release which can then be photocopied. If you are cutting and pasting, figure out ahead of time the size needed and get the scanned image output at that size. Usually the image will be no larger than four-by-five inches.

If the exhibition site is preparing the press release and/or the announcement card (discussed below), do not leave the process entirely up to them. Have them send you a proof to make sure all the information is correct. The announcement card does not have to be completed as soon as the press release is done, but I'd have it finished three months before the exhibit, to be included in the magazine press mailing. Also, if the site is doing an announcement card in color, it is important that you see a printed proof and approve the color separation before the finished card is printed.

Mailing Envelopes

The same image that is on the press release might be on your press kit mailing envelope. A six-by-nine-inch envelope can be mailed for thirty-two cents and is large enough to photocopy an image onto.

Fax Press Release

When you are creating the press release, a fax version should also be made. This might be different than the mailed press release if you are having an opening event and want to stress that event over the exhibition. The fax press release is usually most effective if sent to newspapers and other media covering newsworthy events, the day before or morning of an opening event. A superb quality photo on the fax will save you the trouble and expense of faxing a long description of the work and provide an eye-catching piece of promotion.

Announcements Cards

One of the most important components to an exhibition or other art event is the announcement card. These cards are used to attract people to the exhibition and opening and should also be included in any press kits you mail out. Announcement cards sometimes simply give the names of the artist or artists exhibiting and sometimes reproduce examples of the artists' work. It is very important what image is chosen for this card; the single image will signify the entire exhibition. The image should be strong and representative of the work being exhibited. It should also be a piece that reproduces well and will look good on a card. Generally, museums, universities, commercial galleries, and some nonprofit galleries design and pay for the announcement card. Some small commercial galleries, co-op galleries, and artist-organized shows leave the responsibility for the cost of the card to the artist. In these cases, artists usually use a black-and-white card or, if they have the money, produce their own color card. There are many eye-catching or elaborate versions of announcement cards that have been created by artists; some are handmade or handprinted, others may have expensive die cuts in the paper, and some are mailed in envelopes rather than as postcards. One way to minimize costs of producing a card is to use the color separations from a work which has been previously published (see Color Separations below). The separations will have to be the right size to fit the card.

Information, such as date, location, and opening information, has to be the same on this card as on the press release. The printed image on this card, even if it is in color, should be the same one that is used in black-and-white on the press release.

The "right" number of cards to be printed depends on the gallery's and your mailing list. Some printers have established minimum printing runs and this number differs for black-and-white to color images. As an example, in my area 1,000 black-and-white cards cost about $100 for the half-tone, typesetting, ink, and printing, while 1,000 color cards can range (with or without separations) from $450 and up. A business called Modern Postcard 1-800-959-8365) prints 500 full-color postcards from a photograph for about $100. Call for up-to-date information.

Whatever the amount printed, the artist should have 100 additional cards for themselves, which can be used as part of another press package and as part of a promotion piece in getting other exhibits.

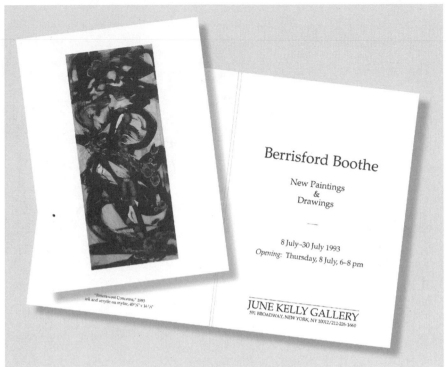

Figure 4: Announcement card mailed in envelope

The post office has certain regulations regarding the size of the announcement postcard for the twenty cent price to apply. Cards larger than 4¼-by-6 inches will cost an additional twelve cents, or the thirty-two cents first-class rate.

You can use the image and written information on the announcement card to make a poster (at least eleven-by-fourteen inches) by photocopy or other inexpensive method, and put it on walls or in storefronts before the opening. This is a low cost way to further promote the exhibit.

Reviews

One of the objects of sending out press releases and press kits is to receive a listing in the cultural or art section of local newspapers and possibly to obtain a review. You should realize, however, that outside of the larger cities which have paid art critics on staff, most regional newspapers hire freelancers to write reviews. These critics usually choose what they want

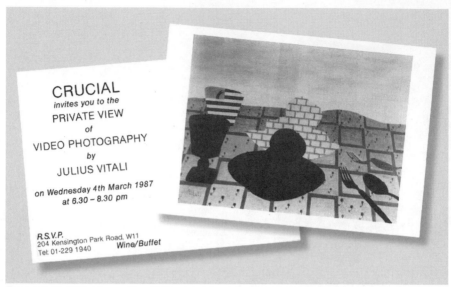

CRUCIAL
invites you to the
PRIVATE VIEW
of
VIDEO PHOTOGRAPHY
by
JULIUS VITALI
on Wednesday 4th March 1987
at 6.30 – 8.30 pm

R.S.V.P.
204 Kensington Park Road, W11
Tel: 01-229 1940 *Wine/Buffet*

Figure 5: Black-and-white announcement postcard

to review (unless they are specifically assigned), based on the press release, announcement card, and other supporting materials. The pay freelance art critics receive for reviews can range from twenty-five to fifty dollars (and up). They are paid by the column inch (the amount of printed words that fit into an inch space). Due to this low payment, it is often younger writers that end up being critics, and the quality of the writing can be erratic.

A good review should always be kept and used as supporting material for future shows. In fact, if a review appears at the beginning of an exhibit, it should be mailed or faxed to local and national art publications. This might make them send their critics (freelancers) to your show.

Opening Events

You might consider doing something special for your show's opening. This could be a lecture, performance, or demonstration of technique—anything that might be considered newsworthy. The press release should emphasize the significance of the opening due to the planned special event. The sooner a notice, article, or photograph appears in the newspaper or on television, the more traffic will result in the gallery.

Slow news days are usually Saturday, Sunday, or holidays, with the business week—Monday through Friday—being the busiest for journalists. For that reason, an opening held in the afternoon (when journalists realize they've had a slow news day) or on the weekend is more likely to attract the media. Although events on Friday night might work if they are before 9:00 P.M., you have to give television or newspapers time to edit and process the information. I believe that Saturday is the best day to run an event as a news item, as it will appear in the Sunday paper, which is more widely read than any other day. This maximizes potential audience regarding readership.

When Newspapers or Magazines Respond to Press Releases

If a newspaper or magazine is interested in an article or review about you or your work, make sure a photographer is sent along with the reporter. Sometimes the reporter will be sent out first and after the article is written, the photographer will be assigned. Art is a visual medium, and it is very annoying to have an article run without a picture. If you are uncertain that a photographer has been assigned to the story, you should give the reporter color slides or black-and-white prints to cover all bases. Also, find out if the photographer will be shooting color or black-and-white. If he shoots color, the chances for a feature article will improve.

It is important to inquire about procedures, so that you know what to expect. If the assignment photographer shoots only black-and-white film, color cannot magically be added. If she shoots in color, however, the pictures can be reproduced in black-and-white. You almost never know until the article appears. This is the nature of the media beast.

Media Saturation

If you exhibit in the same area repeatedly and send press releases, be careful. Unless your work undergoes a distinctive change, reporters and reviewers can only take so much of you. Regional saturation endangers your ability to receive publicity. Do not do a major mailing often. Once every six months is sufficient. At a local level, you may be successful with mailings every three months, but this depends on how successful the original press mailing was. If it did not result in anything, then three months later in the same area would be appropriate.

Often, when you have saturated one region, you have a better chance of becoming a news or cultural item out of your region. For this reason, you should try to show your work outside of your home area. It is hard to coordinate transporting the work and finding accommodations, but without this effort your reputation will be based on luck rather than hard work.

The NAAO understand this dilemma and do their best to find you lodging in homes, or if they have to, in the gallery, when you are exhibiting out-of-town. It is not uncommon to find yourself sleeping on the gallery floor in a sleeping bag. Whatever the situation, stay with friends, camp; but do what has to be done to advance your reputation outside of your home area.

AP, UPI, and Reuters

It is important to know if any Associated Press (AP), United Press International (UPI), or Reuters reporters cover the area of your exhibition site. These reporters are the link to national newspaper and radio syndication. These people need to be contacted and cultivated since they possess the power to make reputations. For syndicated articles, they will usually interview you and take pictures of you and your work. The member newspapers/radio of the syndicate can decide whether to treat the article as a feature or filler. It is their choice. They pay a yearly fee and can use the material as they see fit.

Advertising in Publications

Do not expect galleries, whether commercial or nonprofit, to pay for advertising. Remember, the gallery has a full calendar of exhibitions and might want to save funds and effort for a particular show, knowing that newspapers will not cover them every month unless there is nothing else to cover. Ask the gallery if they will cover the full expenses of advertising or whether you will have to contribute.

If you are thinking of creative publicity strategies and ads are being considered, then either you and/or the commercial gallery (nonprofit if the money for the ad was written into the grant) have to know the best market in which to place these ads. You can receive free sample issues of most art magazines, along with rates for display advertizing, just by calling the

particular magazine and talking to their marketing/advertizing people. After viewing many of them you can determine whether they are regional or national and you can best decide if your budget can handle the cost of the ad.

If you decide that advertising in art magazines is the best way to proceed, there are some factors you should be aware of. The cost of a one-time ad in a prestigious art magazine is a small fortune. But taking out an ad could improve your chances of getting a review in that magazine. Although it is not guaranteed, these magazines do tend to publish feature articles and reviews on people who take out ads. This happens, although it might not be in the same issue your ad appears, and it could be months or years down the line.

Certain reference books available in public and college libraries—*Art Index, The Reader's Guide to Periodic Literature*, and *Who's Who in American Art*—are commonly used by people who might want to contact you for a college thesis, book project, magazine article, or group exhibition.

Art Index is an index of certain national and international publications that deal with art, crafts, photography, film and video, design, architecture, and other related fields. They index all art articles, art reviews—both solo and group—especially if a photo is used, and they index certain art ads. If you know which magazines are indexed in the current *Art Index* (about three hundred international magazines are indexed in the 1995 edition), and which ads are indexed, you can plan to pay for an ad that will be cited in the index. You can always add the citation to your resume.

Art Index will only index art ads that have photos accompanying them. In order to qualify for indexing, an ad for a painter, collagist, or decoupagist must have a color photo one quarter of a page or larger. The ad will most likely have to be larger, because the text would have to be laid over the photo of the painting to stay within the minimum requirements for indexing. A half-page ad with text and photo each taking up one quarter of a page will be indexed. If you ran a black-and-white photo of a painting, no matter what size, they would not index this ad. However, sculpture, photography, drawing, or film stills, can be either in color or black-and-white as long as the photo is one quarter of a page or larger.

For ads with just the name of the artist and gallery and no image, the name of the artist is indexed but that of the gallery is not. If you have questions call the editors of *Art Index* at H. Wilson Co.: 1-800-367-6770.

Where to Submit Materials

When deciding where to send materials, you should make a list of all local and regional publications that might find your exhibition or other art-related event newsworthy. This list can often be expanded to include national publications, which might be interested for any of a number of reasons. Depending on the type of art that you create, you may find many opportunities. By using *The Reader's Guide to Periodic Literature* (available in most libraries), you can research references to articles on subjects related to your work. Take for instance, a popular topic like the environment. *The Reader's Guide* lists articles appearing in these magazines: *E Magazine, Earth Journal* (formerly *Buzzworm*), *Environment, Garbage, Harpers, Mother Earth News, National Geographic, People*, and the *Utne Reader*. They either have columns devoted to the environment or they do features on this topic. If your work deals with environmental topics, you might query them or send out your article/press release with photos and see what happens.

If you are a photographer, *The Reader's Guide* lists *Petersen's Photographic* and *Popular Photography*, and the *Art Index* lists *Afterimage, American Photo, British Journal of Photography*, and the *Photographic Journal*.

The *New York Times* is a national newspaper and no one can doubt the significance of having an article or review in the *Times*. They do art reviews on Friday and they tend to cover more museums shows on Sunday, although not necessarily New York City museums. You might not think the *New York Times* would be interested in reviewing your work, but you should know that the *Times* has regional editions that are published on Sundays for New Jersey, Long Island, Westchester, and Connecticut (designated section 13). These regional weeklies have their own art critics and they do reviews in their region. There is one drawback. If you had a solo show in New Jersey and got a review in the New Jersey section of the *New York Times*, the review would not be seen outside of New Jersey. Although the *Times* is read around the world, you can only get the New Jersey section in New Jersey. This is a bit of a pitfall as a lot of important people never see these four regional weeklies. The regional critics are, however, first rate and a review by one of them, I believe, is very important for long-term strategies. There is far less competition to receive a review

by a regional critic, but the review is still in the *New York Times* and, if positive, can be used as part of your portfolio and press material.

During the summer months the Hamptons, located in Suffolk County on Long Island, have traditionally been the vacation spot for the art crowd from the New York metropolitan area. At this time, the *New York Times*, Long Island section, concentrates on reviewing the shows in the Hamptons and deemphasizes the rest of Long Island. Hampton galleries are busiest in the summer and, consequently, the exhibition calendar takes on an added significance. Galleries know the *Times* will review them, and it is also a social scene where networking occurs for projects that will happen at a later date in New York. If you are going to exhibit on Long Island, this would be the best time to do it.

My own experience with the Long Island section is that if the reviewer has never covered you or your work, it is much easier to obtain a review for a solo show. However, once you have been reviewed in that section, unless there is a major stylistic change in your work, it is unlikely you will be reviewed again in that section unless you are in a group show.

You might want to try to have a solo show outside New York and hope for a good review from regional *Times* critics, before tackling New York City. A regional section review might help you get into the main section when the opportunity arises.

Ulrich's Directory

Among the most comprehensive ways to build a list of magazines, is to consult *Ulrich's International Periodicals Directory*, which comprises four volumes and a fifth volume for newspapers. *Ulrich's* does a great job of finding and then cross-referencing subjects and if you know the title, you can track down the magazine. They have more than 140 thousand serials listed throughout the world. In addition, they also publish updates three times a year. The *Ulrich's* hot line, mainly used by librarians, is a toll-free number that customers can call to get help in solving research problems and questions. Consult the beginning of *Ulrich's* for the number. You may inquire about only two publications. If you have more questions they ask you to fax them or write them. The fax number is 1-908-771-7725 and the address is R. R. Bowker, 121 Chanlon Rd., New Providence, NJ 07974. They will either phone or fax back with the information you need. The

Ulrich's operator can give you instant updates regarding information. The publication entries give the name, address, telephone, and fax numbers, as well as the editor's name and a brief description of the magazine's content.

This directory is extremely important when mailing out slides to various magazines. There are a few other directories available, such as *Burelle's Media Directory* and *Power Media Selects*. These are specific to television, radio, magazines, and newspapers; their uses will be discussed throughout this book.

Feature Articles

Placing feature articles in magazines can be part of a publicity campaign associated with an exhibition or can, as discussed in the previous chapter, be pursued independently as part of a long-term strategy for gaining a reputation.

The number of slides of your work necessary for this type of article varies from eight minimum to forty maximum, depending on the type and scope of the article. Twenty would be sufficient for most mailings. It is necessary to include a photograph of yourself working on your art. This not only shows who the artist is, but is a snapshot of the studio and your lifestyle. One or two pictures of this type should be sufficient—nothing formally posed. A wide angle of the studio showing many works with you in it and a close up of you working would be fine.

Captions for these artist/studio pictures should be included, giving the location, type of work, anything particularly interesting about the piece being created, type of tools used, and the like.

The rest of the photographs—of the work—should be taken in the manner described in the appendices. Images of the whole work and details may be included. The captions accompanying slides of the artwork should include the title, size, medium, date, and any particularly interesting things you have to say about the piece. Type the captions on a separate piece of paper from the text and number each slide to correspond to the numbers on the typed page, so there is no misunderstanding. This is especially important when submitting materials to foreign magazines. If they find something confusing and still decide to use it, the results might not be satisfactory.

If you are sending an article written previously about yourself and your

work, photocopy it and white-out the byline of the author and type in its place "For Information Only." (This is a method utilized by some of the press photography agencies, since they receive payment for the use of the photography and not the text.) This indicates that the article is not to be used verbatim, and that the material has to be rewritten. The ideas and concepts are what is important, not the writing style. Rewriting the article does not violate the copyright of the original author.

Sometimes when I give material to SIPA or Gamma Liaison Photo Agencies, they take the English text and translate it to French before it is rewritten. When it is rewritten it goes out in French and then is translated to Dutch, Italian, German, or the appropriate language. I have the published piece translated back to English to find out what is says. Often, when the text has been translated from a second to a third language, the results can be surprising—to say the least.

For English publications this is obviously not a factor. However, whenever you send out previously published materials, I'd supplement them with your own written ideas. Primary source material is always of interest to editors. Sometimes they create quotes to make it appear that you were asked a direct question, even when this is not the case. These editors want their readers to feel an intimate connection with the artist. Read the magazines and get an idea of their writing style before sending materials to them.

Visiting Magazines and Newspapers

In my experience, making personal contact with magazines and newspapers is the most effective way to achieve success with these publications. Consequently, it is an obstacle if publications institute a drop-off policy or rely solely on mail solicitation.

Sometimes calling cold for an appointment with an art director or photography editor will activate voice mail or an answering machine. It is uncertain whether you will receive a return call. Therefore it is best to call until you reach a live voice (this is where six-second telephone billing helps; see chapter 4). Artists usually meet with the editor's assistants. If you bring in your portfolio or slides and you "pass the test," then the assistant refers you to her superior. This might sometimes be a fashion or beauty editor; it all depends on the magazine and type of art that you create. Look at the mastheads of the magazine to determine who to

contact. Make sure the issue is current, as people in this field have a high turn over rate. It is a good idea to call the magazine and ask the receptionist if so-and-so is still the photo editor.

You visit a magazine or newspaper to introduce yourself, show your work, and begin a dialogue, through which you can find out what they need and tell them what you'd like their publication to do for you. This can take the form of a feature article or review in conjunction with an event or exhibition. If your artwork lends itself to illustrations, mention you are available for assignments. Try to network contacts from the editors (art scouts) for galleries, other artists, people working at other magazines, and the other people at that magazine. If, during the course of your visit, the editor says "you can use my name when you contact this person," it is a lead not to miss.

There might be as much as six months lag time between an assignment or acceptance of an image and its publication date. This is especially true for monthly magazines, because they work three to five months in advance of the publication date. If you are lucky enough to have something appear immediately after visiting a magazine, thank the image god; but the truth is that often publications are hurting for interesting material, and if you can provide them with a newsworthy item, then you have a feature article.

Tearsheets

I would recommend requesting as many free copies or tearsheets (if color) as possible. Ten is a minimum, and you will easily find use for fifty or more. Articles in black-and-white photocopy well, but color is more difficult to reproduce. If something is published in color, you want as many tearsheets as possible, even if you have to pay for some of them. Ask for them before the magazine appears; tearsheets are used by both the advertising and editorial departments, and their availability is a matter of first-come, first-serve. The reason you want so many tearsheets is obvious: they can be sent out to galleries and other magazines; they can be included with grant and other applications; they can be used in many other ways.

Sometimes publications will give contributors a certain number of free tearsheets and then offer a reduced price for additional copies. You can then weigh the cost of a single photocopy verses the reduced cost from a magazine. Color photocopies will probably cost at least eighty cents apiece.

A different method of obtaining tearsheets is to buy the publication in

quantity from a magazine distributor in your area. (Look in the *Yellow Pages* under "magazine distributors.") You would have to know the issue number and the date of that particular magazine, and then wait for unsold copies of the magazine to be returned to the distributor. When buying in quantity, the price should be close to wholesale, but you should check the specifics with each distributor.

Color Separations

Whenever an article with color photographs of your work is published, Remember to ask for the color separations. These are the four separate color keys that make up the printed page. If you can obtain them for free, (and this of course depends on the publication) it can save you a lot of money. Separations costs vary according to size, but even a small separation is around $100. The uses of these separations are many. They can be reused many times, and if the published size fits a postcard, poster, brochure, or future catalog, the separations really have value for you. Later in your career, if a university or museum wants to publish a catalog on your work and you can provide them with the color separations, a significant amount of money can be saved. It could make a difference between the decision to publish a catalog for your show or someone else's.

You can even mention to a magazine that you would like the color separations since you are planning long-term events and want all options. The magazines eventually discard the separations, so they are worth asking for. As more magazines use electronic publishing, these separations might be on computer disk. These are still valuable, so remember to ask about them, too.

Being Paid

Do not expect to be paid for publicity review photographs, however sometimes short features and notices with accompanying photographs will receive compensation; but you should ask to be paid for feature articles written about you and your artwork. A "first-time-published" article might warrant not being paid, but do not let this become a habit. You should be paid a photographer's fee for a feature article written about you and your artwork. If the publication refuses to pay, then determine if it is worth it to be published. You should always be paid for assignments.The receipt

of money, in addition to free publicity and tearsheets, makes article placement extremely rewarding.

Example: I created the "Hairy Chest Tie," which originally was commissioned by the *Village Voice* for their "V" fashion section. The *Voice* published two tie-related articles and one fashion photography spread. The "Hairy Chest Tie" is not a real tie at all. It is a photograph of my chest cut into the shape of a tie and then rephotographed on a model's body (it was held on by tape). Subsequently, I made four silkscreened versions, which are about three generations in quality down from the photograph, but the humorous, and subversive, quality of the original still holds up. What started out as a surrealistic fashion joke turned into something profitable. I wrote an article about the tie that was syndicated by a photography agency and then later on by myself. The total sales from this one article worldwide is over $6,000 since 1982.

Publicity from the articles led to the ties being exhibited in numerous galleries, including a traveling exhibition, "Fashion and Surrealism" at the Fashion Institute of Technology in New York City and the Victoria and Albert Museum in London.

In addition, I've had interest in the ties from many stores and individuals over the years. Due to my insistence on achieving a photographic realism and the complexities of manufacturing and distribution, the tie has never been mass produced. The "Hairy Chest Tie" is a good example of how a single idea can provide both income and publicity.

Magazines sometimes devote a whole issue to a single theme or concept. In order for this to be successful, the editorial content has to be thought out well in advance. Many magazines rely on freelancers for up to 90 percent of the material they publish. When you submit an article, keep in mind that other material can be built around it; or it can be used to support other articles in a theme issue. In the best scenario, you would have a feature article appearing the same month as an exhibition and be paid for this article, a photographer's fee and/or a writer's fee.

Once you begin to understand how magazine publishing works, money can be made off the media to help defer the exhibition costs. If you received funding for a special project through a nonprofit organization, the media is more likely to write a feature article or review the event, since public funds were awarded. It should be stressed in the press release that public monies were received.

Reputation

It is much easier to receive publicity when the press knows who you are. Once you have received publicity in connection with exhibits, grants, or other events, you can begin to generate your own stories to fit the needs of magazines and to bolster your career. Women's magazines, in particular, are often interested in the "slice of life" story.

I received a call from a German woman's magazine called *Petra* because they were interested in a profile story about an artist at home. The article would be mostly photography, and would emphasize the environment of the home and how it relates to creativity. They wanted to focus on the artistic touches that an artist would create in a home or apartment, such as unique domestic items or hand-painted furniture. If you take the utilitarian and create something magical—a hand-tiled kitchen mural, designs around a window, or a unique outdoor paint job—it might get you attention.

What you create should be related to your artistic style or concepts. The environment an artist creates and how he or she lives is the emphasis a lot of magazines are looking for. The text could be about how the space was transformed (before and after shots), the concept behind what was created, and any anecdotes about the process. In this type of article it is important to have photos of the artist in action. If you did something in the kitchen, have an action photograph taken during the installation. Do not forget about your studio if it is part of this environment. Take another photograph with you in it.

The "slice of life" story will not be the first article about the artist, unless the house is unique and the story emphasizes the space rather than the artist and his or her work. Usually these types of stories run a year or two after articles about an artist begin to appear. If you plan to create something artistic in your home or apartment, keep the idea for this type of article in the back of your mind. Don't forget the before and after comparison pictures. These stories might also be sold to interior design magazines, home magazines, and the like.

Networking through Magazines and Newspapers

Since magazines and newspapers are always receiving information about people, shows, and lifestyles, they are the best source for networking.

Getting an appointment with an editor can result in the most current information. They know what's going on and who might be able to help you. These editors sometimes have interests and connections in their field and other related fields, which can help advance your career (sometimes even giving you a gallery recommendation). If they decide to publish your work, you have their respect and this can often translate into their support in other pursuits. To illustrate: I arranged an appointment with the New York editor at *Petersen's Photographic* magazine. She became interested in my work for publication. As I began submitting my articles, I got to know her and I found out she was one of the curators of the Arles, France photography festival. She included my work in this festival.

Art critics are especially important in major cities like New York. Often curators will ask the critics to recommend artists when they are putting together an exhibit. The critic acts as an art scout not only for the newspaper or magazine but for people who need current information about artists. Curators rely on them for their knowledge. Try not to make enemies of critics, as over time they may become very helpful. In fact, when you meet them, either through work or socially, explain your goals. If the opportunity arises for them to aid you (like writing a recommendation), they may be willing to do so.

Barbara Nessim

Barbara Nessim is an internationally known artist and educator. For more than twenty-five years, her paintings and drawings have appeared in numerous galleries and museum exhibitions as well as in major publications such as *Time* and *Newsweek*. It took her eight years to begin to make a living as an artist and an illustrator. In fact, she remembers the days before photocopies and quick prints. Before doing a mailing, she would create wood block lithographs of the names and addresses of potential clients—in effect, one-of-a-kind artwork to solicit business. This artistic gesture worked for her twenty-five years ago. It is a time- and labor-intensive approach; however, it can be well worth the effort. Today, with the widespread use of desktop publishing, work done by hand has an added appeal.

Barbara Nessim has successfully bridged the gap between fine art and commercial art. For this to work, one's aesthetic has to be first established in fine art. The commercial work is an outgrowth of it.

Nessim's sketchbooks are a source of inspiration to her, and she creates three or four a year. These are unedited ideas or private visual conversations that show up in her other work. In fact, her "Random Access Memories" is an interactive computer art exhibition that draws on her notebooks. In the exhibition, fourteen drawings are randomly accessed from a database of four hundred images to create miniature sketchbooks, each a unique work of art. Nessim does not see this as a promotion tool, but since her name and address are on each book, and they are free to the gallery audience, it could be viewed as one.

Commercial art, or art for publication, is usually not the same as an artist's fine art. It is work of a different caliber, but should be clearly influenced by the same aesthetic as the artist's other work. When Nessim first started out, an art director gave her guidance on how to make her work commercial enough to be sold as illustrations. The commercial portfolio has to change constantly, follow trends, or show new directions in artistic growth.

Now in her fifties, Nessim still will solicit business occasionally, but since she has paid her dues over the years, more people are calling her for shows and illustrations.

In May 1991, a six-page feature article about Nessim's work appeared in *Omni* magazine. She always asks for tearsheets and overruns of her articles and will occasionally buy reprints from the publisher. In the case of the *Omni* article, she paid $2,000 for 2,500 reprints in full color. This became a wonderful promotion piece for her mailings and other presentations.

Currently, she works in all media, from drawings to computer art. She lectures extensively around the U.S. and is the chairperson of the Illustration Department at Parsons School of Design, in New York City.

Foreign Contacts in the United States

Sometimes it is better to play the foreign market first and get an article or two in foreign publications, and then go to the local or regional level. This will normally result in more significant coverage since foreign articles always interest the local media.

If you are planning to contact publications outside of the U.S., there are many different ways to find out where to send materials. Researching in *Ulrich's Guide to International Publications* will give you the publisher,

Figure 6: Good example of a page in a publicity portfolio

address, phone, and fax number. Fax them to find out if they have a U.S. correspondent or "stringer." Visiting a magazine stand and discreetly copying down the information is another method. Sometimes magazines list information about foreign correspondents in their mastheads—names, addresses, and phone numbers. Since these correspondents are located in the U.S., this is the most efficient way to contact these publications. Call or write to them. If the are interested in your work, they will forward your material to the magazine's main office. Dealing with correspondents, you can be assured your materials will be returned to you when they are through with them.

The United States Information Agency (USIA), as part of the U.S. commitment to a free flow of information across international boundaries, has three Foreign Press Centers. These are located in Washington, D.C., New York City, and Los Angeles, and assist accredited resident and visiting foreign journalists in their coverage of the United States. Every year the USIA publishes a *Directory of Foreign Correspondents in the United States*. This is a free publication, which you can receive by writing or calling the Washington Foreign Press Center, 898 National Press Building, 14th and F Streets, N.W., Washington, D.C. 20045; 1-202-724-0032.

If the USIA questions you, mention that you wish to contact some of the correspondents regarding an exhibition, or that you wish to submit material to them for publication. These correspondents include newspaper reporters, magazine photographers, bureau chiefs, and radio and television newscasters. Sometimes they represent a magazine publishing group that consists of several publications. It is unlikely that a foreign newspaper or television station will cover you unless you are from that particular country and exhibiting in the U.S. In that case, they have a particular slant which allows them to write about you. Magazines provide the best opportunities for being published abroad. The USIA directory does not give a description of the periodicals.

Another way to get information about foreign correspondents is to write to a particular country's consulate in New York, Los Angeles, or Washington, D.C. Tell them you want to submit an article to many magazines, and they should be able to send or fax you a list. This, again, is just a list and not a description, but if you do your research you will be able to determine the proper magazine to send material to.

Consulates usually have a library with their country's publications. You might have to make an appointment to use the library, but it is a good way

to see what types of magazines are published in that country. Consulate libraries are an excellent place to prepare if you are planning to travel abroad with your work (see chapter 6). Some public and university libraries carry foreign publications and can be another important resource.

As I mentioned, sometimes one person acts as an agent for a publishing group that owns several magazines. *Paris Match* magazine, for example, in located in New York City as part of Fillipachi Publishing, a group that also includes *French Penthouse* and *New Look* (a monthly magazine that has nudity and articles on interesting new developments in culture). *New Look* uses art that is on the edge, and can be a good market for contemporary art. *Paris Match* is the link to *New Look*; the listing in the New York directory is under "Paris Match," not Fillipachi. The New York office sends out packages to Paris via the Concorde jet. However, they will keep your materials on file in Paris unless you specify to send it back if not accepted. Sometimes, if *New Look* is not interested in the material, it is passed on to the editors of other publications, since numerous magazines are part of the group.

The New York City phone books (*White Pages* and *Business to Business*) are a good source of information. Look under "Publishers-Periodical"; but you have to know either the name of the magazine or publisher. *Ulrich's Guide* (available in most libraries) gives you this information, which you can then cross reference. This might take a bit of time, but once you know this information you can use it every time you do a new mailing.

Under "Magazine Dealers," the phone book lists many dealers that carry foreign magazines such as: Dina, 270 Park Ave South; Hotalings, 142 West 42nd Street; and Rizzoli Bookstore, 31 West 57th Street, and in Soho, 454 Broadway. There is a great magazine stand near Grand Central Station in the former Pan-Am Building. They do not mind if you browse through the magazines, but be discreet about writing down addresses.

If you need to obtain telephone directories, dial 1-800-719-5656. Whether you need a directory or 6,500 different directories, NYNEX offers out-of-state, international, government, fax, state, business, zip, area code, address-telephone, and toll-free 800 directories. The cost varies from a low of twelve dollars to hundreds of dollars. The *New York City White Pages* costs thirty dollars plus five dollars shipping and sales tax if applicable. The *Business to Business Directory* is thirty-five dollars plus five dollars shipping and sales tax if applicable (you might need only this directory as it lists consulates, art galleries, and magazines).

Possible Magazines for Feature Articles

A partial list of magazines for potential feature articles is given below. Try to look at these magazines before submitting articles. Whether you should submit or not depends on the type of work you create and the type of features they publish.

Monthly magazines

(Send materials four to six months before exhibition for feature articles):

U.S. *Artforum, Art in America, Artnews, American Artist, American Art, Ceramics Monthly, American Crafts, Earth Journal, Sculpture, Fiberarts, New Art Examiner, Smithsonian, Women Artist's News, Vanity Fair, Harpers, New Age, Interview, Utne Reader, Vogue, Mademoiselle*

U.S. Photo Magazines *Popular Photography, Petersen's Photographic, Studio Photography*

Foreign *Domus, City Magazine* (New York, Los Angeles, San Francisco, and Chicago), *Vandidadas, Du, L'Arca*

Foreign Photo Magazines *British Journal of Photography, Camera Canada, Foto Practica*

Weekly magazines

(Send materials two months before exhibition for features):

U.S. *USA Today Weekly, Parade, People, US, Time, Newsweek,* weekly newspapers magazine sections (not syndicated), weekly entertainment papers like *The Village Voice*

Foreign *Der Speigel, Epoca, Elle* (France), *Grazia, Panorama, Petra, Scope, Stern*

Tabloids

Most people completely disregard the supermarket publications such as the *National Enquirer, Star, Globe, National Examiner,* and *Sun* as a publishing venue. I am not one of these people. My point of view is not

to debate taste or whether the publication is high- or low-brow. Many people have written about the debasement of art through publicity of this sort. I'm not drawn to this argument. I want to create income from reproductions of my artwork that will support my career as an artist.

If you are picked up by a photo agency, the first place they will try to sell your work will be to these publications. The reason is that they publish in color, are weekly, have a high circulation, are competitive (there are five of them), and pay well because of the competition.

If you follow these publications at all—if you happen to be a closet tabloid reader—you'll notice that they try to use art and photography stories in every issue. They particularly like bizarre collections or any art with an edge or sense of humor. They run articles on odd jewelry and fashion. In fact, they tend to use the same stories repeatedly. I've seen Salvador Dali's surrealistic gold jewelry published many times. It might not be used in the same publication, but it makes the rounds of these five magazines. The tabloids try their best to come up with new material every week, but with five competitive publications they need a lot, so they have to recycle and are eager for new material.

Titles are very important when selling to these publications. In fact, the titles are sometimes the only thing that is important. If your work has this type of edge, whether it is bizarre or funny, and the title describes your art, you are welcomed. An example: an artist created hand-painted necklaces from seashells. The title of the article became "Art from the Sea." When one of my creative tie articles was published, its title was "You'll Tie Laughing."

These publications pay one hundred dollars or more for an image in color and slightly less for black-and-white, and they sometimes use more than one photograph. Note that the foreign magazine editors read these publications. If you have an article in them, it is likely that other magazines will contact you for the same material. Foreign tabloids have similar readerships to the U.S. publications, but some of the magazines are a combination of *TV Guide*, *Time*, *Life*, and the *National Enquirer*. They have people, humor, general interest, fashion, and special last page sections, besides the feature material.

The *Sun* used three of my video/computer photos for a story called "Computer Reveals Faces from Beyond the Grave." The images were manipulated faces with saturated colors, which were just what they wanted. The story was fabricated; yet, they made it look believable. These

publications are fiction. However, they will use eccentric or bizarre artwork and text as is, as truth is stranger than fiction.

The *National Enquirer* has the largest circulation of the tabloids and pays the highest photo fee. The address is 600 S.E. Coast Ave., Lantana, FL 33464; 1-800-628-5697 or 1-407-586-1111. Contact the *Star* at: 660 White Plains Rd., Tarrytown, NY 10591; 1-800-992-3905 or 1-914-332-5000. The *Globe, National Examiner,* and *Sun* are all owned by the same publisher. Contact them at: 5401 N.W. Broken Sound Blvd., Boca Raton, FL 33487; 1-800-749-7733 or 1-407-997-7733. Talk to the photography editors to bounce stories off them.

Specialty Trade Publications

There are some specialty publications, such as airline in-flight and hotel in-room magazines, that publish short features on interesting cultural events in the areas they serve. They can be national or regional and are general interest publications for business and leisure travelers.

If you exhibit in a city that American (*American Way Magazine*), Continental (*Profiles*), Delta (*Sky Magazine*), Northwest (*World Traveler*), TWA (*Ambassador Magazine*), United (*Hemispheres*), or US Air (*US Air Magazine*) flies into, you might want to contact these in-flight magazines about the possibility of an article. Premier magazines in London publishes an in-flight magazine for the Concorde flight between London and New York. Air France publishes *Air France Atlas* and *Air France Madame*, magazines covering both regular flights and the Concorde flight from Paris to New York. Most foreign airlines that fly into the U.S. publish magazines in both English and their own language, covering cultural events in the home country and the U.S. city they land in.

The same is true of hotel in-room magazines. *Where* covers eleven U.S. cities, such as New York, Los Angeles, Washington, D.C., and Philadelphia; seven Canadian cities; and two international cities (London and Paris). *Guest Informant* covers thirty-six U.S. cities. To find out about these, look in *Ulrich's Guide* (available at the library) under Travel and Tourism—Airline In-flight and Hotel In-room.

CHAPTER 3

Publicity: Television and Radio

Artists sometimes forget about television and radio, but these media reach a wide audience and should be included in any publicity campaign. How do you get access to television and radio coverage? It is unlikely that you will get an appointment to see radio or television news editors, as they are always under deadlines. It is best to try to reach them by letter, fax, or by sending video or audio tapes. Since this is a video era, television seems to respond to VHS videotapes better than to written press releases. Generally, a publicity video should be no longer than ten minutes. The editors do not have the time to watch anything

lengthy, so ten minutes is the maximum and it is better if you can make your point in three minutes. Remember, television news clips are usually two minutes or less. Using sophisticated editing techniques, both television and radio can convey a lot of information in two minutes and a significant amount of information in as little as ten to fifteen seconds. Video and audio press releases will be discussed in more detail later in this chapter.

Press Releases for Newspapers, Television, and Radio

Three to four weeks before the opening of an exhibition or other significant art event, send press releases and feature articles/ideas to newspaper columnists and local radio and television talk shows. In all these media, the news works on a tight deadline. You are not news three weeks before the event.

I would visit your local newspaper and see the art or entertainment editor to see if a feature article can be written about you. Do not be shy! If you are mentioned in a feature article or in a captioned photograph (especially in color about the opening), you are more likely to be perceived as a news item by radio and television, especially if a few publications have picked up on your work.

One week before the event, send a written press release with photos to the radio and newspaper news desks, and send a video press release to the television (cable and broadcast) news desks. If you are successful in planning a feature article and it appears in conjunction with the exhibition, it can be used as a mailing piece for television, radio, and newspapers. Newspapers and television are pleased to have recently published material to use in creating the story. Gallery listings including your event should be sent to the television news shows that have a one-minute weekly cultural round-up. Watch the news shows or call and ask about the specific features for each particular show, so you can tailor your materials to fit their formats.

As mentioned in the previous chapter, art openings are an excellent opportunity for television to cover the exhibition or event. On the evening before, or morning of, the event, fax press releases to the television, radio, and newspaper news desks. Get the fax numbers a few days before, so you don't waste time trying to gather them on the day of the event. Because the news is concerned with the moment, your opening is news the day it occurs. Every day, television needs filler (unfortunately, art is put into this

category) for the last piece on the local news, so do not neglect this opportunity. It is always beneficial to have many people at the opening. If television coverage happens, then numerous guests will prove that there is an interest in your work. Invite your friends!

Talk to the television news desk for your area about coverage. They can tell you what kind of staffing they have on weekends and can advise you about what the best times are to schedule your opening or other event in order to receive coverage. Anything out of the ordinary done at the opening will always be a plus in terms of media coverage.

Some Television Tips

In dealing with television news desks the best time to schedule an event is between 10 A.M. and 2:30 P.M. This allows it to be aired on the 5 or 6 P.M. news as well as the 10 or 11 P.M. news. It is possible that events held as late as 9 or 11:30 P.M. can still be aired as a live feed. If only a cameraperson arrives at your event then your previously recorded voice and image is used in conjunction with the live newscast.

If you have the time, it is advisable to offer a press preview. Since the public is not invited, the media can concentrate on you and your art. The preview is usually held in the morning a day or two before the show (or other event) takes place.

On weekends, the news departments have skeleton staffs, but they still cover events. It is important to make sure that your event is listed in the day book (an electronic calendar), which is often a computer database that lists events the news director considers important and which may be covered. Calling a day or two before the event and asking if the event is in the day book is one way of finding out or getting it listed. Remember to say that your event is very visual. If you are doing something special or even a bit bizarre, tell them that, because the combination of the two makes for great television news stories.

CNN does not cover stories on weekends, except for major events. The Fox network news runs for an hour from 10:00 to 11:00 P.M., while the ABC, NBC, and CBS stations and affiliates have only a half-hour of news from 11:00 to 11:30 P.M. Therefore, the Fox networks are more inclined to cover soft news like art openings, because the hour-long news format is more flexible. In the major television markets, like New York City and Philadelphia, ABC sometimes runs the hard news from 6:00 to 6:30 P.M.

and the soft news from 5:00 to 6:00 P.M. An opening held between 5:00 and 6:00 P.M. could be run as a live feed. If an event takes place over time, they can cut back and forth from the studio and the site to report on the progress throughout the duration of the news program. When sending out the press release/fax, let them know the coverage could be done live. The more information that is offered, the easier it will be for the news director/ assignment editor to create a narrative segment.

Remember, it is possible to have the media arrive, shoot the event, and then decide not to use it. Stories get killed all the time because of tape or camera failure, lack of air time, and many other reasons.

Why go through this process for a few seconds of coverage? Because step by step, this is how a reputation is made. The more your work appears in a public forum, the more opportunities are open to you. The local television affiliates can make the tape available to a national audience through a "feed." This means that any affiliate that is part of the syndication might want to use a local market's news to supplement their news or to show on Sunday when they do a roundup of the events for the week. Exposure is the key; it opens opportunities that lead to bigger things. This method is especially important for artists exhibiting in NAAO galleries where sales often are non-existent. If you prove your ability to garner publicity, you will be more attractive to commercial galleries.

Media Reference Books

If you don't know how to get in touch with your local media, go to the library and find the *Gale Directory* or *Burelle's Media Directory* for your city's media. These directories give a current and complete listing from which to begin your tailored media assault.

The media also looks for stories and guests on their own schedule and timetable. If they need to use an artist as a guest or spokesperson, they often look for information in a book called *The Yearbook of Experts, Authorities, and Spokespersons*, published by Broadcast Interview Source in Washington, D.C. (1-800-955-0311). If you feel you fit into these categories and want to be included in the book, the standard reference listing with a logo is $395, and the deadline is usually in May. The *Yearbook* is a primary reference in newsrooms and other centers of broadcast and print media throughout the nation. It is the book to which reporters, news directors, producers, and others turn when they must

swiftly find expert and articulate guests in response to breaking news, issue-oriented events, trends (art), and a host of features on every imaginable topic.

Broadcast Interview Source also publishes two other annual directories: *Power Media Selects*, a directory of more than 3,000 top media contacts ($166.50); and *Talk Show Selects*, a directory of more than 700 top radio and television talk shows ($185.00).

Two other invaluable resources are *New York Publicity Outlets* and *Metro California Media*, both published by Public Relations Plus (P.O. Box 1197, New Milford, CT 06776; 1-800-999-8448 or 1-203-354-9361). The cost of each book is $149.50, which includes two yearly updates, in June and December. Subscribers can call to check or request updated information. The information is as current as it can be since they send out questionnaires and do their own research.

The table of contents of the *New York Publicity Outlets* (which covers a fifty-mile radius from Columbus Circle, New York City) lists African-American Press, Ethnic Publications, Feature Syndicates, Magazines, Newspapers (Daily in CT, Manhattan, NJ, NY), Other than N.Y.C. (Other Boroughs, Foreign Language, Special Interest, Weekly), News Services (American, Foreign, Photo), NY Correspondents of Out-of-Town-Newspapers, Radio (Networks, Stations, Programs), Syndicated Newspaper Magazines, Television (Networks, Broadcast Stations, Cable Systems, Programs (Broadcast and Cable), and Trade Publications (ten sublistings).

These books are expensive for one person to buy, but if you think that your work is appropriate for the television medium, it might be a worthwhile investment. If an art group has the funds, these directories are invaluable for finding phone numbers and contacts.

Another possibility requires a charge of three dollars a month. It is The National Talk Show Guest Registry, which is a database of potential guests for cable and broadcast talk shows. Artists can send a "written story" about themselves and their art (your hundred-word rap), and, if selected, the written entry will be included in the Registry. The Registry is looking for twists, angles, or hooks that can be highlighted in a story summary with special keywords for quick computer retrieval. Submit story ideas to The National Talk Show Guest Registry (6660 Reseda Blvd., #111-A, Reseda, CA 91335. Call 1-818-342-5355 or 1-818-773-1389).

Working with Entertainment Television

If the opportunity arises to appear on a television talk or entertainment show (cable or broadcast), there are several things you should be aware of. Television in the United States is notorious for trying to get something for nothing. When talent coordinators or producers call, their rap is to offer you free publicity in lieu of payment for services. You must weigh the value of the offer. Remember, you have to pay to get to the television studio, pay for a hotel, and for any necessary meals. You should ask to be paid at least enough to cover expenses, and it is not out of line to ask to be paid for your time. Some shows do have smaller budgets than others, but if they do not have stimulating content (such as interesting artists as guests), it will be reflected in their ratings. Work with the talent coordinator to arrive at an acceptable arrangement. Once you have an agreement, ask for it in writing. The written agreement can act as a legal contract should any dispute arise.

If travel is part of the arrangement, it should be from door to door. If a limo or taxi is necessary to get to the airport or television studio, make sure it is part of the agreement. If the job requires a few days stay, find out if a rental car will be available for your use. The food allowance might be over forty-five dollars a day per person. The hotel should also be part of the package, and it should be a good hotel. Negotiate the artist fee for your time; and remember, this fee is in addition to travel, food, hotel, and material expenses. Sometimes, the fee is figured according to a film/video union scale and can be a few hundred dollars. If the show is commissioning a work, find out if they keep the work or if it reverts back to you. This will determine the fee, but five hundred to a thousand dollars a day is not uncommon. The entertainment field pays consultants a day rate, and the day may be very long. It may be longer than eight hours. You work until the taping or live event is over. It is not a bad idea to agree to work a certain amount of time for one fee and, beyond that, to receive overtime. Use an analogy, and ask them how professional models are paid; by the hour, day, or overtime rates?

Be careful about signing away copyrights to your slides or other work. A fee should be paid for material used on television (see ASMP rates in chapter 4 for guidelines).

Remember that television news programs and CNN do not have a budget to pay an honorarium (but they might pay expenses), as they are

not entertainment shows. Therefore coordinate these events with an exhibition, since you will be there and could be interviewed either before or after the opening.

Relax

If the thought of being on television makes you nervous, try doing a modified yoga breathing. Take a deep breath for twenty seconds, slowly taking in the air; hold it for ten seconds; and then let it out slowly for twenty seconds. Do this many times in the dressing room, and if necessary modify the length of the breaths to fit the needs of your body. This will relax your breathing and calm your body down before being interviewed.

Getting Copies of Television Coverage

You will want to have copies of any television news clips or interviews, which can be used to create a video press release. Usually, you should record the program "off-air" when it is first broadcast, since it is most likely the only time it will be shown. CNN will broadcast your piece a few times over a twenty-four hour period before it is released to its sister cable station CNN Headline News, where it will run many times the next day.

If you believe that the television news will appear at your opening, it might be advisable to bring one or two blank tapes to the gallery along with a prepaid mailing envelope. This can be given to the cameraperson or interviewer so they can make you a copy of the broadcast news spot. If they agree to tape it for you, you save money and trouble, and the quality is usually better than that of clips taped off the air.

If you cannot get the program taped, contact the station the next day and find out the procedure for receiving a copy. You will most likely have to send them a tape and pay a fee. Ask about policy procedures for obtaining a copy.

If you are on the road, you might bring your own VCR. Connect the input from the hotel cable into your VCR and the output of the VCR into the television. This way you can tape a show if necessary. If you are not in when it airs, a timer can be set.

There are also press clipping and electronic media monitoring services, such as Burelle's, that tape an enormous amount of material every day: approximately four-hundred and fifty local stations in one-hundred and

seventy cities besides the news and public affairs programs on ABC, CBS, NBC, PBS, and major cable networks. It is expensive to get video clips through these services, but written transcripts are reasonably priced.

Do your best to contact the station or have somebody tape the broadcast for you. It saves time and money. These news clips become precious items for your portfolio, so pay attention to them.

Creating Your Own Publicity Video

How do you create a video? One way is to find out if there are any public access television stations in your area. Public access television must give you access if you request it. You may have to wait your turn, but you will be able to appear on television and get a videotape of the appearance.

The quality of the video you produce will depend, in part, on the facilities available at the station. Do some research. For example, the studio may be able to transfer slides to video. You can assemble different broadcast/cable clips if you have them, have someone interview you, or adapt an article or press release by showing images of your artwork and reading the text. If this is your first attempt, get a book from the library about making a video. Talk to the people who run the cable company about what they offer for public access taping. Watch the news and other public access shows to get a feel for different format and styles.

If you can get access to a camcorder, you can create a mini-documentary about your art. Have a friend shoot you working in your studio and at gallery installations. The video can be edited later. Remember, you are not trying to do something that is to be broadcast; rather, you are making a teaser to entice the news editor to cover your work for an event. If you do not have editing equipment, get two VCRs and edit as well as you can. Don't be concerned with being frame accurate. Unless you have access to the right equipment, do not try to create a professional-looking tape. Keep things simple and informative.

Using VCRs you may edit the sound and image at the same time. Another option is to shoot and edit the work without being concerned about the sound and add the commentary later on. Either way, the first step is to set up the two VCRs with one as the play deck and the other as the record deck. Assemble each edited shot in order by using the pause button on the record deck. After editing all the shots you will have a master tape, with or without the appropriate sound.

If you can afford to pay for editing, have access to professional equipment through friends, or, if in an artist-in-residency situation (see chapter 9) you have access to professional equipment, you will be able to produce a much cleaner tape. If not, it is still possible to add sound over an edited tape by using two home VCRs (the second must have an overdub setting) and an audio tape deck that has a microphone input.

The audio output (line out) from the first VCR has to be connected to the input of the audio tape recorder. The connectors from the VCR are RCA plugs and will fit most audio cassette recorders. If not, get the right connector from Radio Shack. Once you have this connected, the outputs from the audio cassette player have to be plugged into the second VCR audio inputs (line in). The audio cassette player is used as a monitor to record the soundtrack to the second VCR. It is advisable to watch the videotape many times in order to get the feel for the amount and what type of commentary you are going to add in conjunction with images and scenes on the master tape.

Try a few practice runs until it is right. Play the first VCR and adjust the microphone level so that it will not distort on the second VCR. You should be able to hear the sound come through the second VCR to know that everything is working properly. Push the record button on the second VCR and begin your overdub commentary (only if there's an overdub setting). If any mistakes are made, just repeat the same procedure. When it's to your liking, you have a finished master tape. Copies of this can be sent out.

Many consumer VCRs now come with more advanced features like stereo sound and a video/audio insert feature. These decks will provide more flexibility (like recording two audio tracks) and the ability to make cleaner edits. Read the manuals. This equipment is much more sophisticated than a normal VCR. If you want a professional-looking tape, you will need to practice your editing technique. Renting or borrowing these decks is one way to save costly professional editing time.

Getting Tapes

Once the three-to-ten-minute videotape is completed, copies need to be made. It is not worth the weight in extra postage to use a two-hour tape (besides being a waste of videotape). A two-hour tape weighs eight-and-a-half ounces, and a ten- or fifteen-minute tape weighs four-and-a-half

ounces. Most tapes mailed out to television stations will not be returned, so it is best to keep a supply of ten- or fifteen-minute tapes. These are available from Rafik (814 Broadway, New York, NY 10003; 1-212-475-7884), a video production house that specializes in shorter tapes. They sell both ten- and fifteen-minute tapes for around $2 apiece in groups of ten. B & H Photo (1-800-947-9920) also sells fifteen-minute tapes in any quantity for under $2 apiece. These tapes come without covers or labels. It is not necessary to mail a cover with the tape, but you do need labels. B & H does not sell labels. Rafik sells blank labels, $3.25 for forty labels (spine and face). They also sell VHS labels for computer printers, but they are solely face or spine labels. These are ten to twelve a sheet for 40¢.

Another way to get short videotapes is to reuse tapes you can receive free in the mail. Ads on radio, cable television, and in magazines urge you to call an 800 toll-free number and receive a free promotional VHS video for an exercise machine, a bed, car, investments, college, or vacations. Why not contact them? They will gladly send the tapes to you, your friends, relatives, anyone. Get as many as is necessary (it's good to always have ten on hand). They will keep calling you back to sell you whatever, but just say no and keep the video.

Remember, the way to tell the amount of time on these tapes is to look at the area to the left of the record tab (which is usually removed). It should say T-10 or T-15. Most of the videos that you receive will have the record tab removed. In order to be able to record, cover the area where the record tab has been removed with a piece of tape, and then test it. Remember that you will need a spine and face label, to mark the tape with name, address, telephone number, event, date, and other pertinent information. You can use extra labels from commercial videotapes or buy blank ones.

Radio

More people listen to the radio than ever before. However, this does not mean that the opportunities it presents for artists have increased. What is popular today is a variety of music, classical, rock, country, blues, and folk, and religious offerings and call-in talk shows. In the New York City region there are forty-three different AM and FM radio stations. Compare this to the seventeen different television stations and five daily newspapers. Most of these radio stations, however, feature standard programming. The

few exceptions include those stations carrying National Public Radio (NPR), which sometimes features artists on the shows they create, such as "All Things Considered" and "Fresh Air," as well as other music, interview, news, and talk shows. For information about local programming, contact National Public Radio at: 635 Massachusetts Ave., N.W., Washington, D.C. 20001; 1-202-414-2110; fax: 1-202-414-3329.

"Art Beat," a new national weekly radio magazine, is a half-hour program distributed to public radio stations. Each program consists of four features, a commentary, and a national arts calendar. Materials should be submitted to "Art Beat," 925 Tyson Drive, West Chester, PA 19382; 1-800-922-9683; fax: 1-610-344-7106.

The best opportunities for fine artists are on the radio stations on the FM bandwidth at the bottom of the dial. These are the eclectic, nonprofit, or college radio stations. Local college or nonprofit stations offer a better opportunity to be a guest or be interviewed than do the national shows. In certain cities, announcements on college or local radio stations can reach a significant number of people. It is definitely worthwhile to send press releases to these stations whenever you are having an exhibition.

Currently commercial talk radio or contemporary music seem to have proliferated on the AM bandwidth. However, this depends entirely on where you live. Most AM talk radio is syndicated shows that are bought by local affiliates or independents. However, FCC regulations require radio stations to offer community affairs programs. These are usually on Sunday mornings or late at night and might offer the best opportunities for artists.

Radio, like television, culls its topics from AP, UPI, Rueters, or from the print media. I have been on the radio as a result of my work appearing in either newspapers or magazines. However, if you are on one radio show it is unlikely that that will lead to another radio show.

There are a few issues with which artists have to be concerned. One is that radio is obviously not visually based; and two, documentation of radio appearances has to be done on audio cassettes. This is the least desirable way to mail out publicity. It is possible to use the radio commentary as a voice-over when making your own videotape, but technology has made audio cassettes the least attractive way to present serious information. Today, most radio stations use audio CDs exclusively, as they allow one to selectively screen the different selections for review. A cassette is much harder to screen.

If you do mail out cassettes to radio stations, I would recommend the

shortest tapes, which are thirty minutes in length, or fifteen minutes a side. These are commercially available in lots of ten or less, and they save postage as they are lighter than longer tapes. I would limit the audio press release to less than ten minutes. Realistically, this is as much as you can expect someone to listen to when the material is sent unsolicited. Two or three minutes is a good length. If you calculate that the one hundred word rap equals thirty seconds, then three minutes is six hundred words, or two to three typed pages. The beginning of the tape is most important. It must hold the interest of the radio programmer. Other support material, such as a press release, should always be sent with the audio tape.

Radio interviews are done both in person and via telephone. In terms of sound quality, it is always best to be at the radio station conducting an interview, since the microphone equipment is much superior to the telephone microphone receiver. In terms of convenience it is obviously much easier to conduct a telephone interview.

In order to find out about the radio stations in a particular city, consult the *Gale Directory*, *Burelle's Media Directory*, or the local phone book. If you are trying to get on the radio in the New York City region or in California, then consult *New York Publicity Outlets* or *"metro California media."* They list the radio stations as well as the individual radio programs. *New York Publicity Outlets* lists the Canadian Broadcast Corporation (CBC). CBC is a television and radio network which offers art interviews and commentaries about Americans as well as Canadians. They are a public broadcaster and can syndicate their shows on American Public Radio and NPR. (Canadian Broadcasting Corporation; Linda Perry, Program Coordinator; 747 Third Avenue, Suite 8-C, New York, NY 10017-2803; 1-212-546-0506; fax: 1-212-759-1305.)

Radio offers an immediate, live experience to listeners, through a car speaker or in the office or home. For this reason, radio is best suited to publicize something which will happen very soon after the broadcast is heard. One has to schedule events to allow time for broadcasts occurring on the same day.

Radio, unfortunately, is a non-paying market.

❧

CHAPTER 4

The Artist as a Small Business Entrepreneur

Time and time again the phrase repeated is, "it's not that there isn't a market for my work, it's just that I don't have the time to find the market." Be prepared to find your market. Making money off your art gives you free time to have either a part-time job or no other job at all. This freedom allows the fine artist to spend as much time as is needed not only to create art, but to successfully market, publicize, and sell that art.

Artists are small business entrepreneurs. Just like in business, the more successful you are the more you will be known. In the United States success equals money, which is unfortunate but true. In our society,

more and more, artists need to function like small businesses. This can be difficult for artists who savor the image of the artist-as-bohemian that was dominant from the turn of the last century through the sixties. Today, a more appropriate model would be the painters of the Italian Renaissance who ran their studios as businesses.

If artists are going to function as small businesses, they need to be familiar with the tools of marketing and publicity. They need to own or have access to certain equipment in order to start and continue the business. It is not so important that you go out and buy all the equipment tomorrow, but if you are seriously planning on making a career as an artist, you have to know what is necessary to operate a business.

I have already mentioned the importance of having written material and good quality slides and black-and-white prints, but that is just the first step in being a small business entrepreneur. In this chapter, we will discuss tips and techniques for running your art business efficiently, as well as ways of increasing profit by working with or functioning as a press agency.

The Home Business

For most artists, the key to running a smooth business is knowing how to disseminate publicity efficiently with the purpose of increasing sales and creating opportunities. Having a photocopy machine (or access to one) is necessary for savings and convenience. Copiers from manufacturers such as Canon, Lanier, and Minolta (to name a few) make superb copies from newspapers or color magazine articles. Make sure the copier can enlarge and reduce by individual increments, has a photo mode with a good grey scale, and can accept two-sided copies. In chapter 10 the pros and cons of working with professional copy shops is discussed. Most serious artists will find they want the flexibility that comes with owning their own copier.

If you have a good computer with a graphics program, a scanner, and a high-resolution printer you probably don't need a photocopy machine. But a photocopier is a cost-efficient way to accomplish many of the same tasks you might do on the computer. I have been creating my own stationery with a copier, using press type or previously published material in different mock-ups to create letterhead and mailing envelopes.

I've been photocopying images of my work onto six-by-nine-inch mailing envelopes that I use to send out slides or other inquiries. This size envelope will go through the photocopy machine and is within postal

regulations to cost thirty-two cents for up to four double-sided photocopies. This is a very impressive way to introduce people to your work. It gets attention; people notice your mail, which is important when sending out material cold.

As mentioned before, if you are fortunate enough to be on television news or entertainment shows, you will need to tape these shows and later make duplicate copies. To make copies you need to have access to two VHS video machines. The duplicates are for publicity material, some grant applications, or other uses where a video makes more sense than sending out slides.

You may also find it efficient to have your own darkroom to develop exhibition prints, portfolio prints, or black-and-white publicity photos for newspapers and some magazines. However, with photography you have an option of using photolabs or doing it yourself. Developing and printing your own film will save you money and give you control over the quality of your photographs. There are many good books on setting up a home darkroom available through your local library or bookstore.

Telephones

Since telecommunications is one of the ways you will be interacting with potential clients (remember the one hundred word rap), it might be necessary to have two phone lines, one as a business line and the other a residential line. An answering machine, a live answering service, or voice mail through the local phone company are good ways of presenting a professional image.

Because of the deregulation of the phone companies, there is not one phone company that offers the best prices for all calling times. Some companies offer six-second billing and reasonable rates for business hours but not for weekends. To illustrate, there are a few regional phone companies such as Frontier Long Distance (1-800-836-8080) in Rochester, New York, and American Long Lines (1-800-922-7730) of Pennsylvania. Usually with these companies, calls within your home state (called intralata) are much more costly than out-of-state calls. They might offer three sets of business rates. Intralata calls within local area codes:

day/min	eve/min	night/weekend/min
.13	.11	.095

On-net calls to other area codes within a mileage band of 292 miles:

.14 .095 .095

Off-net calls to all other area codes divided into six bands that range from .2090 to .0999, depending on time of day.

If one uses these companies, they bill in six-second increments, with an eighteen-second minimum per call. This means if you receive a wrong number or get an answering machine and do not want to leave a message, hang up. The charge is on just eighteen seconds worth—about two cents—instead of the full-minute amount. Sometimes it is necessary to talk to a person directly rather than leaving a message, and you might call ten times before reaching that person. The cost would be twenty to forty cents for ten calls, rather than a few dollars.

In addition, American Long Lines has a 103 Business Watts plan, which offers six-second billing to international numbers with an eighteen-second minimum. This can result in a substantial saving compared to telephone rates that are billed in minutes only. For night/weekend and regional calling, research which companies have better rates.

If the volume of calls exceeds the cost of the additional phone line, a second phone line is a smart long-term investment. Basic service in eastern Pennsylvania is eleven dollars a month, a minor cost for convenience. When conducting publicity, it is necessary at times to keep a line free for incoming calls, and having a second line gives the impression of being a true business.

Local phone companies offer voice mail, an internal digital answering service. You call a local phone number and dial a four digit code to retrieve messages. The cost is about five dollars a month, and you don't have to rewind a micro-cassette tape, an unlimited amount of message time is available, and most services have a feature that allows you to save important messages.

Today a fax machine is a wise investment, and although an additional phone line is not necessary, it is convenient. In 1993, *Consumer Reports* magazine rated thermal fax machines, and they gave the Brother 780mc the best rating, especially for the photo mode and speed in sending documents. A fine artist will be faxing images/photos of their artwork. The fax machine needs to have at least sixteen shades of grey in the photo halftone settings to send a readable image. Usually one has to fax a photocopy of the original artwork, which is already one generation lower

in quality. If your fax machine transmits poor-quality images, it becomes a reflection on the artwork. The Brother machine does not use plain paper. It uses thermal plus paper, which is a step up from regular thermal paper but with the feel of plain paper. It has a photocopy option built into it, but cannot reduce or enlarge. (The Damark, May 1995 catalog was offering this fax machine for around $300; 1-800-729-9000.)

Postal Services

The mail is a vital link for artistic success. There are several ways to correspond: the U.S. Postal Service, UPS, FedEx, Airborne Express, plus others which provide a variety of services. Everybody uses the U.S. post office on a daily basis. In most cases, this massive operation is the least expensive of all the providers. They, however, do loose or damage a small percentage of what is mailed, but for a majority of your printed communication they are the most realistic choice. Since artists usually send out slides, printed matter, audio/videotapes, catalogs, and sometimes original work, the cost over time can be enormous. It helps to know postal regulations in order to save money.

Insurance is also an essential consideration. The post office has four classes of mail, first to fourth class, and a variety of rates which vary depending on distance. This is especially true for third- and fourth-class mail.

Let's consider the following example: you see a listing in an art journal, to which you respond by sending out slides, resume, and a statement with an SASE (self-address stamped envelope). What are your choices? If the deadline is two weeks away, you can safely assume that if you send the package third or fourth class, it will be delivered on time. If you are running close to the deadline, then the use of first class, priority, or express mail are options. First class is thirty-two cents for the first ounce and twenty-three cents for each additional ounce up to twelve ounces. Over twelve ounces and up to two pounds will go priority mail, which is the two-day rate at three dollars.

A set of twenty slides in the plastic sleeve with a letter, resume, statement, reviews and two mailing envelopes (possibly padded) will travel first class at either $1.93 (8 oz.) or $3.00. The return postage (fourth class) will most likely be $1.70 or more. The total cost is $3.63 minimum. Consider this over time, and it adds up fast. And this is without insurance or return receipt. (Remember, you should not need insurance if sending out duplicate slides.)

If you can get your material organized two weeks before the deadline, then you benefit from the cheapest postal rates. If you have an audio or video tape, film, or catalog of at least eight printed pages as part of your package with slides and printed matter, you can probably mail at the special fourth-class rates. This costs $1.24 (up to one pound and 50¢ per pound up to seven pounds, then the rates change) per piece within the U.S. If you only have slides or printed mater, you will probably have to send it out special forth-class or book rate, but this depends on which nonprofit place is to receive it.

You have to allow a window of time for the package to be received. Fourth-class mail is sent by air, but its processing is slower. First-class mail is given priority.

If you are sending out material which cannot be sent at the special fourth-class rate, then third class is almost the same price as first class. A one-pound package is $2.95 compared to $3.00 priority or $1.24 special fourth class. I'd add enough photocopies, announcements cards, and other materials to make it weigh more than five ounces. The cost for first-class mail at five ounces $1.24. Anything over this and up to one pound that can be considered at the special fourth-class rate should go that way, as long as you give yourself enough time for the slower delivery.

Most art spaces that offer grants have deadlines and require entrics to be postmarked by a certain date. If you can get it organized, mail it early. Even if it is delayed, the postmark stamp qualifies you for the deadline. I would recommend getting these packages handstamped rather than stamped by the postal meter, because hand-stamped mail must be sent out that day. I wouldn't recommend sending something fourth class on the deadline date because the art spaces might only accept mail for that listing up to a certain date and, at fourth-class rates, mail going any distance might take two weeks or more.

There is a difference between first- and third- or fourth-class mail in how it is endorsed for return or forwarding. All first-class mail will be returned to sender at no additional cost or forwarded for up to twelve to eighteen months. The same service is not provided for third- or fourth-class mail unless you write on the envelope "Forwarding and Return Postage Guaranteed." This insures that if the envelope is forwarded and the addressee refuses to pay forwarding postage or it is the wrong address, it will be returned to you with postage due. You want your material back, and opting for this method means you might have to pay return postage

every now and then, but the cost should be no more than if you'd mailed the package first class.

Make sure the address is correct and up-to-date when you send out your material. Remember the six-second telephone billing? Call and verify addresses for a few cents. It pays in the long run!

Return postage for your material has to be paid before you send out the package. I'd recommend using the fourth-class rates, since once a space has the material they will hold on to it for months anyway, so it doesn't make much difference to wait a bit longer for it to be returned.

There is another rate which you should be aware of, called the library rate. This is for material to be returned by a school, college, public library, or museum, but not alternative spaces. The post office regulations allow slides to be considered for this rate, as well as audio and video tapes, catalogs, and books. This rate is $1.12 for up to one pound. You cannot send materials to these organizations at this rate, since you're not considered a library. However, SASEs included with material sent to these institutions would qualify. This is a $.12 per-piece savings (it adds up!), and is the same cost for material sent back to you from anywhere in the United States. If you are unsure, call the organization and ask if they use this rate for return of artists' materials.

It is important to note that special fourth-class (audio or videotapes and catalogs) and library rates are subject to postal inspection regardless of how the package is sealed. If the postal inspector decides to inspect your package and finds its contents do not meet the rate regulations, then you can be charged at another rate, either third or first class (usually third).

The U.S. Postal Service employees use a Domestic Mail Manual (DMM) to determine rates. If you have any questions, go to the local post office and ask questions. Every two weeks they receive new updates on postal regulations. Things can change.

When you have to mail something of value (i.e., original slides or artwork), the Postal Service has three ways to mail these items: insured mail, registered mail, or express mail. Insured mail provides reimbursement for up to six hundred dollars and is available for third- and fourth-class mail, as well as first class and priority. You need to prove value by receipt, invoice, bill, or some other proof of value. In the case of original artwork, an insurance floater by a gallery or museum would have to be used. Your own insurance policy covering artwork might work, but a third party that has exhibited and insured your work is the best documentation.

Regarding lost or damaged slides: normally the cost of replacement film and processing will be allowed and not the value of the slides. Just because you insure, does not mean the post office will pay the insurance value. Proof is everything.

Registered mail is the most secure means of delivering valuables. You receive a receipt as proof of mailing and for an additional fee of $1.10, a return receipt may be obtained. Up to $25,000 postal insurance is available. Certified mail is used to obtain a record of delivery, with no insurance for first-class mail.

The basic price for express mail varies from $9.00 to $10.75 for up to one-half pound, but most packages will be mailed at the $10.75 rate. This allows for overnight delivery with insurance. Insurance can supposedly be added from $500 up to $50,000 in coverage, but I'd talk to the local postmasters about that.

General Delivery is intended primarily for use at post offices without carrier delivery service and at non-city post offices, which service transients and customers not permanently located. The Postal Service will hold the mail no more than thirty days unless otherwise requested or determined by the local postmaster, who can make exceptions. You must present an I.D. to receive the mail.

If you were to have an exhibit in, for example, Tampa, Florida, were to be gone over a month, and were expecting checks or other important mail, then the mail could be sent to a specific Tampa post office as long as you have the post office address, your name, and the words general delivery marked clearly on the envelope. Picking up the mail is easy, and this mail can even be forwarded if you fill out the right form. This is especially good for people who are on the road doing festivals, craft shows, workshops, lectures, or a book circuit. As long as you know the dates and places ahead of time, your mail can follow you at no additional fee.

If you have mail delivered to your home or apartment and plan to be away, the post office will hold your mail for only thirty days. After that you have to make arrangements to have the mail collected. Another option is to obtain a post office box for six months or one year and either have your mail forwarded to the box or change your address. By paying for the box for six months (this is the minimum) the mail will be held for those six months. I'd explain your situation to the local postmaster, who can suggest the best solution to accommodate your temporary lifestyle.

Be aware that getting a post office box just to have mail forwarded is

not possible, as a number and street address is necessary. The post office cannot give out a street address for forwarding without a court order.

A note about nonprofit third-class rates (known as bulk mail): this service is subsidized by Congress. They have to pass a measure every year to fund this rate. If you ever exhibit at a nonprofit gallery, library, or museum, they can mail out your postcard or other material via bulk rates at the twelve cent basic rate. This is a bargain. However there are a multitude of restrictions. The mailing cannot be a co-op mailing by the organization and a person. Only the nonprofit organization's own material is allowed. Mailings must be to over two hundred addresses for the organization to use the bulk rate. Allow six weeks for delivery of out-of-state bulk mailings. This mail has the lowest priority, and unforwarded or expired-address mail can be discarded. Mail sent within state should only take up to two weeks. However, talk to the local postmaster to find out how long the bulk mail is held before delivery.

Foreign Mailings

The time will come when you will need to mail out packages to foreign addresses. There are two basic options, either air or surface (boat), and various rates apply. Air mail takes about one week and surface, three months. I'd recommend sending via air. I've sent things back from Europe by surface many times, and I've found that if they are not very securely packaged, they may be damaged. Surface mail is not considered a priority, and trying to track down lost or damaged material in a foreign country is a lost cause.

If you send out slides to foreign magazines, it is best to send them either via printed matter or A.O. mail. A.O. is an abbreviation for the French words *autres objets* or other articles. This rate is restricted to slides, photocopies, audio and video tapes, and other objects, but not letters. Of course, if you type information on the back of a photocopy, it is unlikely to be noticed.

Rates for normal airmail are 60¢ for one-half ounce and 40¢ for each additional half ounce. A set of slides and photocopies (four ounces) can be mailed printed matter or small packet, and the cost ranges from $1.71 in the Western Hemisphere (except Canada and Mexico), $2.16 to Europe, $2.48 to Asia and Africa, and $2.65 to the Pacific Rim.

When sending international mail, a customs declaration must be filled out. This is a little green label (form 2976) which is attached to the package

and indicates the contents. For duplicate slides and most of the other materials you will be sending, simply write "no commercial value," or mark it "sample merchandise" with no value. This way if the package is opened by customs officials, the recipient will not be charged a customs duty. The package can be delayed up to three weeks if customs decides to open it.

When mailing slides to foreign magazines on speculation, the post office does not need to be told that you might be receiving a photographer's fee. The magazine can still reject the material.

Return postage for international mailings presents a problem. International reply coupons, which cost $1.05, must be purchased at the post office. They have to be included in your package for return postage. One coupon is exchangeable in any other member country for stamps representing the minimum postage of an unregistered letter. Each country sets their own rates, and they might not be in half-ounce increments; therefore, it is impossible to know how many coupons to include with your package. I would just send out the slides without return postage and hope that the magazine will return them. If unsure, write, call, or fax them and ask what their policy is about returning foreign mailings.

Sometimes material can be sent through correspondents for foreign publications who are working in the U.S. If they accept the materials, they take on the costs of the postage both ways.

Other Services

UPS costs less than the post office for sending larger items. This is because they charge by zone; plus they give $100 free insurance as part of the price. When sending out original artwork, whether it is a painting, drawing, or photograph, never send it framed with glass. The glass almost always breaks, and when it does, it is likely to tear or ruin the art. UPS will usually ask you what you are sending when you fill out their forms. If you have to send framed work, use Plexiglas, or use an established art mover.

Paintings need cardboard telescoping mirror boxes, found at moving companies. They collapse when fitted over the painting. It is also advisable to cut two pieces of cardboard to the exact dimensions of the painting and to tape these two pieces together around the painting. This helps prevent anything sharp from piercing through it. If you pack it securely in this way and use UPS, put "Fragile" stickers on the package and have UPS date the stickers. I have seen artwork delivered to galleries being thrown onto the ground, even with fragile stickers on them. A UPS worker told me he

doesn't know if the stickers actually refer to the contents of the boxes or if they are old. If you date the "Fragile" stickers, it might help reduce damage.

Most magazines believe that FedEx is the best way to deliver material with a minimum of problems. FedEx is expensive, but many magazines have FedEx accounts and allow artists, photographers, and writers to send material to them without paying a fee. FedEx will pick-up from, and deliver to, your home or apartment. You will need to have the publication's FedEx account number to send your material. Do not be shy about asking for it; this is the standard for the industry. Even if you solicit them through a phone call to the photo editor, ask them if you can send material via their FedEx account.

A note about damaged material: if artwork is damaged in transit, you will need to submit a museum/gallery insurance floater to prove the value of the art and decide what percentage of the damage can be fixed and at what price. If you fix it, you can charge around ten dollars an hour for so many hours of repair. Of course, the insurance value has to be provable to receive insurance money. If you insure art through UPS for a large amount, they will want to see what is in the box and how it is packaged. Naturally, they do not want to pay claims; so I would get the name of the person who approved the amount of insurance and packaging. You need to create a paper trail when proving the value of art. Generally it is necessary to get an insurance floater from a museum or nonprofit organization before you send out the artwork, including transportation insurance from your studio to the museum and back. The art organization is considered reputable and its insurance floater will prove the value of the work. Talk to the museum or gallery to find out the best way to send your artwork. Ask for and keep on file all insurance floaters from the spaces that offer them. They provide the proof for the value of artwork by a reputable third party.

Photo Agencies / Press Agencies

The main business of photography agencies is selling images and short features to magazines. They will also sell images to whomever will buy them, such as book publishers, corporations (for annual reports), ad agencies, and poster and postcard companies. They deal mostly with 35mm color slides, a standard format for magazines.

Having these photo agencies sell your images is not as difficult as it might appear, especially if your artwork is superbly photographed. I've worked for four photo agencies over the years: Black Star, Images Press, SIPA Press, and Gamma Liaison. Although the bulk of their sales are pictures of famous people, magazines also need features, as well as fillers (a photo with a caption). New, "interesting" art is always wanted, especially if it is a new technique, if it is colorful, has a good composition, or other notable feature. This does not mean that landscape painting does not have a market. If you believe your work is exceptional, then that work can be sent out.

Photography agencies will duplicate your original slides and either keep them on file or return them to you. The duplicate slides are sent directly to the magazines or to a sub-agent. These are agents in other countries who make the actual sale and take a percentage.

Usually between twenty and thirty sets of slides with text are distributed worldwide by the agency. The countries that receive this material number about twenty-five. They include: the United States, England, France, Spain, Italy, Germany, Holland, Austria, Belgium, Denmark, Norway, Sweden, Finland, Turkey, Hungary, Greece, South Africa, Australia, Japan, Canada, Brazil, Chile, Argentina, Portugal, and Mexico. Generally, third-world countries like India, Pakistan, or Haiti pay so little that the agencies do not bother with them. However, if you are planning to act as your own agency—and that is exactly what I suggest you do—some of these third world countries are perfect for getting yourself published. But remember, pay is small or nonexistent and sometimes the quality of the paper is no better than newsprint.

Since photo agencies take on the cost of making the duplicate slides and doing the mailings and billings, their share is 50 to 66 percent of the sale of your images, a hefty percentage by any standard. It's obviously more profitable if you can sell the material yourself and avoid the agencies. I try to sell the images first myself, and if I have no luck, then I go through an agency as a last resort. (For a list of photo agencies, see the NYNEX *Business to Business Directory*, which has over seventy entries.)

I'll give an example: a photo with a short article is sent to Holland. The photo agency has to give the material to a sub-agent in Holland, who will translate the text and captions from English, French, or German (depending on which language the agency provided to them) to Dutch. If you work with a French agency like Sipa or Gamma, the text gets

translated into French, then to Dutch. The Dutch agent then places the material with a magazine, and if a sale is made gets copies or tearsheets for the main agency and takes 33 percent of the sale for providing this service. The agent then exchanges the currency from Dutch Guilders to either French Francs or U.S. Dollars. The main agency receives the remaining 67 percent, and this is split with the photographer. On a $500 sale you'd receive $166.

If the main agency can sell the material directly to a U.S. publication or to a French, German, or Italian magazine directly, then you would split the sale fifty-fifty. Some photographers generate a significant number of images and they are very happy with this arrangement, but if you have a feature article about your artwork, technique, and aesthetic, it might be better to try to sell if yourself and keep the proceeds.

Photo agencies have a standard fee scale/tier system for receiving payments from magazines for various services like research, holding, and kill fees. When I was working for these agencies a magazine would call looking for information about a particular topic or personality. The agencies would charge a research fee of $50 to put together these images, which would then be sent out to whomever called. If the magazines did not use the material and returned it within a week or less, the $50 fee was the only fee to be paid. If they decided to use the material, then the $50 fee was waived as the amount of the scaled fee for the use of the photograph would be much greater. This fee was set up to keep away frivolous requests.

If a magazine decides to hold onto the material for longer than a few days or a week, then they could be charged with a holding fee, (as the material will not available to others in the same market—there is only one set of slides in each county). The holding fee varies depending on the amount of material being held. The holding fee is waived if the material is used.

If a magazine indicates that they will use the material and then decides not to use it, they have to pay a "kill" fee. This is usually 50 percent of the price for publication, and depending on the agreement, the research and/or holding fee may or may not apply. This depends on the total cost of the image or images that would have been paid if published.

Sometimes the photographer does not share in these fees as the images are not sold, only held, which is a touchy, grey area. The policy depends on the agency. If you act as an agent for your work then you can try to

share in these fees, especially the kill fees. The presence of fees will encourage the return of materials that might otherwise be lost. Include a schedule of fees with all requested material, as the agencies do. If receiving publicity is more important than a sale, it will create a better feeling if you do not include the schedule of fees.

By functioning as your own photo agency, you can also avoid some of typical problem encountered when working with photo agencies, such as finding material published in a magazine, but not listed on the sales report. Often the agency is unaware of the use themselves! The agencies often do a poor job of getting you tearsheets of the published pages, leaving you in the position of tracking them down yourself. The sales report tells you the magazine, page, and issue; however, you still have to find the magazines' addresses and then write to them directly for copies.

Advance Information

One benefit of becoming your own photo or press agency is getting on mailing lists of museums and other important institutions. Press information will include listings of upcoming shows (sometimes far in advance) and other information that might be helpful to your career. However, this practice raises an ethical question; are you actually planning to do stories or do you just want the press information? If all artists also become press agencies, the rules will have to be changed as accountability becomes a factor. As it stands right now, this is not the case. The museums give away press releases for free publicity. In turn, the writers take it upon themselves to cover the museums. To avoid potential problems, it might be wise to team up with a group of artists and writers to receive the press materials.

The American Society of Media Photographers

In preparation for starting your own photo agency, you should know about The American Society of Media Photographers (ASMP). They are the closest thing to a photographers' union in the U.S., and they have many publications which can help you out. These books can be found in the library if you do not want to purchase them. They offer a schedule of fee guidelines, which explains what photographers are paid for usage, depending the circulation of the magazine and the image size used.

To give an example: in 1991 *Seventeen* magazine used one of my photographs on one-eighth of a page and paid me $175 for its usage. If the size of the photograph had been half of a page, the amount of money

paid would have been much greater. A magazine will sometimes negotiate a price with you and then run the image whatever size they want.

The ASMP books which would be of interest to artist/photographers are *Assignment Photography* and *Stock Photography Handbook*. It is entirely possible that your work could be considered for illustrative purposes and/or commission for a magazine illustration. In this case, your fee would be greater than for stock photography. You can ask the photography editor or art director what they pay, and you should always mention ASMP rates, as it shows you are aware of the guidelines. Always ask for something in writing if a magazine is interested in using your work, because if disputes arise around a kill fee or other unforseen problem, having it in writing provides a legal means for settlement.

Pricing is an art in itself, and everybody needs guidance since negotiation is the norm. Famous photographers can ask for more money based on name recognition and reputation, while others have to display ASMP rates knowledge to have equal footing. Write to ASMP, 14 Washington Rd., Suite 502, Princeton Junction, NJ, 08550-1033; or telephone 1-609-799-8300 for their publication list.

A quick guideline: Covers pay the most, followed by two-page spreads, one-page spreads, and percentages of a page. A feature article with many photographs might require a special deal, or publishers may pay a flat fee per page or image and use whatever they like. Remember, grant only one-time rights, in order to be able to resell the images.

Acting Like a Photo Agency

Setting up your own agency, or at least acting like one, does not require you to do much. If you just use your own name you do not have to set up a separate business account. Begin by getting a rubber stamp made. It can say: "Photo by [your name]," or give your name followed by the copyright symbol, the year, and the words "photograph not to be reproduced without written permission."

The copyright symbol reminds people that they may not use your images without your permission. The copyright symbol does not have to be present to enforce the copyright. Photographic labs will not duplicate slides with a copyright symbol unless a written notice is included that says "(your name) who is the photographer, gives permission to duplicate his/her copyrighted material."

Stationery, both envelopes and letterhead, are a must. This is a minor

expense to have printed or photocopied. I personally favor having an image of my work on both the envelope and stationery; it allows for instant visual identification.

New Trends in Digital Images

One recent development from Kodak is a new on-line service called the Kodak Picture Exchange. This will allow Kodak to become a mega-photo agency. Kodak is pushing a new technology called Photo CD, which is a visual CD that can record up to one hundred photographic images. It is the same size as an audio CD, and it is recordable. Many photography labs in New York City will transfer your photographic images to this digital form for about two dollars per image. A discount usually comes into effect over a certain number of images, and the cost of the CD itself is about nine dollars. With the tax, the total cost would be about $250 to have a full photo CD disc made.

Kodak is soliciting many stock photography agencies to convert their images to photo CD, and then send them to the Kodak Corporate office. A user with desktop publishing can link up with this service via a toll-free number. The cost is $85 an hour ($1.42 per minute), and there is a $10 charge for each design proof requested (plus other charges for downloading). Kodak provides free software. Cost is $30 a month fee and one half hour free on-line time. Once the art director chooses the right image there is an on-line order form to request the image from the stock agency.

So far, Kodak is asking the larger photo agencies to submit a minimum of 5,000 images on photo CD. I called to ask them about smaller agencies submitting work, and they said they will review their policies if this service proves successful. It might be possible in the future for individual photo agencies to send their images to this service. (I have over 1,000 images that I could put on photo CD, but I'd have to team up with other artists to qualify for Kodak's minimum requirements.)

The Digital Future

The New York Foundation for the Arts (NYFA), which administers New York State Artists grants, currently has a small working group which is researching technology, digital forms, and electronic media as it relates to the application process and to current artistic practices. This is because artists are using certain new technologies, and if they become popular and

widespread, the grant panels might embrace them for grants or incorporate them into the application process. NYFA wants to be proactive on the technology front.

This is a look into the future, and, as I've been conducting research and interviews for this book, I've found that artists, grant panels, and companies like Kodak are all concerned about the information highway and the way it will evolve. Since the grant panels and art councils are concerned with professionalism, technology, and its standardization, many things are currently in formulation.

If the computer and photography research teams can find a better way to electronically capture light than in the pixel format via an electronic/computer camera, then photographic fine grained film will have great competition. Currently, pixel use in cameras is one-quarter the resolution of fine-grained film. It has not yet become competitive due to quality (it is adequate for black-and-white film, but not for color). If these companies can find a way to equal film grain, a digital camera revolution will occur overnight. These CD-ROM and/or photo CDs (where digital images are stored, i.e., the documentation of your artwork) will become common-place. Film might eventually become obsolete, going the way of the LP record. The proliferation of computers, modems, and digital cameras might allow the grant panels and magazines to require artists to submit their work on photo CD or computer discs instead of 35mm slides.

A possible scenario for the future: if artists have computers, modems, and photo CDs of their work, it could be downloaded through the phone lines and sent to NYFA or any grant panel or magazine. Since everybody can access a touchtone phone (standardization), a digital camera, and a computer, why not transmit their work samples to a central base like NYFA? Though your phone bill might increase, it would eliminate mailings, postage, and 35mm slides as well. If people have access to this equipment the idea is not too far fetched. In fact, grant panels might not meet at all. Eventually, the process could be done via teleconference or E-mail. All the grant documentation would be seen either through a video projection or high definition TV at the panelists' homes. Technology will make all of these issues even murkier. It all comes down to standardization, affordability, and copyright. Stay tuned!

The Business of Art: An Interview with Laurence Gartel

If you are a prolific artist and publish articles on different styles or mediums, or are the subject of an exhibition catalog, consider these preliminary chapters to a book. The next logical step is to be included in a book, whether it is a general study of contemporary art or a monograph.

Laurence M. Gartel is an artist whose work has been exhibited at many museums, including the Joan Whitney Payson Museum, Norton Gallery, Smithsonian Institute, Museum of Modern Art, and the Musee de la Photographie and the Bibliotheque Nationale in France.

J.V. *You first began by having articles published around the world in the early eighties, and a big break for you came in 1986 when* Zoom *magazine's international editions published a portfolio of your work. Since then you have had a monograph published on your work and have been commissioned by Absolut vodka for one of their magazine ads. What can you tell an emerging artist?*

L.G. The first thing an artist has to understand is that what he or she is doing is a business. That means there is a product, a buyer, and a seller. Looking further, the product sold has to be resold by the wholesaler. Obviously it is a direct sale to a client and that person has to be very satisfied.

Unlike other fields, there is no set price and, quite frankly, there is no competition. This is really hard for people to comprehend, but no one creates art like you. The price of your work is based on supply and demand. If many people admire your work than you can charge substantially for your efforts.

Anyone purchasing this book obviously wants to pick up tips on furthering or starting his or her career. I read several books myself in the beginning, and they all had check lists and the usual, obvious information. My initial suggestion to any artist is to be determined and firm. An artist is someone with a drive, a burning desire to create. But an artist cannot survive on just creativity or divine beingness. They must exchange art for money. This is commerce. It is a matter of survival.

An artist has to set goals and aim for the lifestyle he or she wishes to live. As an artist, a dreamer, he or she must dream about the ideal way of life. There are a few misnomers that should be clarified once and for all.

(1) No one said an artist has to suffer and live in a cold water flat. (2) It is okay to make money from your work. (3) You can see fame and fortune in your own lifetime—if you don't, other people will make money on your efforts.

J.V. *Can you offer a few choice tips for success?*

L.G. In my estimation there are a few tips to achieving success: (1) Understand that Rome wasn't built in a day. It takes years to establish yourself. There is no such thing as overnight success. (2) The building blocks to establishing yourself are the understanding that it is just that: a slow grinding effort, one brick after another. Finally you have a building. Your foundation was talent, but talent is not the mortar that holds the bricks. (3) Public relations is everything. This is the sizzle that sells the steak. The more people that know about you, the more your stature is established or reconfirmed. I can recall an older colleague who said he must exhibit at the Frankfurt Book Fair because if he missed the event, people would assume he was dead. Whether he meant this literally or figuratively, I knew it was true. It is important to be out there and be seen. People confuse this with having to be ahead of other artists. This is not the best strategy. You should attempt to be seen in the mainstream media, because this is where your actual sales will be generated. Getting into the view of the general public helps to establish your unique position. You do well because you are not concerned with peer pressure as much as concentrating on the general populace. This is a good strategy and it works. Opportunities may present themselves but the concept is to utilize the press to create notoriety.

J.V. *How do you do it?*

L.G. The thing to do is to follow this list. (4) Volume, quality mailing. Contact as many people as you can about your work. Just start talking. Most of the time, if you hook up with someone interested, they will probably start talking about you themselves. The next thing you know, you have met your next patron. One thing that will distinguish you from others is a professional presentation. This means that promotional materials are of the highest caliber. Professional materials add credibility. Knowing that the artist can deliver a quality product gives the prospective client security.

After you complete numerous assignments successfully, people will not question your credibility and your fees will rise.

Most artists get into trouble by thinking that after one successful job that has high visibility the phone will ring off the hook. An art career is something that takes years to cultivate.

J.V. *One of your most visible and successful works was an illustration you created for the cover of* Forbes *magazine. Tell us about this.*

L.G. I had called the art department on many occasions. I finally got the deputy art director on the phone. I asked for a definite appointment to show my portfolio. I have never gotten a job by "dropping off" work. (This is requested due to the sheer volume of people wanting to show their work. There is a huge supply of artists going for exposure.) Once I got the appointment, I knew the odds of my doing work for the magazine were greater. In meetings you should find a common bond and create an alliance. This makes the union into a friendship. The following week I got a call back and they asked me to do the cover. In many ways they took a chance. I delivered a great cover, which has to be one of my most outstanding pieces and the most memorable. "If *Forbes* hired him he must be good." It has stuck ever since.

J.V. *What does it mean for an artist to have a book published?*

L.G. The meaning of being published depends on the objectives of the artist. Having a book published is a thrilling event. It is recognition of hard work; it means that your point of view is worthy of reproduction; and it is also an opportunity for many people to become familiar with your work. Being an author puts you into a unique category, because most artists never get a book project, let alone get their work published. People understand and respect a book, even if they may not appreciate the aesthetic. For an artist it is a confirmation and a citation.

J.V. *How does an artist receive a book contract?*

L.G. Many factors go into the final selection of any author by a publisher. First, is the work interesting to a broad readership? Secondly, will those readers be compelled to purchase a book on your subject? After these two

questions are answered the publisher will take a closer look at the work. Remember, you are not the only artist submitting a proposal. Typically, a publisher wants to know that you have "hundreds" of fine quality specimens that they can edit from. They are looking for people who have worked for years in their chosen craft.

In finding a publisher, one has to search for a perfect fit. A publisher, like an artist, has a point of view and an objective in producing titles. Your aesthetic has to match that of the publisher. Some publishers sell and promote photo journalistic photography, other publishers are interested in nature subjects. While some publishers sell only vintage works, others deal with contemporary subjects. It helps to know a publisher's taste. The artist must research this thoroughly. It will save a great deal of time and effort.

In querying a publisher, first find out their interests by writing a letter (while knowing full well what their interests are already). Suggest sending more information. This also cuts down on the expense of duping slides and other materials. The next step would be to send high quality slides along with a substantial resume. Fellowships, teaching experience, grants, and an exhibition record are all items a publisher looks for. Basically, a publisher wants the artist to be accomplished.

J.V. *What does a book do for a career?*

L.G. While a book may sell, no one has ever gotten rich off the royalties of an art book (with the exception of Madonna). However, it is a calling card for numerous opportunities. Getting on a lecture circuit is a lot easier with a book. Also, a book offers visibility with promotional impact. Magazines are often anxious to give space to a new book release. Having a book means you are for real and people take your work seriously. It means that someone thought enough about your work to put money behind it. Book publishing, particularly picture books in full color, are expensive to produce. If you are in search of more employment in commercial or fine art, a book will open up many doors. People can see a lot of your work, very quickly and in a concise manner. A book stands like a monument. It is there forever and represents a moment in time and the concerns of that period. It sets a cornerstone for the artist and his/her place in art history.

J.V. *Students of computer art refer to your book as a seminal reference work and the book becomes larger in importance.*

L.G. In the case of my book, *A Cybernetic Romance*, published by Gibbs Smith Inc., people cannot fathom the idea of computer art produced prior to the birth of the Macintosh and programs such as Photoshop. As a pioneer of computer art fifteen years prior to all the commercialization of personal computers, my book stands as a watershed for the entire medium.

&

CHAPTER 5

Exhibitions A-Z

It is believed that the first formal exhibitions were held in European taverns during the seventeenth century, when art was purely representational and photography had not yet been invented. Since those times, an evolutionary process has taken place, creating a multitude of exhibition opportunities for both the sale and display of artwork. The usual progression of a fine artist's career is to show first in a local restaurant, open studio, or library; then to do group or solo shows in co-ops, alternative spaces, or commercial galleries; then, colleges and regional museums; and finally to significant commercial galleries and major museums.

What factors fuel this linear progression? Media hype, reviews, and a place in important collections all contribute to the signature value of art. The number of artists recognized by blind luck is extremely small, but recognition does happen through word of mouth. If this is your modus operandi, start conversing with as many people as possible (see chapter 3, about getting on a talk show), since oral communication will be your method of achieving a reputation. There is no single formula for moving your work through these steps; the routes to getting your work exhibited will be described in this chapter along with examples of artists who have successfully used them.

Fashion Moda

Fashion Moda ("a Museum of Science, Art, Technology, Invention, and Fantasy") was a local alternative art gallery, located at 3rd Avenue and 149th Street in a South Bronx, New York storefront. In 1979, Fashion Moda began presenting exhibitions involving artists and other professional people, community residents, and children. It still operates on a limited basis today. Its intention was to make artwork and ideas from cross-cultural sources available to people within the widest possible spectrum of educational, economic, and cultural backgrounds. The artists included Keith Haring, Crash, Futura 2000, Lady Pink, John Fekner, Stefan Eins, Marianne Edwards, Candace Hill-Montgomery, John Ahearn, Joe Lewis, William Scott, and Jane Dickson, among others.

The South Bronx, with its abandoned buildings and outdoor graffiti, is not known for its cultural offerings, but it was a perfect forum for this independent artist-run gallery. Stefan Eins, Fashion Moda's director/founder (and an artist himself), was successful in publicizing graffiti art. He attracted the attention of the New York art scene as well as domestic and international magazines and newspapers. This brought the Fashion Moda artists to the attention of the curators of the New Museum of Contemporary Art. The New Museum invited three New York-based independent artist organizations—Fashion Moda, Taller Boricua, and Collaborative Projects—to select, organize, and install a series of installations and exhibitions at the New Museum. Fashion Moda presented the first show, "Events" in 1981. Because the exhibit was in a museum in a New York City location, it received noteworthy publicity (a Sunday *New York Times* feature article). After the exhibition many of these artists began

AMOS ENO GALLERY

20TH ANNIVERSARY
1974-1994

594 BROADWAY, #404, NEW YORK, NY 10012 (212) 226-5342

Figure 7: Poster publicizing an exhibition

Courtesy Amos Eno Gallery

to exhibit in commercial galleries in the East Village and Soho in New York. This culminated with two exhibitions: "Post-Graffiti Artists" at the Janis Gallery located on West 57th Street in New York City in 1983; and "Committed to Print," a 1988 exhibition at the Museum of Modern Art, in New York, featuring Keith Haring, John Fekner, Jane Dickson, Robert Longo, and others from the group. Today, graffiti art is not as popular as it was. Like other art movements, it ran its gallery course, a major innovator—Keith Haring—died, and the movement splintered off into different directions. Lucy Lippard, an art critic for *Seven Days*, a New York City weekly publication, said in April 1980, *"the liveliest events in the art world always happen when artists take things into their own hands."*

For most visual artists, a museum like the New Museum of Contemporary Art (583 Broadway, New York, NY 10012; 1-212-219-1222), offers the best opportunity to make the step from emerging to established artist. Many artists, after exhibiting there, have gone on to commercial success through galleries or other museums. Call or write for slide review guidelines.

Before inundating the New Museum of Contemporary Art with slides, you should have significant accomplishments under your belt. Try to curate artist-organized shows. (This will be discussed at length later in this chapter.) Start with a show in your studio or coordinate a day of open artists' studios in your area. When a regional museum has an open competition, enter it. These museums, like the Allentown Art Museum in Allentown, Pennsylvania, often have a community gallery. They usually give regional artists the opportunity to exhibit in a four-person show during the summer months. Sometimes they print a catalog or brochure for these artists and will buy a work for their own collection. The recognition from a regional museum will generate publicity and possible local collectors. This is the usual method for beginning a career.

A Body of Work

It takes years for an artist's body of work to be created and nurtured. You must allow it to mature over time. Even the graffiti artists practiced their art for years on the streets before being recognized. Be patient, allow an audience to become acquainted with your work, and a resume to be established. Private collectors and museum collections try not to take artistic chances. They want to see a long-term commitment to the work

Figure 8: Catalog from a show of Barbara Nessim's work

and its aesthetic concerns. This is represented by a full body of work and the appropriate support materials: newspaper and magazine articles, reviews, radio and television spots, teaching positions, grants, artist-in-residencies, sales, and donations to public and private collections.

For emerging artists establishing a body of work, group shows are your best opportunity, followed by open competitions. You should also apply for local or state grants. Before venturing out, you will need to have an appropriate number of quality works: at least eight to twenty, which should have a consistent theme or quality, such as medium, size, series, or a clear exploration of your aesthetic. Do not confuse curators or judges in the beginning of a career by submitting an array of styles or techniques, unless you will develop each into a separate series (each series being at least eight to twenty works).

Galleries use the magic number forty as a quantity of work to be exhibited in a solo show. This means that if curators know you have more work in reserve, they will want to choose from that body. If you were to create one artwork a week, for a year, fifty-two pieces would be created, of which forty could be chosen. Today, it is realistic for an established artist to hope for a solo show every eighteen months. Therefore, your output does not have to be one work a week. This may be a good goal to set,

however, depending on your style and the degree of complexity involved in your work. Creating art at this pace would enable you to produce a significant body of work, five hundred pieces, in ten years.

The work does not all have to be one particular style or in one media, but generating this amount will establish you as being adept at your craft. If what is created is top-notch (at least in your eyes) then making money should be your goal, since your talent will have been proven over time.

If you are not ready for a solo show, assemble a smaller number of works for a group show. Twelve artworks need to be created for a group show of which eight are selected for exhibition. Your ideas might not have matured, but you still need to show your work. You need public feedback on your work.

After pounding the pavements and pumping the post office with mailings to galleries, competitions, and grantors, and after executing artists-in-residencies or commissions, it is entirely possible to come up empty-handed, without any major or even minor successes. Be persistent; that is the life of an emerging artist.

Berrisford Boothe

Let us look at the career of Berrisford Boothe, an artist whose recent work can be described as a combination of simple geometric motifs, figurative marking, and transparent fields of color. The images have evolved from the 1940s New York School of gestural abstraction. Although Boothe is only thirty-three years old, his career is solid and gaining momentum and recognition. Boothe is currently a full-time assistant professor at Lehigh University. His most recent exhibition schedule includes a 1993 solo show at the June Kelly Gallery in Soho, New York City, and a spring 1995 installation at the Fabric Workshop in Philadelphia, titled "Material Culture." The exhibition consisted of seventy plus panels of hanging silk designed as three interlocking ovals.

Originally from Kingston, Jamaica, Boothe received his M.F.A. from the Maryland Institute College of Art. While at the Institute, he was chosen to be the sole recipient of the thrifty-but-prestigious Walters Museum of Art Travelling Fellowship. Valued then at $3,000, the fellowship allowed its recipient to travel anywhere to make art. Keenly aware of Britian's class-based racism and, as he put it, the "rapid Americanization of England," Boothe chose to settle within the arts community in Bristol, England.

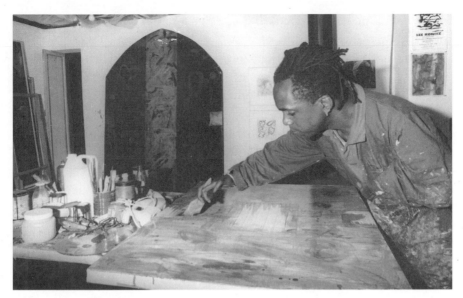

Figure 9: Berrisford Boothe in his studio. A good example of a
painter-in-action shot to include with a feature article.

Photo © 1996 Julius Vitali

With the monetary conversion rate eating away at his funds and a
shortage of affordable studio space, he joined a fledgling group of artists
in an old warehouse space on Redcliffe Street. The Redcliffe artists' group,
started by painter Claire Churchouse and sculptor Charles Farina,
grounded Boothe in the arts community. During the remaining months of
his stay, he was able to create twelve canvases which he describes as the
"Angry Young Black Man in Your Face" series. The works, similar to those
that won him the fellowship, were exhibited to favorable reviews when
he returned to the United States.

After returning to the States, Boothe taught part-time at his alma mater,
Lafayette College, and part-time at Lehigh University. Within a year, the
latter asked him to join their Art and Architecture faculty. During the
transition period between jobs, Boothe, now feeling confident about the
Bristol paintings, spent some time walking the streets of Soho, "looking
for a space to show." He remembers visiting galleries and trying to
convince the dealers to pick up his work. This approach did not work. He
was making a name for himself in regional Pennsylvania exhibits, but
nonetheless decided that it was time to "stop painting pictures about

things/issues and begin to look at himself as a self-appointed artist outside the trends and flux of the art market."

Encouraged by improvisational jazz musician Gary J. Hassay, he began a series of automatic drawings in a variety of media all the while "searching for the me in the mess." After hundreds of drawings and several collaborations with other artists, dancers, and musicians, Boothe came to realize his long affinity for expressive, lyrical, gestural compositions.

As a studio teacher and lecturer on African-American art, Boothe had occasion to visit New York City galleries, including the June Kelly Gallery where he acquainted his students with quality work and introduced himself to the dealer.

Nearly a year later, he approached her regarding a show with a specific body of work he felt would interest her market. With a show date at the tail end of the summer season, Boothe again created a new series of paintings. These were based on drawings, which included multimedia work on mylar developed in collaboration with the painter Howard Greenberg. The show had a total of thirteen new paintings, ten on wood panels and three on mylar, and six drawings. Two paintings sold in the $2,500 to $5,000 range, and later six drawings sold in the $400 to $700 range. Through the work of the dealer, two pieces on mylar were chosen to be included in the Albright Knox Museum show "New York Scene comes to Buffalo."

Prior to the June Kelly show, Boothe had been working hard to increase his name recognition in both the New York and Philadelphia markets. He frequented gallery openings and introduced himself around as part of an overall strategy. This worked for him, and he was able to get his first one-man show in Philadelphia at the Ester Klein Gallery. With strong and favorable reviews in tow, he was invited to be an artist-in-residence at The Brandywine Print Workshop in Philadelphia. A friend and noted painter, Michael Kessler, introduced him to Kippy Stroud at the Fabric Workshop. Inclusion in a workshop roster often comes through a recommendation of a current or previous residency artist. After being invited, Boothe submitted a project drawing for the installation "Material Culture."

The Fabric Workshop insists on the integration of fabric into the process and product. "Material Culture" incorporated the colors of Boothe's native Jamaican flag: black, green, and gold. Boothe explained the work as a way to "purge" the ideas, influences, and concerns that helped shape his life and beliefs as a Jamaican-American. The installation allowed individuals to walk through membranes of silk, losing themselves in the illusion of depth they created.

In July 1994, the *Philadelphia Inquirer* magazine did a feature on the Fabric Workshop and featured Boothe and his project prominently. In February 1995, the *Philadelphia Inquirer* reviewed the exhibit favorably. This exposure greatly enhanced his name recognition. Never resting on thin notions of fame or achievement, Boothe continues to enter regional and national exhibits "based on who the juror is. A good juror with a great eye can get you far," says Boothe, "especially curators of contemporary art."

The example of Berrisford Boothe shows an artist simultaneously developing his aesthetic and body of work, while networking through opportunities in regional galleries and education to develop a reputation in a wider art market. The information about Boothe given above is also a good example of material for a feature article. Together with reproductions of the work and an image of Boothe in his studio, it could be submitted to magazines for publication.

Cooperative Galleries

Artist cooperatives in New York City first started in the thirties. During the Depression many galleries were forced to close and artists had to finance exhibitions on their own. These artist's co-ops collectively shared costs, made exhibition decisions, and handled all the functions of running a gallery. They followed the Mexican and Soviet artist collective model which had leftist overtones and membership.

Today co-op galleries have taken on a hybrid form, remaining artist run, but surviving on a combination of fees and grants. They are not successful enough to rely solely on grants and have to make up the difference through yearly dues.

Co-ops can be a perfect place for emerging artists to begin exhibiting their work. From 1984 to 1985, I was president of the Hempstead Harbor Artists Association and the Discovery Art Gallery, originally located in Glen Cove, New York (now in Sea Cliff, New York). It was one of the best forums for emerging artists to exhibit on Long Island, due to its 4000-square-foot space and its fourteen-year history. The critics expected interesting art to be exhibited. Over the years the gallery has received reviews from *Artnews*, *Newsday*, and the Long Island section of the *New York Times*, as well as the local papers.

If a commercial gallery route is your chosen goal, then associations, co-op galleries, and art bars are beneficial places to meet people and network. For artists at the beginning of their careers, I would recommend becoming

a member of a co-op gallery and paying the fees for a theme-related group or solo show. Find out what kind of response the public has to your work. If negative responses occur or responses are luke-warm, you need to re-evaluate your career options as an emerging artist. This can be emotionally devastating. After creating work over a few years, hopes can be dashed by a poor review. In haste, people then decide to be art teachers or leave the field altogether. Positive reviews boosts morale. Of course, if what you have created is radical, political, or is socially or environmentally conscious work and the critic just did not get it, then negative or cool reviews can be dismissed.

Co-op galleries, either nonprofit or for profit, allow artists who are at the same career level to interact socially as well as artistically. It is good for your career to interact with other emerging artists. Artistic identification can produce collaborations, contacts, networking, and friends. But do not let the big-fish-in-the-small-pond syndrome become your reality. Co-op galleries should be a stepping stone in your career, not the culmination of your career. It is very comforting to know that you will be in three group shows in the coming year and have a two- or three-person show in eighteen months. The co-op is an excellent temporary forum. Too many artists rely on this situation, however, as the pinnacle of their resume, being satisfied with a good review or an occasional sale.

A regional career and resume establishes you as a local talent, but you need to establish a reputation that is not localized. An unfortunate side-effect of the co-op gallery is that the artist learns to expect to pay for exhibiting. Vanity co-op galleries exist all over the United States; some of them are located in major cities like New York. The artist sometimes pays a hefty fee to exhibit. Try not to be pigeonholed into a gallery which does not guarantee anything. You can easily end up paying additional fees for announcement cards, opening costs, and ads. It is possible that sales will occur through the announcement mailing or someone walking in off the street and buying a work, but if you want to develop "patrons" the only rays of hope are established, commercial galleries. Critics avoid vanity galleries in major cities like the black plague.

Know the Market

You will want to look into commercial and NAAO (see below) galleries, both locally and in other cities. It is essential that artists visit galleries,

libraries, and community colleges to see what is being shown, to know the spaces and their requirements, to talk and/or show work to owners or curators. Obviously, the major cities like New York, Chicago, Miami, Los Angeles, or San Francisco are a magnet for contemporary artists. The competition can be fierce, and research and persistence is necessary. A plan has to be created, implemented, and then carried out.

Remember, art galleries specialize in certain types of work. Sometimes it takes the form of an "ism," trend, gender, or politics. A realistic portrait painter should not try to exhibit at a minimalist gallery, but at a figurative gallery. Finding out as much as possible about the art market by researching newspaper or magazine listings and reviews, networking, and pounding the pavement, will save time and money. Find out what galleries in what cities exhibit work like yours. Concentrate on strategies for building your career so that you can interest those galleries.

Artist-Organized Shows

One of the more remarkable phenomena is the artist-organized show. This is different than a co-op gallery. Usually it is held in a temporary site or space either donated or rented for the specific occasion. The artist-organized show allows you to create a forum for showing your work and receiving publicity. These shows are often an important intermediary step between showing at co-op galleries and participating in exhibits at commercial or other well-established galleries.

One such show, called "Sculpture on the Creek," was an outdoor summer sculpture exhibition held during 1993–94 in Martins Creek, Pennsylvania. The sculptures were spread over three acres of land and some of the artists created site-specific works. Planning is extremely important, as all costs, which include rent, utilities, repairs, press release, photos, mailings, curating, opening reception, and creating the work, have to be covered by the artists. For the 1994 show, each of the twenty-four artists contributed $26.50. If one is able to pull an event like this off, the satisfaction dividend carries through to everybody involved. I have been involved with many of these types of shows over the years, usually concerning humanitarian topics.

Often, the media eats it up, especially if the show relates to a topic of local concern. If any of the artists have a local reputation, they should try to obtain "free space" from local government, businessmen, or utility

companies. Promote the fact that this will be good for community relations and will bring more traffic, due to the publicity generated.

When I first moved to Pennsylvania, I found out that the pristine countryside near my home was going to be the site of one of the East Coast's largest landfills. For many months the newspapers discussed this issue. A core group of five people (four artists) called Friends Urging Environmental Liberation (FUEL) decided to organize an exhibition. One of the artists' studios (Lisa Fedon) in Pen Argyl, the same town as the landfill, was the exhibition site. The Saturday opening had political speakers from both sides of the issues and an art performance. This enabled the local newspapers to report on the events in the next day's (Sunday) newspaper. Donations from the opening (about $200) paid for all our expenses. The exhibit lasted three weeks and brought together about fifteen artists.

Eight weeks before the opening, a call for entries was mailed out to the local newspaper, which ran a few small articles with a photo. Many artists contacted the group and from them the work was selected for exhibition. The show created another way to visually describe the vital news item, from a positive, artistic point-of-view rather than the written point of view. It was covered by the same journalists that had been writing about the issue. Unfortunately, the local art critics were contacted many times but they responded with "since it ran as a news item it was covered." It is probable that the art critics would not have covered the event in any case.

Artists often appreciate artist-organized shows because the artwork created comes from the heart, as installations and unusual pieces are encouraged. Sales are usually non-existent because of the topical nature of the show but that is not the prime reason to create this type of work.

Frank Shifreen

Frank Shifreen has had such a colorful art career that a whole chapter could be written about his achievements. He is an artist, curator, and genius of artist-organized events. The way in which he operates provides a textbook case for understanding the myriad possibilities and concrete results of sponsoring artist-organized projects. He uses a unique combination of guerrilla tactics and sound business practices.

From the start, Shifreen found the best way to begin an artist-organized

show was to create low-cost, black-and-white posters that could be plastered all over the city. Shifreen first started doing this in 1976 for his own solo exhibitions. In 1979 he began to have open-studio party shows at his Gowanus, Brooklyn studio. Here many artists started to network ideas.

Since his building had 9,500 vacant square feet, Shifreen asked his landlord if he could occasionally use the space as long as it was unrented. He and artist Michael Keene decided to have a monumental show, which the group of artists then assembled. Six months before the show, Shifreen put up call-for-entry posters and sent out press releases. Grant applications were also written, and after receiving a $1,500 grant from the Brooklyn Council on the Arts, Shifreen assembled more than 150 artists to create the "Gowanus Memorial Artyard." Artists had to send in proposals to be accepted for the show. The organizers received over 1,000 proposals and selected 150 artists. Each artist was given a twenty-by-twenty-foot space to create monumental art. The participants included well-established artists like Carl Andre and Keith Haring. The show opened May 16, 1981, and more than 4,000 people came out from Manhattan on Saturday and Sunday. Sculptors, painters, video, and dance performances increased attendance.

Unfortunately, Frank Shifreen had a misunderstanding with his landlord, and as a result of the art show he lost his living space and was arrested for stealing his landlord's electricity. Because of this action and the success of the show, he made the cover of the *New York Daily News* on June 15, 1981.

In addition, *New York* magazine did an article called "Gowanus Guerrillas" on June 8, 1981. They called this exhibition "the event of the season." Because Shifreen was an organizer, they used a color photo of his art to illustrate the story. Although there is no written rule, reviewers usually will use the artist-organizers work to illustrate an article since they do all the legwork and receive little credit. This is a creative pay-back. After this show Shifreen was asked to participate in many exhibitions.

With this success under his belt, in 1982, Shifreen and Scott Siken organized "The Monument Redefined," an exhibition held in three sites. The outdoor site covered twelve acres, and the artworks were visible from the window as one rode the F subway train. The space for two indoor sites was donated by the Downtown Brooklyn Cultural Center. Some of the sponsors were the Department of Parks and Recreation, the City of New York, Con Edison, F. W. Woolworth Co., and the Organization of

Independent Artists. Shifreen made some interesting associations preparing for this exhibit. He discovered a direct link between art and real estate interests, since art has to be hung on walls and exhibited. Management and realty companies will sometimes lend space for various reasons. It is a good idea to make friends with real estate people, since the space can be among the most expensive aspects of an artist-organized show.

The concept of "The Monument Redefined" was to create true monuments—public statements rising out of a collective need and based on a personal understanding. Size was not a prerequisite; the challenge was to communicate social responsibility. The call-for-entries consisted of a poster and free ads from *Artforum*, *Arts*, and *Artnews*. Some of the jurors were Marcia Tucker, the director of the New Museum; Henry Geldzahler, the N.Y.C. Cultural Commissioner; and Mary Boone, the gallery owner. Three panel discussions were held at Cooper Union and artists as well as art critics took part. Thousands of artists submitted proposals and 400 were selected by the curators. The selected artists had to pay a $25 fee for the catalog.

Again the show attracted well-know artists, including Christo, Vito Acconci, Nancy Holt, Chris Burden, Dennis Oppenheim, Nancy Spero, and Leon Golub. The *New York Times* and many art magazines reviewed this important exhibition. It is possible to excite the public with ideas and political controversy.

Just as Frank Shifreen was about to organize the "Brooklyn Terminal Show" he fell ill and did not have a major hand in its organization, although he did exhibit in it. This September 1983 "Terminal Show" was one of the biggest artist-organized shows ever attempted. Over 550 artists assembled in what, at one time, was the largest building in the world.

Through his contacts with artists, critics, and museum curators, Frank Shifreen was asked to organize legitimate shows, as well as to exhibit in commercial galleries. But this did not stop him from continuing to develop artist-organized shows. The Pan Arts group in Manhattan made Frank the editor of its magazine, which served as a catalog for their "Art and Ego" show in 1984. In a 6,000-square-foot space, approximately 300 artists exhibited in various media, such as sculpture, painting, performance art, film, and video art. The space was donated by a landlord excited by the ideas and energy of these artists.

Frank believes the East Village art movement of the mid-eighties came into existence as a result of the artist-organized and not-for-profit shows

of those years. The shows created an opportunity for galleries and dealers to take on emerging artists along with art that had a political or social consciousness. In 1985–86 Frank Shifreen had five one-person shows as a result of the publicity and connections cultivated through his artist-organized events. He became a successful grant writer, writing grants for the performance artist Karen Finley, and a $100,000 grant for a blind artist for the New York Commission for the Blind. He wrote himself into the grant as an art teacher.

The "Brooklyn Bridge Centennial Show" was put on with Pratt institute and Creative Time, a nonprofit public outdoor sculpture organization. Shifreen was one of the organizers that helped coordinate grants, artists, and sites. The 22 Wooster Gallery gave him the paid position of Program Director for the Artists Talk on Art series. He organized panels on diverse topics. These were always well-attended and provided lively discussions. He was a member of Group Scud, which bought and reconstructed a trailer and used it as portable gallery space parked in front of New York City museums and Soho galleries. Because a member of Scud remained behind the wheel at all times, the group was able to average three to four hours of rent-free exhibition space in prime locations. He helped organize the "Art Against Apartheid" exhibition, to benefit and raise consciousness about South Africa, held on twenty-six sites in New York City. The Organization of Independent Artists helped coordinate "Art Against Apartheid," as Frank Shifreen wrote many grants for them. From 1986 to 1989 he was involved with the international artists organization called Plexus which created multi-cultural art environments. Some of these exhibitions traveled to Rome, as well as other parts of Europe. In 1990, after a decade of significant achievements, Frank Shifreen finally took time out to travel, write, and go back to college. However, in 1993 he again joined with younger artists in Brooklyn to form "Cat's Head" in the Williamsburg and Greenpoint area.

Frank Shifreen understands the value of devoting time to organizing, curating, and to doing the publicity. He follows up press releases with phone calls to the reporter or critic. Human contact is critical to long-term success. Frank Shifreen knows art critics will follow your career if they believe in your work, and this strategy has helped his illustrious career.

Nonprofit Alternative Spaces — the National Association of Artist Organizations (NAAO)

Started in 1982, one of the best organizations supporting artists is the National Association of Artist Organizations (NAAO). NAAO publishes a national directory called Organizing Artists. It includes more than three-hundred-fifty listings of nonprofit arts organizations inclduing their organizational mission, budget information, disciplines served, types of programs, kinds of facilities, and proposal information. This is a bible for emerging artists. The NAAO consists of nonprofit galleries, alternative spaces, and museums that pay artists an honorarium for exhibiting. The directory is updated periodically. At the time of this writing, the most recent directory costs $25 for artists. The NAAO mailing list is available pre-printed on labels for mailings ($40 members, $60 non-members). Contact NAAO at 918 F Street, N.W., Suite 611, Washington, D.C. 20004; 1-202-347-6350.

If you are selected for a NAAO exhibit, either a group or solo show, expect to be paid a fee for exhibiting. This is in addition to money made by selling work. The fees range from about $25 (group) to $1,000 (solo). These spaces tend to be experimental in what they show and favor installations, new genres, interdisciplinary works, social/political themes, and performance art.

Another reason to contact these spaces is that many of the directors and curators are asked to sit on federal or state organizational and individual grants panels. Governmental grant panels usually do not have commercial gallery owners as panelists, unless they are experts in a particular field or know nonprofit organizational procedures. These individual and organizational grant panels are primarily made up of professional artists (previous federal or state grant recipients), contemporary museum curators, and NAAO member curators and directors.

Receiving an individual or organizational grant from these panelists might mean not only being financially compensated, but also being asked to show in another NAAO space. The panelists take notes and could then contact you. After the grants are awarded and the notification letters mailed out, it is important to request the grant panelist list. If you received a government grant, the panelists thought highly of your work and querying them about exhibitions and residencies would be advisable.

NAAO usually has a conference in a different city every eighteen months. This is the place to network as performances, workshops, and seminars are offered. The art spaces that make up NAAO are at the forefront of avant-garde art, and an emerging artist's career can be advanced by regularly showing in these spaces. Most NAAO sites receive local, state, federal, and private foundation support.

I would recommend becoming an artist-member by paying $35 to receive NAAO's directory and membership mailings, including their Bulletin, Inventory, and Flashes.

When you get the directory, start contacting the organizations listed regarding shows, installations, workshops, lectures, artist-in-residencies, or fundraisers. They also offer a grant to member organizations of up to $25,000 to organize, travel, and insure an exhibit between NAAO sites.

Cindy Sherman and Robert Longo

Two artists who started out in the artist-organized alternative-space gallery scene were Cindy Sherman and Robert Longo, former State University of New York (SUNY) at Buffalo students. In 1974 they were living in Buffalo in a building supported by the Ashford foundation. The alternative space "Hallwalls" was so named because the walls of the hall of the building were used for exhibition purposes. The gallery space (walls) was located in the hall between founders Robert Longo's and Charles Clough's studios.

The New York State Council on the Arts awarded them an $8,500 grant, and they soon became one of the most important alternative spaces in the country. Cindy Sherman was the secretary and used Hallwalls as a forum for her work. In 1975 she was included in the annual survey show that the Albright-Knox Museum (Buffalo) mounted of New York state artists.

Being part of an artist organization in the mid-seventies (pre-NAAO) put them in contact with other New York state sites, such as New York City's Franklin Furnace, Artists' Space, and the Kitchen. They realized that living in Buffalo, even with a top-notch alternative space, they could only take their careers so far. Therefore in 1977, when Sherman had received an NEA emerging artist grant, she and Longo decided to move to New York City. Sherman took a job as a receptionist at Artists' Space, which put her in contact with the alternative and commercial art scene. Between

1977 and 1980, she created about seventy-five pieces for the "Untitled Film Stills" series.

This culminated in her first solo exhibition at the Kitchen in 1980, and with the success of that show, she had her second solo show that same year at Metro Pictures, a commercial gallery in Soho. Her reputation from the Metro Pictures show instantly made her globally known, a situation that most artists only dream about.

All artists start from ground zero. The creation of a body of work, persistence, timing, and, most important, the public forum of exhibitions (especially in New York City) with positive critical reviews all help to make a career.

University and Museum Galleries

University and museum gallery exhibitions are the pinnacles of artistic achievement, and many artists approach them for solo shows before they are ready to exhibit on this level.

In chapter 4, creating your own press agency was discussed as a way to be placed on the university and museum information/publicity press mailing lists. If you do this, create two different names for your agency, one to sell photographs and the other to receive press information. Names like X-City Press Service or Long Island Press Service (LIP Service) are good choices. It is better to make up a name for your business and to allow your own name to be solely identified with your creative work.

Press mailings will indicate not only the current shows but also upcoming ones. These future shows hold the most promise, as they are usually not completely formulated. There is a long period of organization, during which the museums or galleries have to apply for catalog, travel, or insurance grants and decide which works will be included in a show. The lag time before the show, while the exhibition is in-the-works, is the best time for artists to contact the museum. Many university and museum press mailings will indicate the date for the show, which could be two to three years away. In fact, some of these press announcements do not even have a date and indicate that the exhibition is in the planning stages and just give a working title and brief description.

At least you are aware of these upcoming shows and have a chance to be considered, if you believe that your work fits the exhibition's concept. Contact the curators via letter, fax, or phone calls and indicate you heard

about the show through the "art grapevine." Ask if they are still reviewing work. It is a great opportunity to be in one of these shows, since most university or museums print catalogs or books of important exhibitions.

Be aware that when you ask to be placed on a press mailing list the organization assumes you are an agency, journalist, or photographer. They may ask for verification by letter or fax. If so, I'd indicate that you are a new agency that works with the local, national, or international press, and that newspapers and magazines are also interested in significant museum or university shows. If you have articles about your work, mail those and indicate that you were the one who placed the article. You could also try to place articles about artist friends, split the proceeds, and have more diversified tearsheets as proof of your legitimacy. Again, if you are not actually functioning as a press agency, placing art-related articles and photographs in periodicals, you are placing yourself in an ethically tenuous position, requesting this information. However, if you are working as your own agent, receiving such information is one of the benefits. This same approach can be applied to nonprofit or commercial galleries, as it is important to know what is happening in your region.

Universities, especially Ivy League schools with private galleries, offer many opportunities, including exhibitions, workshops, master classes, demonstrations, artist-in-residencies, lectures, performances, and visiting artist residencies sponsored by the art department.

College galleries are curated with or without ties to the art department. Occasionally the art department curates the gallery and then offers supporting activities that are coordinated with that particular exhibit. The same is true for university museums. It all depends on how the gallery operates, either independently or in conjunction with the courses being offered that semester. It can be a great arrangement if an artist can tie in with classes and an exhibition, potentially receiving an honorarium, lecture fees, or artist-in-residency fee, plus travel, accommodation, and shipping expenses.

Education Departments of Museums

Another way to find out a museum's schedule is by contacting the museum's education department. These departments coordinate educational activities for all museum functions including exhibitions. Educational functions are sometimes masked fundraisers and/or grant or

profit-making opportunities. Try to get an appointment with the education coordinators, as they offer a vital link to the curators. They are aware of future exhibitions, and they can act as "art scouts" to the curators. Education coordinators are always thinking ahead about how to best compliment the museum exhibitions and activities. It is much easier to arrange an appointment with them than with a curator. If an artist is hired for a workshop or master class demonstration, he might also be able to exhibit his work. It is a natural complement, since budgets are tight and exhibition links work well for the museum's literature. But not all artists who do museum education work are in exhibitions.

Curators recognize the power that they yield, and it is extremely hard to arrange a curatorial appointment. Usually they have assistants who filter out queries, letters, and phone calls. Include museums on your publicity mailing list, as they do follow certain artist's careers. A museum group show is a realistic goal. If you receive a solo show at a museum, it is because you have cultivated collectors and are already successful in commercial or nonprofit galleries.

If you are included in a museum show, coordinate a show at a commercial gallery in the same month and city. This happens to famous artists all the time. A commercial gallery will piggyback on the museum's publicity. The media is more likely to review your work, since museums are usually extensively reviewed, and if you can arrange other exhibitions, sales are more likely. Museums do not sell work. However, some of them have lending libraries or commission artists to create special prints or lithographs for an exhibition. Try to capitalize on this. The major galleries and museums do it all the time. Look in the Sunday *New York Times* Arts and Leisure section, and compare museum listing and gallery ads. An emerging artist might not be ready to show at these institutions, but one should get used to following this procedure.

Children's Museums

These are a relatively new addition to the museum field, and they offer another way for artists to supplement their incomes. Some children's museums have art exhibitions, collections, workshops, demonstrations, and the like. If you create playful, colorful, elementary, or "pure" art that you believe might fit into their schedule of events, visit a few to check out what they offer. Most major cities have them.

Keep in mind that your work or planned activities cannot be too sophisticated due to the age group, unless high school students are part of the audience. Hands-on activities are essential. These museums have curators, directors, educational departments, and an exhibition space. The Children's Museum of Manhattan, 212 W. 83rd St., New York, NY 10024, has a working television studio with computers, enabling video and computer artists to offer workshops and residencies.

Do not discount these museums; a workshop can result in future art opportunities in that area. If you have any articles in school or children's publications, the articles could be sent to those museums as part of an introductory mailing.

Donating Works

Artists donate work to nonprofit organizations (alternative spaces, colleges, universities, or museums) for a variety of reasons: in connection with exhibits, for their resumes, and for tax purposes (for the artist, only the cost of the allowable materials, and for the collector, the current market value, are deductible).

Do not expect the donated artwork will always be accepted. The nonprofit Board of Directors and/or curators have to approve all donations. You should query first to determine if a nonprofit collection is interested. After talking to many museum curators regarding the acquisition and exhibition of work, some general approaches become evident. Remember that working with a museum is a long-term career goal. Always call or write for an appointment. The actual work is preferred over slides. If the artwork would contribute to the collection, the curators will offer suggestions on how to donate the work. It might be wise to have someone else donate the work to receive the tax deduction. This establishes a value which is backed up by a museum receipt (useful for insurance and tax purposes). If the curator asks to purchase the work, it is wise to sell the artwork below market value due to the prestige of the museum. Remember, artists can only deduct the cost of materials if they donate directly to a museum.

It is important to ask if the donated work will be exhibited or put in storage. Even if it's put in storage, it is a worthwhile donation because of the insurance value and resume listing for you. This will be further discussed in the grants chapter.

Selling Work below Market Value

Selling work below market value to museums, libraries, or galleries establishes a receipted insurance value. It is possible to sell one work at full value, then donate other works. An artist might give away four works and sell one. If the market value is $500, in effect the organization paid $100 a piece. If the organization is willing to buy one at full value, insurance credibility is established when dealing with lost or damaged art.

First Night Festivals

Beyond the traditional, established venues for exhibitions, there exist many other opportunities for fine artists. Every year approximately 150 cities in the United States and around the world offer a New Year's Eve festival called First Night. It begins during the afternoon on December 31 and continues until midnight.

This celebration, the size of which varies from city to city, can feature 200 performances staged in over thirty sites. The venues are traditional performance sites like auditoriums, churches, bank lobbies, and store front windows.

The First Night committees invite proposals for these disciplines: music, dance, theater, magic, visual arts, multi-media arts, comedy, and performance art. Events are staged for different age groups, from children to senior citizens. In the visual arts, outdoor installations of visual, sound, or environmental themes are of interest. This is in addition to ice sculpture or other temporary outdoor site-specific artwork. Art performances and installations can be in empty storefronts and windows and can include temporary building transformations.

Priority is given to ideas exclusive to first night. A proposal is necessary (some cities have forms and others do not), with support materials. If a performance is presented, two forty-minute performances are standard, and other support information is needed: the size of the group, technical and space requirements, resumes, reviews, black-and-white photographs (for the brochure and press), and audio/video tapes. It is important to be self-sufficient for these performances. Since so many events are scheduled the technicians are limited. Priority is given to groups that bring their own lights and sound system, and the set-up does not have to be elaborate. If you are chosen to play in an auditorium, technical support can be provided.

The fee can range up to $1500 for two performances, and if one has a regional or national reputation, the fee can be higher. Some hotel chains will donate rooms to First Night, and you can request this in the proposal. Be prepared to negotiate the fee depending on what is offered and the number of people required for the performance or installation. First Night is a very good place to experiment and try out new collaborations. Many of the First Night festivals have an emphasis on environmental art as part of an overall theme.

The proposal deadlines are in April or May, and the decisions are usually made by July or August. All proposals are reviewed by a committee, which is usually composed of artists representing a cross-section of disciplines. The proposals are rated on artistic merit, age appropriateness (X-rated is out, G-rated is best), and originality. The final decisions take into account availability of locations, funds, and overall theme.

Once an artist appears in a First Night festival, he should go to another city the following year. Either do the same thing or come up with something new. If something is completely new, it is possible to appear in the same city; but call the First Night offices to discuss your ideas.

A list of participants is available from First Night International ($25 for artists and $125 for agents or vendors). The president, Zeren Earls, also coordinates a first night conference for new cities. The address is First Night International, One International Place, Suite 516, Boston, MA 02110-2600; telephone number, 1-617-345-0065.

First Night is a good way to receive exposure and publicity, both from the First Night publications and newspapers, which often do little features about the artists.

Outdoor Art Festivals

Some professional artists might thumb their noses at the thought of being involved in outdoor art festivals. This is due partly to the uneven quality of the work and/or the sites. Many festivals use shopping malls, university grounds, parks, and city streets. If an artist is selective in choosing festivals, they can be valid places to exhibit for the short period of time involved.

Some of the benefits are meeting other artists, selling work, winning an award or prize money, and traveling to a warm climate in winter. In general, these festivals require paying fees. These might include an entry fee of ten to fifteen dollars or more. Many outdoor festivals require an

additional space fee, from a low of twenty-five dollars in malls to the three hundred dollars that the February Coconut Grove Art Festival charges. Located just south of Miami, Florida, the Festival can be contacted at P.O. Box 330757, Coconut Grove, FL 33233-0757; 1-305-558-0757. The Coconut Grove festival gives out a total of thirty-five awards: one $1,000 Best of Show, one $1,000 Purchase Award of Excellence. The following thirty-three awards are for first, second, and third place in eleven categories of $750, $500, and $250, respectively.

The Gasparilla Festival of the Arts has been held in the early spring for over twenty-six years in Tampa, Florida. Each year 300 artists are juried into the show from some 1,400 applicants. There is a non-refundable juring fee of $20, and a $175 booth fee (refundable if not accepted). Usually a prestigious museum curator is responsible for selecting the awards. The awards are as follows: $15,000 Best of Show, $7,500 Board of Director's Award, $3,500 Gasparilla Award, $2,500 Anniversary Award, $1,500 Friends of the Arts of the Tampa Museum, $1,000 thirty Individual Awards of Merit. If selected to exhibit, you have a 10 percent chance of winning a cash award. The winners are mentioned in the Tampa newspapers and on the television news. Approximately 275 thousand people visit this festival every year. If you decide to enter, the deadline is usually in September for the March show. The address is P.O. Box 10590, Tampa, FL 33679; telephone: 1-813-876-1747.

If you decide to make the circuit of these shows, it is possible to make money not only from selling the actual work, but from winning best-of-show or other prize categories and to receive publicity (without any effort). You must decide whether this is the right move for your career and your type of art. The magazine which is a must to read if you are seriously interested in this type of outdoor-exhibition lifestyle is *Sunshine Artist* (2600 Temple Dr., Winter Park, FL 32789; 1-800-597-2573; fax: 1-407-539-1499). Request a sample copy or subscription, which is $29.95 for one year. They publish a guide every year, usually in September, of the 200 top outdoor art festivals, craft fairs, art and craft shows, and trade craft shows in the United States.

When writing to the festivals for a prospectus, you will find that the exhibitor has to have a display system for his or her work. This does not usually mean a home-made, starving-artist, Rube Goldberg unit. It does mean a fire-retardant, aluminum structure with an awning, or roof to protect one form the elements. The bigger festivals require slides to be

sent in with the entry fee, not only of the work, but also of the display system. The display panel has to have a clean, professional look. An electric lighting system should be considered.

Florida during the winter months is the mecca for these shows. Many artists will travel south to live and work out of an R.V. or van. Camping is an option instead of paying for motels.

If this is something that interests you, visit some of these festivals to get a taste of what they're like. The festivals are held all over the United States. Talk to the exhibiting artists to get an indication of their lifestyle and success.

Some festivals offer artist-in-education residencies (the Coconut Grove festival), and some produce a color catalog which might require an additional photography fee. Research such options thoroughly before spending any money.

Fairs and Festivals is an annual directory that lists contacts and application information, locations and descriptions of more than eight hundred festivals in twenty-seven states. It is available from Arts Extension Service, Division of Continuing Education, University of Massachusetts, Amherst, MA 01003; 1-413-545-2360. The cost is $12.50 plus $4.25 shipping. They also publish *The Arts Festival Work Kit*, an information handbook that provides practical guidance on every aspect of planning, organizing, implementing, and evaluating an arts festival. Published in 1989 the cost is $14.95 plus $4.25 shipping, or if you order both books the shipping is $5.25 for both.

Reference Materials

There are many exhibition forums and private dealers besides those that have been described. The first step is to visit the galleries. This will answer questions about space requirements, type of art exhibited, and the like. If you want to do research before traveling, or if you decide to "shotgun" slides (sending out X number of sets and hoping the law of averages is on your side), then there are several reference books that can help you. Although every effort has been made to find the appropriate sources, and these publications have a wealth of information; this is still only a partial listing.

American Art Directory, published by R. R. Bowker, is a complete reference guide listing over 7,000 art institutions across the U.S. and

Canada, as well as overseas. It identifies collections, funding sources, exhibitions, key personnel, and other vital characteristics of over 2,500 art museums, libraries, and other organizations; details for some 1,700 art schools and major museums and schools abroad, state art councils, exhibition booking agencies, and more. Entries are indexed geographically and by institution, personnel, and subject.

International Directory of the Arts, published by K. G. Saur, is a two-volume, comprehensive guide to art sources and markets in 137 countries. It contains over 150 thousand names and addresses of art restorers, publishers, libraries, art dealers, galleries, museums, associations, and more.

Museums of the World, published by K. G. Saur, provides valuable research and professional information for some 24,000 museums world-wide. Organized by country and city within individual nations, entries include address, telephone and fax numbers, description of holdings and facilities, museum director's name, and more.

The Official Museum Directory, published by R. R. Bowker, lists over 7,000 institutions in categories such as art museums, historic houses, nature centers, aquariums, botanical gardens, planetariums, zoos, and others—showing where they are, what they exhibit, and who manages them. A Product and Service section that lists more than 1,800 museum suppliers is also included.

Art Diary, published by the editors of *Flash Art*, is an international listing of artists, critics, galleries, publishers, and others in the art world. The current fee—eighty dollars—includes a listing, a copy of the directory and a one-year subscription to *Flash Art*. To find out more information about this directory contact Giancarlo Politi Distribution S.r.l., Casella Postale 36, 06032 Borgo Trevi (Pg), Italy; 39-742-381-691; fax: 39-742-78-269.

Art in America publishes an annual guide to galleries, museums, and artists. It includes U.S. museums, commercial galleries, university galleries, nonprofit exhibition spaces, corporate consultants, private dealers, and print dealers. Artists are listed in connection with galleries or institutions. If you are affiliated with a gallery, make sure they contact this guide to have themselves and you listed. This guide appears during the month of August.

Another book used for reference is *Who's Who in American Art*, 121 Chanlon Rd., New Providence, NJ 07974; 1-908-771-8602. It profiles

visual artists from the U.S., Canada, and Mexico, including artists, administrators, educators, collectors, critics, curators, and dealers, "obtained from nominations provided by current artists, art associations, galleries, and museums, or from citations in professional publications." Read the preface to fully understand the how, why, and what for their selections. There is no cost to be listed, and artists can nominate themselves to be included in this book.

There are other books like the *Marquis Who's Who, Who's Who among American Professionals, Who's Who in the Midwest, East, South, Southwest,* and *West.* Contact them at the same address to find out if you qualify.

Another reference of international stature is the *Dictionary of International Biography* published by the International Biographical Centre, Cambridge CB23QB England; 44-353-721091 or fax: 44-353-721839. It details the success and achievement of some 175,000 individuals from around the world and includes a form which gives you the opportunity to recommend friends, family, or colleagues whom you consider eligible for inclusion.

A directory called the *International Who's Who of Professionals* can be contacted at 414 Bell Fork Rd., P.O. Box 3002, Jacksonville, NC 28541-3002; 1-800-ASK-4-WHO or 1-910-455-8777; fax: 1-910-455-1937. There is no cost or obligation to be included in the directory.

Visual Artists' Information Hot Line

The Visual Artists' Information Hot Line is a toll-free service of the New York Foundation for the Arts, offering information for individual artists on useful books and a variety of other topics. The number is 1-800-232-2789, 2:00 to 5:00 P.M., E.S.T., Monday to Friday.

CHAPTER 6

Making a Career in Europe

Everybody has an image of Europe: the mecca for intellectual and cutting-edge art; the place for expatriates to absorb different cultures, create, drink absinthe, and plan artistic revolutions.

Europe does offer many opportunities. Its culture is entirely different from ours. The European lifestyle is more humane. While the culture is different, the marketing and self-promotion techniques for artists are the same; galleries, magazines, newspapers, and television are still the means to achieve a reputation. But, as evidenced by the circulation numbers, more people read newspapers in England and France than in the

United States. This opens more opportunities for articles, reviews, and other ventures, as well as a greater audience when you do get published. There are many weekly news, fashion, and photography publications that buy illustrations or feature articles. The weekly news magazines include *Epoca, Panorama, Oggi, Europeo,* and *L'Espresso* in Italy; and *Stern* and *Der Spiegel* in Germany; among others. Some of the weekly fashion magazines are *Elle* and *Madame Figaro* from France, *Grazia* and *Amica* from Italy. The weekly photography magazines are all British: *The British Journal of Photography* and *Amateur Photography.*

Many artists have worked in Europe and built up a reputation before being recognized in the U.S. This was the case with Terry Niedzialek, the creator of hair sculpture, whose art rap we discussed in chapter 1. In May 1986, Niedzialek went to Europe with the hope of establishing a reputation and exhibiting her work. One of her first stops was the editorial offices of Italian *Vogue* in Milan. Upon arriving in Italy, she arranged a Thursday appointment via telephone with an English-speaking beauty editor. On Friday, *Vogue* phoned her hotel to set up a photo shoot the following Monday for the June issue. *Vogue* used her work to illustrate a four-page editorial spread celebrating French and American perfume for the one-hundredth anniversary of the Statue of Liberty. The assignment was for her to create American and French flags out of hair. Before accepting this assignment, she secured permission to have me take additional photo-graphs of the models (an Italian photographer was hired by *Vogue*). *Vogue* hired two models, a back-up stylist (if the hair sculptures failed), a freelance editor, and photo assistants, and bought the supplies needed for the hair. *Vogue* had the rights to publish this material first, after which we were free to sell the slides I took at the same shoot. Consequently the American flag hair sculpture, titled "America the Beautiful," has become Niedzialek's signature work. The photographs were published over thirty times around the world, some of them on magazine covers. This visibility brought her attention in the U.S. and resulted in a *People* magazine article in January 1987. After this article appeared, Niedzialek's career accelerated and culminated in an N.E.A. Individual Artist Fellowship in 1988.

Where to Begin

You will have to prepare before heading to Europe, especially if you do not know where to go, who to see, and can't speak any foreign languages.

English is a business language. It is not uncommon for European curators, gallery owners, newspaper and magazine editors, and art directors to speak a number of languages, English being one of them. But sometimes they only speak French, Italian, or German. It is to your advantage to be able to speak at least a little of the native tongue. Translating and learning these words and phrases is a very good idea. To go to Europe without preparation will give the impression of an "ugly American," which will not help your art career. By being creative you can overcome many obstacles, even if you butcher the language. If you speak incorrectly but with emotion and sincerity, you are at least making an effort, and that shows respect, which will be appreciated. No matter which country you decide on visiting or working in, take private foreign language lessons so you will be familiar with the language. Ask the tutor to help you adapt the suggested phrases; telephone work is essential to success!

The major European cities offer the best opportunities: London, Paris, Milan, Rome, Cologne, Berlin, Amsterdam, Madrid, and Barcelona, to name a few. Except in London and Amsterdam, two cities where English is dominant (since Dutch is limited to the Netherlands), you will need to have a dialogue prepared in the language of the city you are visiting. Why these cities? They are the equivalent of New York and Washington, D.C. They are political capitals as well as centers for book, newspaper, and magazine publishing. They harbor fashion and television industries, major museum collections, galleries, and foreign press bureaus. Since European countries are much smaller than the U.S., actually similar in size to some of our states, these major cities take on a significant role in developing an artist's reputation. If one can make it in New York, he can write his ticket anywhere. The same can be said of London, Paris, and Milan. These cities are no less significant in terms of creating a reputation if one is able to manipulate the media. Networking between countries is also easier once one is in Europe. News travels fast in the digital age; and, if necessary, an overnight train can put you in any of these cities quickly and save you the cost of a hotel room while providing a comfortable way to travel.

Going to Europe will require homework, planning, and expense. First, forget about going in the summer. There are too many people from the U.S., and many important people take two months off between mid-June and mid-September. It is better to go off-season, but not near Christmas, the New Year, or Easter. Why is off-season better? The trains will not be crowded, hotel rooms will be available (unless a convention is in town),

and the people you want to meet will be available. The absolute best time to go is the winter. It's off-season, plane fares are the lowest, hotel rooms do not have to be reserved, and you can have the sleeping compartments in overnight trains completely to yourself (during the summer you might find yourself sharing one with up to six people).

Having a travelling companion will make the trip easier on your psyche. You will be able to speak English with someone, two people can cover twice as many appointments, and the cost of hotel rooms can be shared. However, if you have to go it alone, the cafe life will entertain you and provide a good way to meet people.

Flights

How does one get to Europe? Buy the *New York Times*, some other large Sunday newspaper, or the *Village Voice*, as they list many cheap flights to Europe every week. Look in the travel section for charter flights, either one-way or round-trip. There might be certain travel restrictions imposed in exchange for a reduced fare, like flying during the week or at certain hours, but charter flights provide a way to save money. Paying by credit card will help in the event of a problem with a charter company, but ask lots of questions before spending your money. Ask what happens in the event of a cancellation or illness.

During the winter months, regular airlines offer inexpensive fares, since nobody wants to travel in winter. (You do!)

Another opportunity is acting as a courier. Couriers pay for part of the flight and carry documents or other items in luggage to expedite business for companies, since unaccompanied luggage is the last to go through customs and can take a few days. The drawback is that the courier company uses your baggage allowance and more. Therefore you are only allowed carry-on luggage, which might mean one piece that is nine-by-fourteen-by-twenty-two inches. You will not be allowed to bring more. The travel can be one-way or round-trip, depending on the policies of the courier companies.

One company that acts as a courier agent for air freight companies is Now Voyager (1-212-431-1616, Monday through Friday 11:00 A.M. to 5:00 P.M.). They charge a $50 yearly registration fee, which is good for unlimited discount travel. The international couriers use regularly scheduled airlines, while the domestic flights are chartered. They have a

$100 refundable deposit, and you have to pay a $28 departure tax, but the flight fares are always less than the published fares of the regularly scheduled airlines. Sometimes it might cost just $50 for the airfare to Europe, other times more. Check the prices and restrictions before scheduling.

If two people are travelling to Europe via courier, it is very unlikely that they will be able to travel on the same flight. Travel has to be coordinated, with one person leaving on a Monday and the other on a Tuesday and the return flight will also be staggered. Sometimes it is possible to arrange a flight two months in advance, but often you have just a few days. These are non-refundable flights, so ask questions! There are more couriers than flights available, and sometimes these companies only use friends and relatives of their workers.

Most courier flights leave from Kennedy Airport in New York. As with any international travel, it is necessary to have a valid passport. The time you will be in Europe can vary from one to several weeks. Sometimes there is an open return date, but every situation is different. Some of the common courier destinations are London, Paris, Madrid, Amsterdam, and Milan.

There is one newsletter about courier travel. *Travel Unlimited* is a monthly newsletter of worldwide flight information. Flight prices, travel tips, and booking information is updated every month. Courier companies rarely advertise, so a newsletter like this is extremely helpful. The cost is twenty-five dollars for a one-year subscription (Travel Unlimited, P.O. Box 1058, Allston, MA 02134).

Your Itinerary

Once your travel plans are made, the date of departure and length of stay determined, you need to decide which cities you will visit. Paris, London, Milan, Berlin, Amsterdam, Cologne, and Barcelona are good "art cities." I personally found Milan to be the most receptive for many reasons. It is centrally located in Europe, is a business city, and is home to many premier magazines which are published in Italian and English: *Domus*, *L'Arca*, and *Abitare*. The quality of the color printing for these magazines puts many U.S. publications to shame. Artists who have had the same slides published in the U.S. and in Italy will see that the U.S. tearsheets are muddy-looking compared to the Italian printing. The Italians are masters of printing as

is shown by the many books that are printed in Italy by American companies.

A selection of published images from Italian magazines will give your portfolio a professional look. Many fashion photographers and models started their careers in Milan, since significant fashion magazines are published weekly. The pay is not as generous as in the United States; but one has to make a reputation somewhere, and Italy has been known as a beginner's paradise.

Plan an itinerary which follows the work week Monday through Friday with travel or vacation on the weekends. When visiting and working in Europe for the first time, it is best to allow two weeks per city to network, make appointments, get referrals, get a sense of how the public transportation operates, find out where to stay and where to eat, and get a handle on the language. If things begin to develop, stay as long as is necessary. In 1986, I planned to go to London for two weeks and ended up staying for six as illustration work became available, (two commissions for covers the same week), articles were published, and a solo exhibit was planned.

The best time to arrive in Europe, especially if on a fixed schedule, is on a Saturday. It will give you a day to get settled, get your bearings, and get a good night's sleep because you need to recover from jet lag. Try to take a nap on the plane. Go to bed at an earlier hour the day you arrive to try to get on schedule. It is important not to burn-out immediately due to a lack of sleep. "Pace yourself" is the best advice.

On Sunday it is necessary to visit a good magazine/newsstand immediately and begin to write down names, addresses, and phone numbers of art directors and photo editors. The editors of art, photo, fashion, news, design, and architecture publications should be pursued as well. I would try not to buy these magazines since it will become expensive, and if you visit their offices they will gladly give you a free copy or a number of back issues. If you need to visit several newsstands, then do so. If two people are working, one can read off the information while the other writes it down. Try to be discreet at the newsstands, as they are not libraries. Visit a library if you have the time. Much of this research can be done in the U.S. by visiting a good international magazine store and by looking up addresses *Ulrich's Guide*. In Europe your time at the newsstand can be spent confirming information or updating it to include other names. For example, as *Ulrich's* has only the editor's name listed, the rest of the

masthead information has to be found in the current issue of the magazine (which is either to be found at a good U.S. international or European magazine store).

Collect bus, subway, and city maps on Sunday. It is necessary to begin calling on Monday morning for appointments after all the information has been gathered on Sunday. Try to get an appointment ASAP, even for that afternoon. The hours of work for magazines and newspapers are usually 10:00 A.M. to 1:00 P.M., and 3:00 P.M. until 7:00 P.M. or later. This "siesta" schedule is especially true for Italy, France, and Spain.

Magazines are the key to success, since it is the editor's job to know what is currently happening. A recommendation from a magazine will open doors. I was in Milan in 1986 and visited a photo magazine called *Foto Pratica*. I showed my work to the editor, and on the spot they accepted it for an article, interviewed me, and then asked me if I was interested in showing at Gallery Il Diaframa in Milan, as the gallery was looking for experimental photography and the editor knew the curator. The editor acted as an art scout for the gallery and the curator wrote reviews for the magazine. The editor then called up the curator at Il Diaframma and made an appointment for me for the next day. Although the magazine did not pay, they offered me a great spread. When I met with the curator we arranged for an exhibition about six months later.

Newspapers and magazines are great disseminators of information and are, therefore, great places to make contacts. As a potential contributor, you can begin networking by asking questions about galleries or any other contacts. They may ask how long you plan to be in the city or country. If you say two weeks (which can be extended if necessary), you will see how a travelling deadline all of a sudden makes things happen: other appointments, suggestions as to who and what to see, and more.

In Paris, I thought the first people to see would be in the Ministry of Culture. I phoned to ask about Americans getting grants in France, artists-in-residencies, and galleries or magazines that might be interested in my work. It paid off. It is the job of a cultural office to know this kind of information.

Knowing where to find information is key when working on a schedule. Don't be shy; ask questions and determine the quickest way to find information. If you appear to be a professional and an equal to the people you are dealing with, barriers are quickly broken down. They may offer to speak in English as you try to communicate in French or Italian. The

rolodex and personal phone book may be opened up, bearing a wealth of information.

Remember that local people, such as you might encounter working in the department stores, are not the same people as these publishing professionals. Department store personnel deal with "ugly Americans" all the time. Editorial people are educated, usually multilingual, and friendly even when in positions of power. This does not mean instant success, but at least a dialogue can be started.

Tips on Visiting Magazine Offices

Magazine offices have phones, fax, and photocopy machines—all things you will be without while travelling. After the appointment is over, it is okay to ask to make a few local calls to confirm appointments or let people know you might be delayed. Trying to obtain another appointment is a standard practice. You might also ask to fax or to make photocopies. Do not be too greedy. While visiting many offices during the day, you will be able to conduct a significant amount of business using the magazine offices' equipment. Do not ask to use the phone and try to call out of the local calling area without the office's permission. Do not make excessive amounts of photocopies (more than ten copies of the same article).

If an article is accepted, always ask what the pay rate or photograph usage fee is, based on the page rate. Always ask how the covers are chosen, since a cover article is a significant coup. If illustration work becomes available, ask about using the publisher's facilities to create the work, since a hotel room might not be adequate. Ask about the commission fee; does it include a materials budget, film services, kill fee, and the like? Do not forget to ask how payment will be handled, if invoices must be sent or forms filled out in order for payment to be processed. Finally, be sure to get a business card from whomever you are visiting.

Get the most detailed city map you can find with each street, subway stop, and bus route. This is essential when making appointments. When calling a magazine or gallery, the address should already be known to you. Be sure to ask for information such as which subway or bus stop is the closest or how to spell it (either correctly or phonetically). In Paris they publish a small book, *Paris par Arrondissement*, which covers the twenty districts of the city and the surrounding suburbs. This is a must. It costs under five dollars and is a pocketbook which gives all the important bus,

metro, and cross street information. A similar guide is available in London, *London from A–Z*.

In the United States, the publishing industry has an incredibly fast turnover. People leave jobs after a few months. In Europe, editors tend to stay at their jobs longer. Established contacts can be fruitful for lengthier periods of time.

Foreign Languages

Before going to Europe, it would behoove you to become familiar with the language of the country you intend to visit. Take a class, or even better, private lessons. Go to the library and get those old "How to French" records or audiocassettes. Buy a French/English, or the appropriate language/English dictionary. If you plan to travel a lot, a multi-language phrase book might be a good investment; it contains useful phrases in all the major European languages.

You will want to memorize the days of the week, numbers from one to twenty-four, names of the months, and words like morning, noon, and evening, as these are critical in making appointments. In Europe they use a twenty-four hour clock; so, for example, 1:00 P.M. is the thirteenth hour. You should definitely learn the monetary denominations, as well.

Besides the common phrases that all non-native speakers will find invaluable, such as "Speak more slowly, please," you will need to focus on words and phrases that will help you conduct your art business. Below are a few suggested phrases and questions you will want to know when calling or visiting magazines in foreign countries.

- Is there anyone there who knows how to speak English?
- I would like to talk to the art director or editor or curator.
- I'm an innovator in painting, drawing, sculpture, photography.
- My artwork is abstract, realistic, surrealistic, conceptual.
- Do you develop slide film here?
- What do you pay per page?

Using the Telephones

When using the European telephone many options are available, depending on whether you use coins, phone cards, or a hotel phone. If staying in a hotel, it is important to find out if local phone calls are free. Making

calls can require a significant amount of time and effort and if it can be done from a hotel room rather than an outdoor phone booth, the savings might make it worthwhile to stay in a hotel that offers this. Always ask whether the hotel places a surcharge on calls. You may be making over one hundred calls a day, especially if you have trouble reaching the right person. Sometimes it takes ten calls to reach a gallery owner instead of his machine. Unless you are confident of your ability to speak the foreign language, so you can be certain of leaving an intelligible message on an answering machine, keep calling until somebody answers.

Most European countries issue phone cards which can be purchased in post offices or at authorized dealers. They are plastic cards that contain telephone units and are issued in different denominations. With a phone card it is not necessary to use coins. In France, the cards are available in denominations of 40 and 120 units, and a phone card call is slightly discounted (three-quarters of a franc compared to one franc for a local toll call). You slip the card into a slot in the phone and the amount of units left on the card is shown. If you are making a long distance call, the units will be deducted faster than a local call. While talking, you can see the units as they are used up, and the card will be discharged when they are all used, unless another card is inserted. The unit number will flash to indicate this. Do not forget to take your card with you. I have found many forgotten cards in the slots with units still intact.

The telephone system in Italy (SIP) still employs a token called a Gettone—the equivalent of a one hundred lire coin. Buy tokens at SIP offices, tobacco stores, cafes, and bars. They are slowly, however, introducing phone cards throughout the country.

Money

You will need to think about how to handle money and foreign exchange. It is obviously wise to have traveler's checks, however, the best rates for currency exchange are sometimes in cash. This depends on the country where you are exchanging money. Money can be changed at banks, hotels, currency exchange offices, and stores. Ask at the hotel, gallery, or magazine to find out where you will get the best rate of exchange. If traveling with cash, it might be advisable to buy a money belt. It is a bad idea to leave money in hotel rooms.

The other possibility is getting money through a credit or debit card.

Depending on the card, there might be a fee in addition to the bank charges. Since the debit card operates through your bank account and does not incur high credit charges, it is the most favorable way to obtain funds. The debit card draws money directly from your bank account each time it is used, so make sure enough funds are in the account before you leave. The card can be used wherever you see a bank displaying the card company's symbol. VISA is very commonly used in Europe. The rates of exchange for this kind of transaction can be the most favorable, but if you also incur a bank fee per transaction, it might not be the best rate.

Since you are a foreigner you may be passed a counterfeit bill. It can easily happen since you are not too familiar with the currency. If this happens and you do not realize it, you will certainly find out when you try to use the bill. In France the word *faux* (meaning false) means your money will not be accepted. Be prepared to know the word for counterfeit money in each country.

Be careful of counterfeit U.S. currency. The U.S. dollar has become a standard currency, therefore counterfeit dollars are being dumped in Europe. They are easily passed since Europeans are not very familiar with the currency.

Getting to Appointments

Although it is just becoming available in New York City and is already in use in Washington, D.C., the travel card has been in use in Europe for a very long time. Cities such as London, Paris, Milan, and Rome have them. You can buy a weekly or monthly travel pass for that particular city. A weekly ticket can be used for unlimited travel on the Metro and bus for that week. Price varies depending on zones, but if the card is used many times during the day for appointments, the price becomes very reasonable (about twenty cents per ride). It can also be used on commuter trains such as the RER, which has stops in Paris, and travels like an express train.

You need a small photograph of yourself to attach to the weekly stamped card. It is advisable to bring several dime-store-size photos either in black-and-white or in color. These can be made when your passport photo is taken. Ask for six extra photos if you plan to visit many cities.

In Paris the subway is known as the Metro. It is clean and efficient and an excellent way to get around the city. Late at night there might be a longer wait, but it is very dependable for business appointments. The

Metro closes at midnight; the bus operates on a light schedule-hourly from midnight to 5:30 A.M. The weekly pass is a *Coupon-Jaune* (yellow). It is valid Monday through Sunday, available at all metro station ticket booths. The monthly pass is a *Carte Orange*, and it is valid for a calendar month and sold by zones. Two zones cover all of the city. Metro maps are available at all ticket offices.

The subway in London is called the Underground. It is a huge system, since London is a sprawling city. The older London buses have an open back and if they are stuck in traffic you can walk on and show the weekly pass. The Underground and buses operate from 6:00 A.M. (Sundays 7:30 A.M.) to midnight. There are Rover passes (Explorer Ticket) good for buses and the Underground. You can also get a photo card for one week at all London Transport offices. Sunday service is infrequent as some stations are closed. The system is color coded and easy to understand. Use the *London A–Z Guide* to find the streets corresponding to the Underground stations.

The transportation system in Milan, called Metro MM, is a combination of subway, buses, and trolleys. The subway line is limited, so trolleys and buses are the best way to travel over distance. The hours of operation are 6:20 A.M. through midnight. The same ticket is used for all transportation and is valid for seventy-five minutes of travel in a single direction. Tickets are time stamped, and transfers are free for a single direction. Tickets are available at tobacco stands—tabacchi—with the ATM logo. Buy the weekly pass (*Abbonamento Settimanle Ordinario*). It has to have a photo, signature, and an address. The monthly pass (*Tessera*) is available at all ATM offices. Get Metro maps at tourism offices and some main ticket offices.

Rome is an old, decaying city and the streets are constantly being repaired, so expect traffic delays. The Metro is a short line and the fastest way to travel. The transportation system is called ATAC. The hours of operation are: Bus, 5:30 A.M. to midnight (some lines twenty-four hours); Metro, 5:30 A.M. to 10:30 P.M. The weekly pass (good only for buses and trams, but not the Metro) is called a *Biglietto Settimanale*. It also provides free admission to municipal museums. If you are late or in a hurry, a taxi can be the fastest way to travel. However, foreigners might be taken on a longer route and inner city traffic can increase travel time. Plan ahead and use public transportation whenever possible. Ask for an estimation of travel time from your hotel or from one appointment to the next. People

will usually be able to give an indication of what line or bus to take and how long of a trip it will be.

Where to Stay

In Paris, there are many hotels on the left bank in the fifth and sixth districts (*arrondisments*). These hotels are the closest to the contemporary art galleries, and they are traditionally less expensive than the hotels on the right bank.

Rue de Seine in the sixth *arrondisment* has an open air market almost every day, a supermarket, and many bakeries. There are also many hotels and it is a good location for saving money by buying prepared food or buying food to cook. Minimizing daily expenses for food can save substantial amounts of money, especially for two people. Cooking or eating food from a supermarket has to be, at most, a quarter of the cost of a restaurant.

In London, holiday apartments are studios with a sink and refrigerator. They mainly cater to members of the Commonwealth who work in London and live in boardinghouse situations. There are many free papers which give listings about them. If you can't find them, go to tourist information and inquire about them. Also ask about hotels that have cooking facilities. These are sometimes in the basements of hotels and they have stoves and a big refrigerator plus the use of pots, pans, plates, and utensils. Holiday apartments or hotels with cooking areas are usually much cheaper than the standard hotels. The prices vary, but you can pay by the week and it could be a hundred dollars or less for two people, depending on currency exchange, time of year, type of place, use of television, and other variables. That is another reason why traveling in the winter is best. The cheapest prices are available, and you get to know the people who run or own the places. If you were to go again at another time, even high season, you could reserve ahead of time knowing what to expect.

In some of these places there is no phone in the room, but a pay phone is in the building and everybody usually helps out. If the phone rings people answer it and will relay messages via a community bulletin board or by leaving notes on the door to your room.

In Italy, there are pensions which are similar to boardinghouses. The difference is that the owners live in the same space while they rent out rooms. Sometimes food is provided, other times it is not. It is not usually

possible to cook in these rooms. Hotels in Italy are expensive but, as anywhere, if you cook it will save you money. Check first to determine if cooking is possible.

A clear advantage to staying at a hotel is the use of the phone, especially if local calls are free and the hotel can be used as an answering service. You can call in for messages and leave numbers where you can be reached. The person at the front desk can be very helpful in scheduling appointments. Hotel life, for a limited time, can be a very comfortable. Some hotels offer weekly and monthly rates and this can end up costing the same price as living in an apartment in the United States, depending on exchange rates.

Getting Mail

As mentioned before, U.S. mail can't be forwarded to Europe. Somebody has to forward it to you in Europe by paying the additional postage. While in Europe, mail usually can be sent to the hotel where you plan to stay. You can arrange to have your mail held for a certain amount of time. Leaving a large envelope with the correct postage for forwarding is another possibility. This can be sent to a new address if it is not possible to pick up the mail directly. Post office boxes are available for a fee if you plan to visit periodically.

Photography Services

If you plan an exhibition or are able to create work while in Europe and you need to take photographs/slides of an installation or piece of art, Kodak operates labs in London, Paris, Milan, Rome, and many other cities. Usually film has to be dropped off and picked up and service is twenty-four hour. Sometimes the mailer that comes with the film can be used instead of the processing fee, or an extra dollar is charged for the service. Other film that is E-6 processed can be processed in any lab, and the turn-around time is normally a few hours. Make sure that this is not considered rush service since the price will be twice the normal amount. Ask questions and request a price list for services. Complications and misunderstandings are always more likely when dealing in a foreign language. In Europe, when buying Kodachrome film, the processing mailer is included in the price. The film canister has a special red dot on it to indicate this; therefore the

film can be mailed to a lab or brought to one of the special Kodak offices. Kodak owns the following processing labs in Europe:

London: Kodak House, P.O. Box 66, Station RD, Hamel Hempstead UK (tel. 44-2-61122 ext. 44232)

Paris: Kodak Centre, 38 Ave. George 5, Paris, France (tel. 33-1-7235740)

Italy: Kodak Centre, 20092 Cinisello Balsamo, Milan, Italy (tel. 39-2-617901), and Kodak Centre, Via Pistoiese 55, Rome, Italy (tel. 39-6-881721)

For additional information contact the Kodak hot line (1-800-242-2424, ext. 19) and ask about labs or centers in other countries that process Kodachrome or other E-6 films.

When traveling with film via air, it might be advisable to buy a film shield bag made by the SIMA Company. This is a lead laminated pouch that protects against airport x-rays. However, it is not guaranteed against high dose x-ray units. X-rays have a greater effect on film which has been exposed but not processed. SIMA recommends that all photographic film should be in your carry-on luggage. Ask the airport security people to visually inspect the film. That way, it will not be x-rayed at all. The x-ray affects the higher ISO films, especially the ones rated at over 1000 ISO. X-rays can fog film, but this is usually only a problem where the degree of x-rays are high.

Getting Paid

Whether it is for selling articles or artwork, receiving payment in Europe poses certain options. You can be paid cash or checks can be mailed to other cities in Europe or to an address or bank in the U.S. Often magazines will ask how you would like to be paid. The best answer is: cash. However, be aware of counterfeit U.S. currency (discussed above). Being paid in cash is possible as long as you are in the country and can visit the editorial office to pick up the payment. Some magazines will pay on acceptance and others on publication. Being paid on acceptance is the most desirable way, as the money is guaranteed even if the work is not published. Opening up a bank

account is a fairly simple procedure in London but more difficult in Paris and Milan. Trying to open a bank account in Paris in a French bank is almost impossible unless one can produce a telephone or utility bill. Proving residency is the requirement. American banks operate in France and should be contacted to determine if an account can be opened in France.

Italy has a similar policy, although they also have a confusing grandfather clause. If one of your grandparents was born in Italy and it is provable, than a residency card may be obtained to allow certain rights, like getting a bank account. It's best to call the consulate and ask questions regarding this procedure.

To open an account in London simply go to the bank, show your passport, give an address in the U.S. or Europe, and deposit your money. When sales are made in England, give the magazine or gallery the account number and address of the bank and have the check sent there. Foreign checks sent to England might be charged a collection fee to convert the currency, unless the magazine paying you sends the money in the currency you request. If an Italian magazine pays for an article, ask for the money to be sent in English pounds to your English bank account. When in London, you can go to the bank and withdraw the funds.

Minimizing bank fees is an art. Before opening up an account ask specific questions regarding this. This means inquiring about incoming and outgoing wire transfers and the policy regarding the deposit of foreign checks.

Foreign Checks

Sometimes when foreign checks are received in the U.S. the bank has to send them out for collection. This can take up to six weeks to process and can result in two bank fees, the primary bank (yours) and the secondary bank, which your bank sends the checks to. This can result in twenty to thirty-five dollars in fees per transaction. It is an especially annoying process for small sales.

When filing income tax all this money has to be reported. However, the whole trip to Europe can be a business expense if you are self-employed and can prove it. If money is made on your trip, it supports your filing status as a self-employed artist.

Residencies in Europe

The Foundation Claude Monet has studio space for three visual artists in Giverny, France. For information contact Institute de France, Academie des Beaux-Arts, 27620 Giverny, France; 33-32-51-28-21; fax, 33-32-51-54-18.

Many organizations in the United States, such as the NEA, Arts International, the Rockefeller Foundation, the Lila Wallace-Reader's Digest Fund, and the Pew Charitable Trust offer either residencies, international exchange programs, or travel grants. The book *Money for International Exchange in the Arts* (Allworth Press/ACA Books) highlights these programs.

Individuals can apply for some of these grants directly, but a majority of them require a nonprofit organization to apply. The U.S. Information Agency (USIA) curates "Fine Arts Exhibitions" in foreign countries, usually through U.S. embassies and consulates. These exhibitions are organized by museums, nonprofit organizations, and sometimes by independent curators. To find out where federal money was used, contact the NEA International office and ask for a list of funded "Fine Arts Exhibitions" in foreign countries. Or use the FOIA to obtain the documents (see chapter 7). This might be useful for contacts in both the U.S. and Europe.

If an artist is invited to Europe, travel grants have to be applied for. The USIA has set up a Travel Grants Pilot Program for American multimedia, performing, and visual artists at international festivals and exhibitions. For more information: Arts International, Institute of International Education, 809 United Nations Plaza, New York, NY 10017; 1-212-984-5370. Deadlines are in January, May, and September.

～

CHAPTER 7

Corporate Support for the Arts

Government support for the arts is in a state of flux. The politics of the religious right and inflation are taking a toll on a decreasing tax-supported base. Artists still have the option to try for these grants as part of future strategies and we will discuss them in the next chapter. Whatever the future of government funding for the arts, you might also try to receive support from manufacturers, both those whose products directly relate to the art field and others.

Whenever you receive either a grant or corporate support it provides an impartial endorsement of the project or activity being funded.

This can be used as part of a future publicity campaign when the project is finished or the activity is presented. When corporate support is awarded, you will receive a letter announcing the award, written on corporate stationery. This letter should be included in the publicity package along with a press release and any other support material. It is a significant achievement for any artist to successfully approach a manufacturer and obtain materials or money. The newspapers and magazines need to know this information, either when support is first given or when the project is finished. A feature article or television newsclip could be coordinated to help support an exhibition, lecture, or other event.

I've been successful in approaching photographic companies in relation to writing this book. Since I was evaluating photographic film and paper, I sent the cover letter for my book contract and wrote a detailed letter asking for the donation of specific products to evaluate. Seventy-five percent of the companies I contacted responded favorably (the other 25 percent either offered discounted prices for their products or refused the request). In addition, I contacted many reference book companies and received a number of volumes in order to be able to do research for this project. I began a dialogue with the marketing departments requesting donations. After the book is published, I'll use the book's reviews to solicit support for my next project. The paper trail (documentation) is critical for realizing continued support. This becomes especially true if you produce and complete projects. The risk factor for the manufacturer decreases if they can see that other manufacturers have supported other successfully completed projects you have undertaken.

Corporate Sponsorship

The commercial world sponsors events all the time. Did you ever notice the logos on tennis players? They have corporate logos plastered on their shirts, socks, sneakers, and sweatbands. Anything that they wear becomes fair game. Some people consider them walking advertisements. When photographers take close-ups of the players, the logos stand out in the composition. This is the way corporate sponsorship has evolved. If a player reaches the finals, the amount of free coverage the sponsor receives via the game is worth millions, and that amount is what some of these players receive when they negotiate sponsorship contracts.

Artists too, can think along the lines of sponsorship contracts, but the

level of support is minuscule compared to sports figures. Artists have to be aware of the dance among governments, foundations, and corporations. These agencies realize the influence have on culture and are willing to offer support. Not all artists are willing to play the game, but you should know that the opportunity exits.

One of the off-shoots of capitalism is the notion of giving something back to the community and the individual. Photography, music, communications, electronic, and beverage companies, to name a few, are always supporting special projects in the arts. The list is as long as there are successful and profit-making companies. These companies might have a foundation attached to them, as do Kodak and Polaroid, for the support of nonprofit groups only.

Applying for Funding

Each company treats its sponsorship differently. If you want to try to receive support or sponsorship, call the company. They will transfer you to the corporate communications department, public relations agency, advertising department, or service representative for your area.

It is very clear from the beginning of a corporate relationship that most companies will want to see something written. They do not publish any guidelines or brochures (except for teachers) on this subject, and they evaluate each request on a project-by-project basis. Care should be taken in creating a well-written and thought-out project that asks for realistic support. The most difficult way to approach a company is to ask for only money. It can be done, but the money has to be for a very specific use. The more specific the request, the better your chance that the corporation will positively evaluate the project. For example, if you spent your own money paying for supplies and want to mount an exhibition but can't afford the space, then a company might give you the support money for that specific need. If you used two different companies' products, you might ask each of them for 50 percent of the money.

Companies realize the need for corporate giving, but what they want in return is high visibility and good press. If you ask for free film and photographic paper to document an art installation/exhibition, you must link the manufacturer's name to the project credentials. The artist and manufacturer should both receive publicity due to your marketing talent.

Favorite Funding

Corporations realize the moods and trends of the country and recognize when a social or humanitarian issue becomes topical. No company wants to be out-of-step or politically incorrect as there is a chance it will be boycotted, and profits are always the bottom line.

Some of these topics are the environment, homelessness, peace initiatives, or any issue concerning the betterment of people and society. Association with these issues puts your project and the company in a humanitarian light—a high priority for support. It is these projects which garner tons of publicity and therefore thousands of dollars in support. If consciousness can be raised via art projects, then people feel good about the supporting company's products. Ben and Jerry's ice cream donates portions of their profits to protect the tropical rain forests. This politically correct policy not only continues to sell their ice cream, but associates them with contemporary issues.

A "for-profit" organization can work hand in hand with nonprofit organizations on contemporary issues. I was recently asked to create work and help coordinate a project organized by a for-profit gallery, The Sea Cliff Gallery, located on Long Island, New York. Its owner, Don Mistretta, had an idea for a Christmas show called "Feed the Hungry." Over one hundred artists created either ceramic or wooden plates, on which they expressed their feelings about feeding the hungry. There was a twenty dollar fee to enter the show, eight dollars for the cost of the wooden plates; five dollars went to the Interfaith Nutrition Network (INN) on Long Island; and the remaining seven dollars went to the cost of mounting the exhibition—announcement cards, the opening, mailing, press releases, photos, phone calls, and the like. All the plates were for sale through a silent auction. Fifteen percent of the money received went to the INN. The artists could either keep their share of the sale or donate all or part of it to the INN. The price of the art plates ranged from seventy-five to two-hundred-and-fifty dollars, depending on how high people were willing to bid.

The exhibition came about because many of the Sea Cliff artists had volunteered at the INN. Don Mistretta heard such wonderful things about the nonprofit organization that he decided to help in a formal way through a gallery exhibition. He now hopes to start a national traveling exhibit to expand the charity proceeds.

Since this show is by a for-profit gallery working with a nonprofit agency (INN), both corporate and foundation support are possible. Students in public schools have been involved in making the plates as part of an arts/humanities project. Corporate sponsors usually will give money to support this type of project, since it helps the homeless, is art-related, and has a children's education component to it.

Because of its association with an important issue, the exhibit received publicity that it might not have otherwise received, benefitting the cause, The Sea Cliff Gallery, and the artists who participated. I was asked to help as a consultant and photographed all the plates for future articles. For the second annual show, a local monthly magazine, *Creations*, ran one of the plates on the cover, along with a feature article. A television production company volunteered their time and equipment to make an hour-long videotape that was edited into a ten-minute video press release. This appeared on various public access television stations throughout the Northeast. As a result of this exposure, Don Mistretta was interviewed for a thirty-minute feature about the plate show. A book project is envisioned along with other videos. Many project proposals are currently being organized and, once they are completed, both foundation and corporations will be solicited for support. One idea is to create a travelling core exhibition of forty plates. The plates that have been auctioned will be reproduced in multiple editions to tour the country. In each new location, local artists will create plates especially to be shown there. A certain percentage of the money obtained during the silent auction will be given directly to feed the hungry in that area. The high visibility the gallery exhibition receives through its touring will undoubtably interest foundations and corporations. (Artists and organizations can contact the Sea Cliff Gallery, 310 Sea Cliff Ave., Sea Cliff, NY 11579; 1-800-372-6386.)

The Foundation Center

Once you conceive a project and its goals, it is important to know where to look for support. The Foundation Centers around the country have reference listings of companies, corporations, and foundations that offer support. The main Foundation Center in New York City has a list of publications and member libraries throughout the United States. (For information, call 1-800-424-9836.)

Support for Education

Companies enjoy funding education because of the many students and teachers it reaches. The funding has a direct effect on a local community. If you are a roster artist on an A-I-E program (see chapter 9) this might be a way to help supplement the supply budget. The money saved might be added to your fee.

Some companies will give or loan equipment to teachers for education projects. For example, in the photography field, Polaroid's program is called the "Polaroid Education Program" and a brochure is available detailing what they offer (1-800-343-5000). Fuji has a program called "Photopals" for grades 3–6 (1-800-817-2000). Ilford offers a *Photo Instructor Newsletter* (call 1-201-265-6000 to be on their mailing list). Kodak sponsors a multitude of education programs such as "Cameras in the Classroom" (for more information call 1-800-242-2424, ext. 25). Agfa provides education support through a written project description and proposal (contact Dionn Tron, V.P Corporate Communications, Agfa, 100 Challenger Road, Ridgefield Park, NJ 07660. Call 1-201-440-0111, ext. 4714).

Binney and Smith (the maker of Crayola products, Luquidex fine art products, and other art supplies) has a corporate contributions program that includes cash and product donations to nonprofit organizations with a focus on the arts, education, civic affairs, and health and welfare needs. They have placed geographic restrictions on their level of corporate support. Their program goals are to support organizations where Binney and Smith manufacturing facilities are located: Easton, Pennsylvania, a part of the Lehigh Valley; Winfield, Kansas, in the south/central region of the state; and Lindsay, Ontario, Canada. (If you think you qualify, write: Binney and Smith Inc., 1100 Church Lane, P.O. Box 431, Easton, PA 18044-0431.)

Not all corporate support for education projects goes to schools. If an artist has a bona fide education project, it is possible for her to receive support for it on her own. For example, one could create a project to help recognize gender stereotypes, which could include an article, book, or exhibit.

Creating a Portfolio

The other way to request support is to ask for a specific product or group of products in order to create a portfolio or series of work. This could take the form of sculpture, oil painting, photography, or mixed media.

Sculptor Ted Ormai of Kutztown, Pennsylvania, has received materials from Dry-Vit, a company which makes a concrete-like building material used in construction. Ormai creates unique light sculptures out of this material since it is lightweight and durable. Dry-Vit has donated the materials to him through the nonprofit agency, such as a school, or granting organization sponsoring his project. Any materials left over, he uses for future projects.

I have received support from Polaroid, Kodak, and Casio over the years for photographic and art projects, both for publication and exhibition.

Polaroid has a public relations department which is part of the Polaroid Collection. Photographers and artists who use Polaroids in their work (mixed media, collage, montage) can send them a portfolio of images— Polaroid preferred. (For collage artwork, call to ask about procedures.) If they select your work, you receive $200 in Polaroid products (this usually means film), and the photographs are placed in their photography collection. Sometimes Polaroid will sponsor exhibits or place portfolios in magazines or print an exhibition catalog from the work that is in their collection.

In 1980, I was one of forty-two people around the world who received product and equipment support from Polaroid. Over the years they have given me about $4000 worth of film, which includes eight-by-ten-inch and four-by-five-inch Polaroid film. Calumet (a large format camera company) lent me an eight-by-ten-inch camera, on the condition that Polaroid take out an insurance policy for the value of the equipment.

In 1992 I received product support from Kodak. They have service representatives who will visit photographers in their region. Be prepared for the interview by having on hand your work, any samples of the project, and anything that can benefit your project idea. These reps will not fund anything on the spot, although they might give you some film. Artists will have to send the rep a written proposal. Kodak reps have their own regional budgets and a wide latitude in coordinating support for their areas, but for a major project the proposal has to be channeled through the Kodak headquarters in Rochester, New York.

The proposal for my particular project stressed the use of slide film, photographic paper, and professional copy film. I received about $700 worth of these products. Companies are often more interested in supporting work that uses their materials in an innovative or high-profile manner. The title of my project was "Photographic Windows." It involved taking a number of high-contrast color shadow photographs and changing the compositional elements in those prints. I then cut up the eight-by-ten inch negatives (similar to a jig-saw puzzle) and contact printed them in the same composition as the original color shadow photographs. Since I was using many different negatives, each with its own particular density, I had to do weeks of testing to have all the negative densities be the same value in order to avoid significant hand work (dodging and burning of the negatives). It took fifteen minutes to set up all the negatives, and each print is a one-of-a-kind work. I produced a series of twenty (forty prints total), each consisting of one study (the original color shadow image) and the contact printed negatives.

If you have received support for a project, see if the company will publish the work in one of their company projects. Examples are the yearly desk calendar, cover of the catalog, annual report, or company magazine.

Polaroid publishes *Test Magazine*, Nikon has *Nikon World*, Minolta has *Mirror*, and, of course, these companies use images for ads. These in-house magazines are popular with many companies since they showcase artist/ photographers plus push products in a creative way.

If you have an idea, many of these companies have toll-free numbers and will be happy to discuss your project. Success depends on your imagination and your willingness to follow through on your projects. Serious efforts in publicity and marketing will help convince companies of your commitment to long term planning and goals. Once you achieve a successful track record, it will be easier to obtain corporate support.

᠁

CHAPTER 8

Grants for Individuals and Special Projects

Although there is no written rule, receiving a public or private grant can lead to better publicity and can be a significant marketing tool. Since nearly all grants are awarded by panels (usually established peer artists, critics, or scholars in the field), to be selected for a grant is a significant achievement. Because of the competitive nature of the award and the fact that money is given away, the grant may add an impetus for the media to devise a piece about you or the project. It is also easier for the media to report on a funded project since it usually includes an exhibition, performance, lecture, or workshop held in a public place or sponsored by a public institution.

The public nature of grant projects allows for new publishing opportunities. Locally, it might convince publications to do a feature about you and your work or (since you might have already had a feature written about you) allow the project to be covered as a news item. Since they are located throughout the United States, a National Association of Artist Organizations (NAAO) grant can open up the possibility for the press to feature you outside of your local area. If you have been bombarding the local media with press releases and have received some coverage, it is often easier to get publicity out of town, where you are virgin material to the media.

Grants are important to developing a reputation both within the art world and with the media. Since grant evaluation is conducted in a rigorous fashion and is—in theory—free of politics, a grant puts an objective and educated stamp of approval on your work. It helps the artist achieve name recognition, as the grant-givers usually send out press releases announcing awards. The more grants you are awarded, the more publicity you will receive. It is an inevitable progression.

History

Patrons of the arts have existed for centuries. The Medici family in Florence, Italy is probably the model most associated with grant giving. In the United States, the Guggenheim, Mellon, Rockefeller, Pew, and MacArthur foundations are all descendants of the tradition begun by the Medicis. Government support first started on a large basis with the WPA (Works Projects Administration) in the mid 1930s; and since 1965, the federal government has given monetary support to creative individuals. State governments followed the federal example soon after.

There is a distinction between private and public funding for the arts. Private foundations can place restrictions on who can apply for funds (such as only painters or sculptors under thirty years of age), while public funding cannot have such restrictions. But the net result is the same: both give away money. It is important to look for grants that offer non-repayable financial assistance. In other words, money with no strings attached.

Both public and private grant-givers request written and artistic support material with their applications. The grant usually lasts for one year, and if granted money, the artist must wait a certain amount of time before applying again.

Private Foundations

The amount of private support increased over 6 percent in the early nineties, a reversal of the trend in public or government support. The categories of foundation support can be broken down as follows: national, special interests, corporate, family, and community. All private foundations are required by law to print annual reports. The foundations must conform to IRS regulations and are required to complete Form 990-PF. The form is then made available to interested individuals. What is of interest to artists is the complete list of every grant made during the year that can be found on the 990-PF or in the annual report. Smaller foundations use the public notices section of a newspaper as a substitute for publishing an annual report (the public notices then have to be included as part of the 990-PF). You can view the 990-PF at some of the Foundation Centers or through the foundation itself. Identifying who received grants from particular institutions will enable you to spot trends in grant-giving and help you make intelligent decisions about where to apply for support.

The following excerpt from the introduction to the *Annual Register of Grant Support*, 27th edition 1994, published by R. R. Bowker includes excellent advice for artists seeking private funding.

Probably no area of philanthropy is so misunderstood and misused as that of private foundations. According to recent studies, as many as 80 percent of all applications to private foundations are inappropriate or misdirected. While at least part of the blame for this error must be attributed to private foundations themselves, grant seekers often compound the error by tending to lump all private foundations together as if they shared a common purpose.

Not only do private foundations differ greatly from public funding sources, there is a wide diversity among private foundations themselves. What may be an appropriate application to the Ford Foundation, may be totally inappropriate to the San Francisco Foundation.

There are more than 24,000 grantmaking foundations in the United States. The reason that an approximate figure must be used is that the federal government defines private foundations more by exclusion than by anything else. If an organization cannot qualify as a charitable, religious, educational, scientific, or governmental organization, it may be classified as private foundation even if it has never made a grant nor intends to make one. Potential grant seekers should be aware that the mere use of the word

"foundation" in the title of an organization is not evidence that the organization will make grants.

In the category of individual artist fellowships or grants, (and this includes public and private monies,) approximately 5 to 6 percent of the people that apply receive funding. But one can interpret these figures in different ways. If as many as 80 percent of all applicants are dismissed due to inappropriateness or misdirectedness then it is really only 20 percent in competition. To be on equal footing with professional artists (or for that matter, professional grant proposal writers) you must be in the 20 percent of businesslike applications. It is therefore imperative that you know what you are applying for. Before you fill out any applications, call, fax, or write the foundation to have any questions clarified. Do not make yourself ineligible due to carelessness or ignorance; you will be wasting the foundation's and your own time and money.

Artists may be ineligible for a particular grant because of geographic restrictions, too much taxable income, applying in the wrong category (i.e. "travel" instead of "money"), using the wrong form, inappropriate or incomplete project description, enclosing wrong support materials, not typing the application, sending in glass slides, or missing a deadline for the application.

Before applying for a grant, read: "Program Planning and Proposal Writing," published by the Grantsmanship Center. The Grantsmanship Center is the country's oldest and largest fundraising training institution and has trained more than 50 thousand staff members of public and private nonprofit agencies in all aspects of fund development. For further information about the center or to receive a free copy of the center's *Whole Nonprofit Catalog,* contact: The Grantsmanship Center, 1125 West Sixth Street, Fifth Floor, P.O. Box 17220, Los Angeles, CA 90017; 1-213-482-9860 or 1-800-842-8484.

The Application

The following information is appropriate for both individuals and nonprofit organizations, applying for private or public funding. Begin by doing research at one of the Foundation Centers. Ask reference librarians lots of questions, but do not ask them to review your proposal; that is not their job.

A proposal can run anywhere from one hundred to one thousand words. Be to the point, specific, and direct. Do not use flowery language or indulge in wordiness. Write the applications as if the reader knows nothing about art. Do not assume anything. Start with you own personal history, what you are currently doing, and what you plan to do in the future. Clearly defined needs should be backed up with proof: tax returns, reviews, letters of recommendation, and the like. If planning to work within a time frame, provide realistic goals that can be accomplished during this span. (This is sometimes based on previous achievements.) Credibility is everything. Who you are, who you know, and where you have exhibited or received prior support become the keys to receiving grants.

Remember, no concept, idea, or aesthetic is dominant in determining who is funded. Pluralism reigns. Therefore, all types of art are equal. However, art that defines trends; is politically correct; or deals with popular topics that are kaleidoscopic in nature, which include themes of multiculturalism and/or interdisciplinary arts (i.e.; computer art and dance) might have an advantage in funding, since the panelists are human and are a product of their culture.

The reputation of the emerging or mature artist is another concern. Grant-giving organizations want to be part of the infrastructure that contributes to an artists' fame. If a foundation can imply it was their grant that put emerging artist X on the map, then the foundation will be viewed as visionary. Grant hierarchy is important to those applying for grants. Begin with local foundations. Then apply to regional, national, and, finally, international donors. Do not expect a Guggenheim grant to be your first grant. A majority of people are rejected because they apply for national or international grants too early.

Some grants are almost impossible to receive without the backing of a former grant winner. The alternative to that kind of support is to obtain a letter of recommendation from a museum curator. If this is not possible then letterhead counts, especially from famous artists, art critics, or private gallery owners. (For further information see chapter 10.)

If you do no know important art people, start to cultivate relationships with them. The sooner you do, the sooner your long term prospects will improve. Where do you meet important art people? Openings are one place. You can get into the press openings (remember how to start your own press agency; see chapter 4) since you will be receiving their mailings and getting an admission. But you should realize it is hard to do business

at openings. Try talking to critics and curators to feel them out about their attitudes towards new work and unknown artists. Another way to cultivate relationships is to become a member or supporter of a museum. Attend lectures, workshops, and take classes. Without actual contact with these people, it is very unlikely that you will be able to receive a recommendation.

According to the 1995 NEA individual artist guidelines, the applicant's work should reflect "a serious continued investigation of important or significant aesthetic concerns and a potential for further artistic development during the proposed fellowship period." This applies to other grants as well. The work must be photographed superbly and should be in the form of a series documenting your aesthetic "investigation." Having a resume with regional or national exhibits, reviews, articles, or television appearances can only help you pass this rigorous competition and receive an award.

Grant panelists want to see career development as demonstrated by your resume (reputation) and support materials. A coherent and sustained aesthetic is of utmost importance. The written statement is something created over time and can be redefined, changed and updated, but if it is done without a rigorous examination, it will not be considered professional work and will not be considered for funding. It is difficult for artists to be told to go back and figure out the philosophy of their work when they are denied grant funding.

At these times they would do well to consider the major figures in art history, as most of them belonged to a school of thought, an "ism." That "ism" is the aesthetic concern that public and/or private foundations are looking at closely.

Most major figures in art history are not isolated artists. They hung out, exhibited, and collaborated with one another. Think of Cubism, and Braque, Gris, Leger, and Picasso come to mind; Surrealism, and Dali, Ernst, Magritte, and Miró come to mind; Abstract Expressionism, and de Kooning, Gottlieb, Motherwell, and Pollock come to mind. *Be prepared for a reality check when applying for these fellowships!*

Fellowships and Awards for Individual Artists

Awards granted in this category are based solely on work that has already been created which either represents a beginner's approach or a life's work.

Consequently, it is the most competitive type of grant. Awards are completely dependent on the artistic merit of submitted support materials and only a limited amount of writing. The support materials are usually eight to twelve slides.

The National Endowment for the Arts

At the time of this writing the 1996 budget for the National Endowment for the Arts (NEA) has been reduced by 40 percent to $99.5 million, and the NEA staff has been cut by about 50 percent. These reductions directly affect organizations that support individual artists. Artists will also be seriously affected by the complete elimination of the Individual Artists Fellowships in the Visual Arts, Design Arts, Theater (Solo), and Dance categories, along with substantial changes in other categories as well. Clearly the full effects of these cuts and the scope of the restructuring will not be felt until the new program guidelines are published in early 1996.

In addition, the 1996 NEA legislation has stipulated funding for one year. Therefore the 1997 NEA budget is not automatic, but will be reviewed again, leaving the future of the organization in doubt. If a Republican president and congress is elected in 1996, it is likely that the NEA will be eliminated by fiscal year 1998. As of now, only nonprofit organizations are eligible to apply in the Visual Arts category. Contact the NEA Nancy Hanks Center, 1100 Pennsylvania Ave, N.W. Washington, D.C. 20506 (1995 Visual Arts Program number: 1-202-682-5448).

State Funding

Most of the fifty states offer fellowships and will continue to do so; however, deadlines and criteria vary from state to state. Fellowship amounts vary and the competition is statewide rather than national or regional, making it less rigorous. The state capitals are home to the local arts councils, and you need to write, call, or fax them to be placed on a mailing list for application guidelines. Additionally, these arts councils sometimes offer an arts newsletter which lists different grants available and the deadlines. When writing to them, ask for the guide to programs and the individual artist fellowship. The full scope of what your state arts council has to offer will then become apparent.

Some state applications have two written sections of about one-hundred

words in length: one deals with how your work will be advanced by this fellowship; the second is a statement about the work (your art rap) documented by the support materials. There are no project descriptions to fill out. A panel of one's peers (artists who have previously received grants, museums curators, and critics) select the individuals for awards.

Regional and Local Funding

The next funding category is limited to regional or local governments or nonprofit organizations that offer grants. Sometimes these are limited to the county in which one resides. The NAAO publishes a list of many of these groups. Another book, which I'd recommend buying is called *Money for Visual Artists*, (1993, American Council for the Arts/Allworth Press). It is a comprehensive resource guide which includes information on grants, fellowships, emergency assistance programs, technical assistance, and support services. It is indispensable; without it you can't operate as a professional.

In addition, the NEA has developed a program of regional awards which covers the fifty states, Washington D.C., and the Virgin Islands. Due to the situation and turmoil at the NEA as this book goes to press (May 1996), it is entirely possible that the regional arts fellowships will be eliminated or reduced (since they will have less money to spend). At present however, visual artists residing in those locations and who have not received an NEA fellowship for ten years are eligible to apply for one of six regional fellowships in fellowship areas. Call these organizations to find out the current status. The six regional arts organizations are:

Arts Midwest *(IL, IN, IA, MI, MN, ND, OH, SD, WI)*
Hennepin Center for the Arts, 528 Hennepin Ave., Suite 310, Minneapolis, MN 55403; (612) 341-0755

Mid-America Arts Alliance *(AR, KS, MO, NE, OK, TX)*
912 Baltimore Avenue, #700, Kansas City, MO 64105; (816) 421-1388

Mid-Atlantic Foundation *(DE, DC, MD, NJ, NY, PA, VA, VI, WV)*
11 East Chase Street, Suite 2a, Baltimore, MD 21202; (410) 539-6659

New England Foundation for the Arts *(CT, ME, MA, NH, RI, VT)*

678 Massachusetts Avenue, Suite 800, Cambridge, MA 02139; (617) 492-2914

Southern Arts Federation *(AL, FL, GA, KY, LA, MS, NC, SC, TN)*
1293 Peachtree Street. N.E., Suite 500, Atlanta, GA 30309; (404) 874-7244

Western States Arts Federation *(AK, AZ, CA, CO, HI, ID, MT, NV, NM, OR, UT, WA, WY)*
236 Montezuma Avenue, Santa Fe, NM 87501; (505) 988-1166

The Visual Arts Program of the NEA, which gave grants to states, nonprofit organizations, and individuals, will be restructured. The old guidelines and categories are history. Organizations will still be able to apply for granting functions, but there will be a cap on the number of applications from any one single organization. Organizations will only be able to submit one application from the following four areas: (1) Heritage and Presentation; (2) Creation and Preservation; (3) Education and Access; (4) Planning and Stabilization. Unknown artists who create new or experimental artwork (art without a historical precedent) might suffer the most. In order to qualify for a solo exhibition, granted work has to have a regional or national significance, and new or emerging artists are not yet at this stage in their career's to warrant this type of award. Artists who approach these organizations should realize that a group show is a more realistic goal.

Museums (1995 Guidelines)

Museums, state art agencies, regional art, and nonprofit organizations that perform museum-like functions are also eligible for NEA funding. One example of this type of grant would be to an organization sponsoring an exhibition where there are artists' fees for travel, installation expenses, shipping, insurance, catalogs, documentation, education programs, lectures, workshops, and performing arts activities relating to the exhibition. This could also apply to expenses connected to touring an exhibition, either by a museum or (NAAO) organization. A grant like this would be under the sponsoring organization. This is how artistic reputations are made. A major color catalog and a touring exhibition are likely, which will generate major publicity and possible sales (coordinate a

commercial show in conjunction with the museums to drive up sales).

Museums and nonprofit organizations decide exhibition schedules years ahead of time. The uncertainty of NEA funding will definitely affect how contemporary artists are selected for major exhibitions in the coming years.

Artists can also make the most of a museum affiliation by donating work to the museum's permanent collection. The purpose of this is simply to exhibit the work in permanent or long-term displays and/or mount temporary exhibitions. To take it a step further, you might think about recontextualizing pieces for the museum's collection. You will need to assume the role of curator. In this way, when the context is of your own devising, your work can be prominently featured in both the show, and the main asset, the catalogue. Take the hypothetical example of the Mercer Museum in Doylestown, Pennsylvania, a renowned museum with a historic tile collection. By creating and curating a show of "Infant Tile," an emerging ceramic artist might engage the museum to accept a donation of her work for inclusion in this new show. It is unlikely that a museum would accept a donation of an emerging artist's work to present a solo show. Beware of donating work that will not be exhibited but instead will be assimilated into the museum's vaults or even deaquisitioned (discarded, sold, or traded). Do not donate artwork just for the sake of including it on a resume, it becomes a losing proposition.

Grants through States via Nonprofit Organizations

Although each state has its own guidelines and categories, most have a visual arts program. I will use the Pennsylvania Visual Arts Program as an example. It is similar, in its essentials, to other states' programs.

The Pennsylvania Visual Arts Program's purpose and background is to assist contemporary artists of exceptional talent and encourage activities that further their professional growth. The program supports serious work and service programs that foster a professional attitude toward the aesthetics of contemporary art.

The funding categories are: Individual Artists Grants and Specific Support Grants (this includes exhibitions). An individual artist can apply for his own grant or for a grant through a conduit nonprofit organization, and therefore have the organizations approval for the project. Some of the conduit organizations are libraries, schools, alternative spaces, and museums. It is often the artist that initiates and proposes the project or

exhibition. With prior approval, the artist can complete a majority of the grant application, but the organization's executive director must sign the application. The organization administers the funds and sometimes takes a percentage (up to 7 percent) for this service.

Other funding categories that relate directly to visual artists are: Services to the Field (this consists of publications that address professional issues for artists), Professional Facilities (support is provided for spaces providing access to equipment and opportunities for artists to pursue creative work), and Seminars/Lecturers (these deal with aesthetic or professional issues of importance to artists).

Another category offers planning grants for the commission of permanent Works of Art in Public Places. Expenses for consultants, artists' preliminary designs, and architect's fees are some of the items funded. Installation costs are not funded and site-specific, non-permanent work would have to be funded through the Specific Support grant.

The last category funded is Community Projects. Support is provided to projects that are oriented towards instructing the general public in a basic application and understanding of an art form through demonstration and participation.

The Pennsylvania Council recently adopted new eligibility require-ments. Applicants may submit only one Fellowship application and one Conduit application per year, and they may receive only one grant per year (either one or the other). In addition, they have instituted a collaboration with the Mid-Atlantic Foundation, offering Individual Artists grants every two years. Applicants who receive a Conduit grant (the amount is much less than a Fellowship grant) may not apply for a Fellowship grant in the same year. If an organization contacts the artist for a Project grant (this means that the artist did not initiate it), then it is possible to receive the Fellowship award and also be part of that organization's grant. There is a significant distinction between the two awards. Also, the Pennsylvania Council has written that those who receive a Fellowship grant in a given year will not be eligible to apply for two consecutive years. However, the artist can still apply every year for a Conduit grant even if awarded the Fellowship grant the previous year. It does create a perplexing artistic Catch-22, as the art councils and NEA synthesize the best tactic for promoting democracy (dispersing the reduced monies to the most people) while still fostering professionalism.

Recycling Applications

When you apply for a grant and are either accepted or rejected, the application can be recycled. It is not necessary for every project description to be original for every application. If you applied for a special project on a state level and it was approved, then you know the grant proposal is strong. It might be modified, but it could be used again if another organization accepts the proposal. The best venture is to do the project in another state through a NAAO group. There is no clearinghouse network for those who receive grants as the state governments do not print up annual reports. In effect it would be a touring exhibition that is not officially being toured.

If your grant application was rejected, it is important to find out why, as this information could be modified and resubmitted at a later date. If a proposal is rejected on the federal level, the same grant might be approved on a regional, state, or local level. Remember to make photocopies of all applications for your files.

In 1987 Terry Niedzialek and I received a $3,000 Special Projects Grant from the Pennsylvania Council on the Arts, to have an exhibition at Open Space Gallery in Allentown, Pennsylvania. In that year, only twelve applicants applied through the nonprofit organizations, eight of whom were funded. It is highly unusual for an agency to fund 75 percent of the applicants, but these inconsistencies do exist. In this case the amount of money to be distributed was a fixed amount. Therefore, only eight grants were to be awarded no matter how many or how few people applied.

A Note about Panelists

The NEA will only review slides for nonprofit organizations and museums and this process is currently under review due to staff reductions. When an artist's slides are viewed by a state panel like the Pennsylvania Council on the Arts or the six regional organizations, the slides are viewed simultaneously. The Pennsylvania Council views four slides simultaneously, three times for ten seconds for their first round. It is very important to present your strongest work, since eight to ten seconds for four to five slides is not enough time to fully comprehend the work. The panelists do not talk; they view and take notes during this time. At this point 50 percent of the applicants are eliminated. They look at every slide, however briefly.

The second round lasts twenty seconds for each group of slides, and the panelists both discuss the works and take notes. Maybe 60 percent of this group will be eliminated.

The third round can last up to one minute for each group of slides, and the panelists can ask information regarding size, medium, or technique, and the discussions about the art becomes more directed. Again, around 60 percent of these remaining artists will be eliminated.

The final round is the fourth. The applications are finally seen by the panel along with the resumes. More discussions take place, and the final numbers are narrowed down to those grants to be awarded.

This process lasts two to three days for the Pennsylvania Council on the Arts. The panelists for the Pennsylvania Council can fund emerging artists only, if they so choose. Every year the panel is different and its make-up is based on many factors. They try to achieve an even balance of men, women, and minorities based on all regions of the country or state. The NEA has a lay person on their organizational panels, but the states do not follow this procedure. The number of people on the Pennsylvania panel for Individual Artists Grants varies between three and five and usually consists of professional artists.

If an artist wishes to be considered as a panelist, the NEA has a data base called the Automated Panel Bank System. This computer program searches for panelists and has about four thousand names on it. Call or write the NEA Office of Panel Operations, Nancy Hanks Center, 1100 Pennsylvania Ave, N.W. Washington, D.C. 20506; 1-202-682-5533 for this form.

To be considered for the Pennsylvania panel, artists need to contact Brian Rogers at: Commonwealth of Pennsylvania, Council on the Arts, Room 216 Finance Building, Harrisburg, PA 17120; 1-717-787-6883. He looks for practicing artists from out-of-state, but sometimes he uses in-state artists and nonprofit administrators. The panelists are paid $150 a day plus travel. The council prefers to use regional people to save on these travel expenses.

The process for becoming a panelist differs from state to state. You can write the state art council's grant panel officer for guidelines and applications. If you prove to be a good panelist, it is often easier to serve in another, because the names of good panelists are networked from one state to another.

The Scotch Tape Test

It is an act of blind faith when artists submit supporting materials with a grant proposal. You assume the panelists will actually view the work, however, a "scotch tape test" is a way to determine whether or not the slides were viewed. Just fold the slide sheet, and put a piece of tape over it. The seal must be broken to take the slides out of the sheet. If the work is returned still sealed, then you know it was not even opened. The same procedure should be followed for video or audio tapes.

During the early eighties, I applied for a video grant through a public television station in New York City. I did this test and received the materials back still sealed. I called up the person in charge of the grants and explained the situation. I was told I was sneaky to do that test. I was not considered for that grant, since by the time the videotape was mailed back to me the decisions were made. I'm not saying that organizations do not view the slides or other support materials, but a check system is necessary, just to keep them honest.

The Freedom of Information Act

The primary purpose of the Freedom of Information Act (FOIA) is to make documents available to the public. For example, any successful NEA application for an individual artist fellowship or for an organization would be available under the statute to anyone requesting the opportunity to review it.

When appropriate, a fee may be charged for processing a FOIA, request depending on the status of the requestor and the use of the requested information. The first two hours of search time as well as the first 100 pages are free.

To find out which individuals and organizations received grants, refer to the NEA Annual report for any year since 1965. In the report, all grants awarded by the agency in that fiscal year are listed along with the category, project description, and the amount of the award (only for organizations). Future editions are free. They are available every spring or summer and may be requested through the Arts Endowment Public Information officer.

A successful individual artist grant application from the previous year is a valuable tool to understanding what written criteria helped the proposal to get funded. It can offer critical insights into how to write your

application for regional, state, or private foundation grants.

In addition, the information gathered from Visual Artists Organizations establishes monetary guidelines for residencies, workshops, demonstrations, or honorarium fees. The range is from $25 to $1,000. These figures represent group shows (lower fees) and solo shows (higher fees), and are based on the reputation of the individual artist and organization, location (major versus minor city), and other factors. Information based on NEA applications obtained through the FOIA can be used as justification when negotiating fees.

To obtain a copy of "A Citizen's Guide on Using the Freedom of Information Act and the Privacy Act of 1974 to Request Government Records," send a check for $2.25 to: The Superintendent of Documents, U.S. Government Printing Office, Washington, D.C. 20402. Stock number: 05207100929-9.

The seventy-page guide offers sample request and appeal letters and detailed information about the act. Currently the NEA FOIA Officer is Melody Wayland (NEA The Nancy Hanks Center, 1100 Pennsylvania, N.W., Washington, D.C. 20506; 1-202-682-5418).

The publication *AfterImage* (31 Prince St., Rochester, NY 14607; 1-716-442-8676) publishes a list of who received NEA money in the Visual/Media arts. They also write brief descriptions of these funded organizations. It is important to know these organizations in order to apply for future exhibitions and grants.

Finding an Assistant

If awarded a grant or fellowship and the timing of the award is inconvenient due to prior commitments, you might need to hire an assistant or apprentice. Today, assistants do a variety of jobs ranging from secretarial work (mailings and phone work) to nuts and bolts activities (commissioned editions or special projects). How do artists find an assistant? One way is to run an ad in a newspaper, magazines, or artists' newsletters. Try contacting a high school or community college art department and inquiring about a student interested in working with a professional artist. Sometimes educational credits are given to the students in lieu of payment.

The qualifications needed for an assistant are some experience, a personality you are comfortable with, and the willingness to work odd hours. Successful artists sometimes have numerous people working for

them. Networking and meeting successful artists to discuss business practices might be a worthwhile learning experience for an emerging artist.

The *National Directory of Arts Internships* is published every two years by the National Network for Artist Placement, 935 W. Ave. 37, Los Angeles, CA 90065; 1-213-222-4035. The cost is $35. It lists organizations which host internships in dance, theater, photography, and some of the other arts. It also includes visual artists looking for assistants.

The following periodicals can be helpful resources for finding assistants.

Afterimage. Visual Studies Workshop, 31 Prince Street, Rochester, NY 14607; (716) 442-8676. $30 to individuals. Published monthly.

Art Calendar. Box 199, Upper Fairmount, MD 21867; (410) 651-9150. $45. Published eleven times a year.

Art Papers. Atlanta Art Papers, Inc. Box 77348, Atlanta, GA 30357; (404) 588-1837. $25. Published six times a year.

The Crafts Report. The Crafts Report Publishing Company, 700 Orange Street, Wilmington, DE 19801; (302) 656-2209. $24. Published eleven times a year.

F.Y.I. New York Foundation for the Arts, 155 Avenue of the Americas, New York, NY 10013. $15 contribution. Published quarterly.

National Arts Placement – Affirmative Action Arts Newsletter. National Art Education Association, 1916 Association Drive, Reston, VA 22091-1590; (703) 860-8000. Requires membership. Published nine times per year.

New Art Examiner. Chicago New Art Association, 314 W. Institute Place, Chicago, IL 60610; (312) 649-9900. $35. Published ten times a year.

Sculpture. International Sculpture Center, 1050 17th Street, N.W., Washington, D.C. 20036. $40. Published six times a year.

Emergency Assistance for Artists

If a serious illness (either physical or mental) or a catastrophe occurs in your life, which causes you to need financial assistance and your need can be proven, with doctors statements, hospital bills, and other documentation, a number of foundations can offer help. They are:

Artists Fellowships, c/o Salmagundi Club, 47 Fifth Avenue, New York, NY 10003. They assist painters, sculptors, and graphic artists. The amount of assistance is not specific.

Adolph and Esther Gottlieb Foundation, 380 West Broadway, New York, NY 10012; (212) 226-0581; fax, (212) 226-0584. They assist painters, sculptors, and printmakers who have been working artists for at least ten years. The grant range is up to $10,000.

Pollock-Krasner Foundation, 725 Park Avenue, New York, NY 10021; (212) 517-5400; fax, (212) 288-2836. They assist painters, sculptors, and artists who work on paper and who demonstrate merit and financial need (which can include illness). Grant range is $1,000 to $30,000.

The Craft Emergency Relief Fund, 245 Main Street, Northampton, MA 01060; (413) 586-5898. They only fund craftspersons in distress categories that include illness, fire, theft, natural disasters, and others. Grant range is $300 to $1,000.

Change Inc., P.O. Box 705, Cooper Station, New York, NY 10276; (212) 473-3742. Provides emergency aid for evictions, unpaid utility bills, fire damage, and other problems. Applications can be processed very quickly (if necessary, within a few days). For all art disciplines. The range of relief is up to $1,000.

I'd recommend contacting these emergency grant organizations and having an application on file in case the need for help arises suddenly.

CHAPTER 9

Artists-in-Education

In order to be considered for an artist-in-education (A-I-E) grant, and then, for an artist-in-residency (A-I-R), you must be on a state's artist roster. This places you on specialized mailing lists and allows you to make money from your art skills in an educational environment.

The publicity which you have accumulated should make it easier to get your name placed on these rosters. Reputations do count, as peer artists evaluate these applications. Publicity about the A-I-R is an essential part of the grant, since you will be conducting the residency in a public forum: school, hospital, prison, senior citizen center, or other nonprofit organization.

Before we delve into the particulars of getting on a roster, a brief history lesson is necessary.

History

The NEA started in 1965 as part of the Johnson administration's Great Society Programs. The arts-in-education programs came out of the NEA's pilot programs in the new education effort in 1969. North Carolina has been a leader in arts grants, and they had the first arts-in-education pilot program. 1974 was the first year New York State had an A-I-E program. Now all fifty states and the six territories including D.C. have these programs incorporated into their arts councils.

The A-I-E programs provide working opportunities for artists in a variety of educational activities. These include K-to-twelve educational institutions, hospitals, prisons, libraries, senior citizen centers, and any other nonprofit organization that wishes to sponsor an artist.

Publicity and A-I-E

Two art-education publications, which are primarily for art teachers, are a good place for marketing and publicity if you are interested in A-I-E programs. If you can write an article with supporting photographs about your artwork for *School Arts* (Eldon Katter, Editor, 464 Walnut St, Kutztown, PA 19530; 1-610-683-8229) or *Arts and Activities* (Maryellen Bridge, Editor, 591 Camino de la Reina, Suite 200, San Diego, CA 92108; 1-619-297-8032; fax: 1-619-297-5353), then you have entered the privileged world of art education publishing. These are the publish-or-perish journals for art educators looking for tenure status. These journals are actively looking for new art techniques or art that be can easily explained and created in the classroom. They are not a high-paying market (*School Arts* pays contributors between $30 and $120 an article), but in the long term they reach the art teacher audience. The art teachers' approval is essential because the art teacher has to work directly with the artist. Having an article from these journals in your portfolio should improve your chances of becoming an A-I-E roster artist and being approved for a residency at an institution.

All the different art disciplines have similar magazines, either consumer or trade. Some other magazines are: *Theater Crafts, Dance Chronicle,* and

Dance Page. Check out other educational trade publications in *Ulrich's Guide* and then write for the guidelines.

What You Need to Know about A-I-E Applications

A-I-E grants and programs require a two-step process before the artist is eligible for work. For each state, an individual A-I-E grant application must be filled out with the necessary supporting materials: slides, video and audiotapes, letters of recommendation, and reviews or articles. If you are approved, you are placed on that state's A-I-E roster. Usually a booklet is published with a page about you and your work (see the example at the end of the chapter). Then schools or other nonprofit organizations interested in having you do a residency must write you into their grant application. This has to be approved by a different grant panel before you are eligible for work. The pay scale is usually from $100 to $250 a day, plus—on occasion—lodging and food expenses.

Every state wants practicing professional artists. The following guidelines taken from the Pennsylvania Guide to the Arts-in-Education program are typical.

> Professional artists requesting consideration for residencies in schools and communities or special programs in schools should have a willingness to share their work with young people and adults in a community setting, and be able to relocate if necessary. Priority will be given to Pennsylvania artists. In addition, recipients of Pennsylvania Council Arts Fellowships (Individual Artist Grants) are eligible for roster approval. Also, roster artists (meaning approved through this grant process) must be used in all residencies, unless it is demonstrated in the project application that the roster does not include an artist appropriate for the project described and that the proposed artist is well-qualified for the project. Any such non-roster artist must submit a resume and work samples with the host organizations's application for funding.

Professionalism

There is an intangible quality to the definition of the term professional. The art councils want to review all work on equal footing. By correctly following the requirements of the standardized applications, an artist

indicates a level of professionalism. The applications require the artist to submit slides, video, or other support materials. The application process is formal and based solely on the work and supporting materials submitted. It is a competitive process and professionalism is proved by credentials in education, training, and experience (including references and recommendations) as well as by the work itself. The ability to communicate demonstrates your interest and ability in working with young students and adults. In addition, you have to develop and complete a sequential plan for a residency.

Style or discipline of artwork is not an indicator of professionalism. Pluralism in art has been established for over twenty-five years and no current school of thought is dictating any particular trend. The roster artists reflect this pluralism, and their styles range from portrait and landscape painters to video and performance artists. The host sites that hire artists want to choose from the full spectrum of artistic styles. They want the option to decide what is the best for their students.

Eric and Mary Ross are artists on the New York State roster. Eric Ross is an American composer and performer who has performed at the Newport Jazz Festival, the Amsterdam New Music Festival, Pori (Finland) Jazz Festival, and many other venues worldwide. A multi-instrumentalist, he performs on synthesizer, guitar, and piano, and is one of the few contemporary artists to write for and perform on the Theremin—one of the earliest and most expressive electronic instruments. His ensemble specializes in performances of his work and often features leading classical, jazz, non-western, electronic, and new music virtuosi. Working in an avant-garde idiom with his wife, Mary Ross, a photographer, video, and computer artist, he has presented original multi-media works for live electronic and acoustic music. This includes video/computer processed photographs, video, and live dance.

The Rosses are on the Board of Central Education Services (BOCES) artist roster for Broome County and they have presented their work in schools in New York State. (Each county in New York has its own BOCES. For artist-in-education information contact your local BOCES office.)

Credentials

It is unlikely that an artist, fresh out of college, will be selected for the artist roster. The grant panels look for applications that demonstrate the

ability to work in a classroom situation. The power of the artwork is only part of the credentials for consideration.

Experience gathered over time, working with students or adults, is crucial. In the eyes of the grant panel, a "practicing professional artist" will have substantial experience teaching, conducting workshops, or demonstrating technique; will have served on a peer grant panel; or will have received an Individual Artist grant from that state. You can gather educational experience by conducting your own art classes, substitute teaching in your art field, teaching at a community college, or volunteer teaching through churches, after-school programs, libraries, and the YMCA and YWCA. The A-I-E program will not act as on-the-job-training for you to gather classroom experience, unless you come to it through an artist fellowship. This is unfortunate but true. Many artists are rejected due to the quality of their experience. Be aware that some states require fingerprints and do a police check for child molestation and sexual abuse records. (This is only when you are hired for work, not just to be placed on the A-I-E roster.)

Two or three recommendations are usually required. The Pennsylvania guidelines state, "these should come from sites where recent residencies have been completed or, if you have never done a residency, a recommendation from former teachers or another professional artist familiar with the caliber of your work and your ability to work with students." Read between the lines. I'm not trying to discourage anyone from applying, but I'd wait five years after college. An artist has to have a mature body of work, show a commitment to the field, and have some art as well as teaching credentials on her resume.

A-I-E rosters include artists in these disciplines: Architecture, Dance, Film/Video/Computer Graphics, Folk Arts, Poetry/Creative Writing, Playwrighting/Theater, Visual Arts, and Crafts. Subsets of these categories may exist from state to state. Call your local arts council to find out which category you should apply for.

The work samples submitted depend on which media one is using. In general, eight to twelve 35mm slides are required in the visual arts and crafts category. ½-inch (VHS) or ¾-inch videotapes are required for dance, film, video, theater, and music. Sometimes 16mm or super 8mm film and audiotapes are considered. Writing samples are required for literature, music scores, and theater. These materials should be copies, and not originals (due to potential loss).

The grant panels are made up of your artistic peers, meaning practicing professional artists with education credentials, recommendations from a host site or colleagues, published articles or books, and a substantial exhibitions record. The panels usually have an odd number of people on them, to avoid any ties in decisions. The state A-I-E representatives are present to oversee the process and help when questions arise, but the peer panel decides who is to be on the roster and its decision cannot be appealed.

Not all grant panels are made up of artists. Some panels include a lay person. This is someone who is prominent in the community but not directly involved in the arts: a businessman, schoolboard member, or self-employed entrepreneur. The panels try to have an even distribution of regions represented as well as men, women, and minorities. Other panelists come from nonprofit agencies such as arts councils either local or statewide, and alternatives spaces (NAAO). The NEA used to have sixty-one different panels, and each one had a different make-up. However, the A-I-E organizational panels do not have artists on them.

The application should be typed. Depending on the state (there is no standard A-I-E application), the application will ask about your philosophy of teaching, a sample project, and what you plan to create during the residency. Hidden in all of this is the lesson plan. The panel is interested in indications of how you will use the forty-five-minute class time, how that time will structured, and what will be taught and accomplished. The application does not require a formal lesson plan; however, it is hinted at in the application.

What to Expect

The length of the residency can vary from five to one-hundred-and-eighty days. Usually the class time is forty-five minutes but there are also double periods. These are two back to back forty-five minute classes.

One very important issue is discipline. Roster artists are not supposed to discipline students. It is against the law in some states. If the student becomes unruly then the teacher (who is supposed to stay in the room at all times) will come to your aid and do the disciplining. An artist-in-residence is not to be considered a substitute or classroom teacher.

Sometimes artists will be asked to do assembly programs and in-service seminars in addition to the classroom teaching. If working with adult

populations in prisons, hospitals, or libraries, a different approach is required. However, the majority of residencies are with K-to-twelve (grade school to high school) students.

Assembly programs require artists to see the whole student population. This can be done at one time or over two assemblies, (each forty-five minutes). In some cases, if you are doing a day-long demonstration, the entire student population can filter through the space in the course of the day. This serves the same function as an assembly program since each class spends a certain amount of time, about ten to twenty minutes, at the demonstration. Then, whatever is created can be seen by all the students at the end of the day. Either the students return to the classroom with the demonstration, or the work is brought to each class. Any variations on this are generally acceptable, but must be explained to the host site.

Assembly programs should not be considered part of the residency. If an outside artist was hired to do an assembly program, the pay scale would be around four to five hundred dollars (for one or two assemblies, forty-five minutes in length). Many times the host sites will ask you to do an assembly for the regular artist's fee. In these cases, artists-in-residence want parity with other professionals who receive a higher fee in a similar situation. This is a case where the rules can be broken. Artists can ask to be paid for two or three days in one, since preparation time and reputation should be considered. The grant funding is 50 percent from the state and 50 percent from the school or site. Remember, the rules are only guidelines allowing for variations for each residency.

The school day for an artist-in-residence is half a day. The other half of the day is to be spent in the school working on your own art. This is the theory, but the practice is far from this. It is possible to work a ten-day residency in five days, if you count full days as working two days in one. But be prepared for very limited or no lunch time. This is where the assemblies, in-service, or consultant time counts as part of residency payment.

Sometimes sites will try to get you to work longer than what is in the guidelines. If problems arise, refer them to the A-I-E program representatives for guidance.

The host site is responsible for half the fee paid to the artist. These funds can come from P.T.A.s, special fundraisers, other grants, through banks, school budgets, or donations. It is important to know the name of the grant site coordinator for any future questions. Payment should be

discussed before the residency. If the host site requires the artist to do pre-residency work, make a site visit, or other supplemental activities, ask to be paid. Travel expenses should be reimbursed at the standard rate of thirty-one cents a mile. Payments usually begin after half the residency is completed, unless other arrangements are made. The final check will be issued on the last day of the residency. School payments have to be approved through the school boards.

Work Space in Schools

The guidelines state that visual artists-in-residence are to be provided with a work space or studio that has electricity, a fire extinguisher, running water, and security. A key should be provided. Although this is written in the guidelines, in my experience it has not always been the case. Sometimes the artist keeps his personal items and materials/supplies locked in a closet. It is very unlikely an artist will be able to work on their own art unless they have a separate space where their things will not be disturbed. Keep the site in line with the guidelines. If there is a problem, ask them to agree to half days, or ask for two days in one. This is an option that some art councils frown upon and others embrace. Try to work out an acceptable arrangement with the host site before taking problems to the arts council.

Non-Roster Artists

Roster artists must be used in all residencies unless states allow non-roster artists to participate. This apparent contradiction occurs if the site wants a particular artist who is not approved. In this case, usually the non-roster artist submits work samples, a resume, and other supporting material along with the host organization's application form.

This is one way to avoid applying through the A-I-E program or to get a residency even if you were not approved by the A-I-E panel. The site must demonstrate why a roster artist would be inappropriate and why you are qualified. If you are rejected by the A-I-E panel, you can request notes about your application from the A-I-E panel. You will then know why you were rejected and can improve on your next application.

Non-roster artists have to contact host sites directly and present a case to them. An example: a rural school does not have the budget to pay for travel, lodging, or food expenses for an out-of-area roster artist; you are

a local artist and do not need those expenses; your unique art technique does not translate well to slides and was misunderstood by the panel but may be appropriate for the school's needs.

Special Projects

Host organizations are sometimes interested in shorter arts education events including performances, master classes, or day-long workshops. These can be from one to three days, and again, non-roster artists can be chosen if clear justification is provided.

Short-stay company residencies for dance, theater, music, or performance art groups are common. The entire company must participate in a workshop or master class, and the artists' fees are negotiated prior to the application to the arts council. There is no fixed rate, due to the special nature of each company or ensemble.

When the host organizations' grant application is first reviewed, it is mailed to the panelists, who do a pre-screening. Only the written part of the application is sent to the panelists. Then, the panel meets for one or two days to review the work samples. They take notes during the review process and then decide which sites should be approved. This part of the process is similar to the A-I-E roster artists' panel.

The A-I-E Conferences

A-I-E conferences are offered by the states and held once a year. The conferences are an opportunity to have questions answered by A-I-E state representatives. They offer various A-I-E workshops on topics like publicity, education, future trends, and the law. There are guest speakers, workshops, and the opportunity for artists to show their works to the sites.

The typical conference takes place in a large room with florescent lights overhead and tables where artists display their work. Normally visual artists are combined with dance, theater, and music; and overall the scene resembles a bazaar. The noise level can be high due to the numerous VCR's, cassettes, people, and sites in the room.

When artists participate at the A-I-E conference they should prominently display *School Arts* or *Arts and Activities* articles via their portfolio or on a standing table unit. Artists must have materials to give away, such as photocopied articles, resumes, reviews, or brochures. Artists can have

items to sell such as CDs, catalogues, or video's. If someone is really interested, the artist should give away some items. During these conferences it is especially important that one present oneself in a professional manner. The portfolios or actual work should reflect this attitude. A VHS deck might be available for community use, but it is best to bring one's own, along with a monitor.

I've found these conferences to be a great place to network, since artists attend from around the state. During the lunches and breaks, artists are able to make the rounds and see what other artists are doing. At this time tips are exchanged and first-year roster artists are shown the A-I-E ropes. Some states will pay for travel, lunch, or a hotel room.

If a site approaches you and you receive positive feedback, make sure to get complete information about them. You might have to do follow-up calls or letters since the conference is always before the host sites grant application deadline. There are usually a few months before all material is due, and I'd send any new articles or reviews that might appear.

Publicity and Its Ramifications

At the A-I-E conferences, a great amount of time is spent on the issue of publicity. There are reasons for this, and they have to do with continued arts support. If an artist receives a positive mention in an article in the newspaper or in a television news clip, the people in the community notice how the school has spent money. When an A-I-E program becomes newsworthy, it shows interest in and support for the program. Local politicians must be sent this positive media exposure. The result can be an increased state arts budget or, at least, no budget cuts. A certain amount of politics is involved in keeping an arts budget alive, and the state legislators need to be on artists' mailing lists. The politicians may or may not realize how vital the arts are to schools, communities, or libraries. If these politicians are on a significant number of artists' mailing lists and see articles or television news programs (since you will be a master at receiving and disseminating this kind of publicity), it could make a difference it future arts funding. This is not a form of lobbying. It is making people aware of your career. This is especially true now that the Republican Congress wants to abolish the NEA. Most state arts councils receive NEA money for their A-I-E programs, and if an article appears I'd send it to your congress person and senator.

Grant Reporting

After you have completed the project, you and the site are required to formally account for how the time and money were spent. There is another form to be filled out, usually within thirty days after the end of the residency grant. If you do not turn in one of these final reports, it will jeopardize future grants for the site and possibly yourself. Without the final report the grant is considered incomplete, and all grants must be completed before another one is funded.

States Looking for Artists

There are many states that request out-of-state artists since they lack a sufficient pool of diverse talent. Some of these states are Alaska, Delaware, and Montana. There are other states that seem to show no preference between in-state and out-of-state artists, such as Virginia and North and South Carolina.

By participating in several states, you can be on many roster artist mailing lists and receive various state art councils bulletins. This will help you develop an understanding of trends in arts funding around the country. In addition, you will receive exposure; your name will become familiar to panelists who can influence your future career goals.

Artists with Class is a newsletter for independent artists in education. The address: 66 Jenkins Rd., Burnt Hills, NY 12027. A one-year subscription is $12 for artists and $18 for organizations. It is published four times a year.

Future Trends and Alternative Certification

Alternative certification for teaching artists is currently being discussed. This would be for professional artists who would teach as a full-time job. The certification means they would not have to go through formal arts education training in college. This would open long-term arts-in-education opportunities to non-roster artists.

There are many reasons why the educational system is embracing this concept. A crisis is occurring in the educational system and it needs to be addressed. The high drop out rate, lack of critical and creative thinking skills, and poor problem-solving skills are all issues that can be effectively addressed using the creative arts.

Students who major in arts education in college, and who go on to teach when they graduate, are not professional artists. It is not possible. They do not have a mature body of work (if they are in their twenties). When they receive an arts education degree, they are hired as a teacher, not as an artist who teaches. This is not to denigrate the quality of art teachers, but students fresh out of college are not professional artists. Some art teachers are practicing artists, and some are not. Professional artists can act as a role model (since they have a reputation), and can make an impression on students' minds.

Successful artists who want to teach bring with them life experience and survival techniques. These artists are self-employed and have to pay for their own health insurance, retirement benefits, social security taxes, and so forth. If an artist can live by his wits for many years and then be approved for an artist roster or alternative certification, then he can offer experience which is far different from what is found in an educational setting. Educators realize the power of artists in an school setting. Artists are constructive role models and they can introduce multiculturalism, the interdisciplinary nature of knowledge, and most important, critical and creative thinking which leads to skills in problem-solving.

Obviously, certification would not be automatic. There would have to be a system of certification with the necessary application forms, interviews, and submissions of resumes. New Jersey had a pilot program for alternative certification, but if hired, these artists would be required to earn a masters degree in education within so many years or they would lose their job.

If an artist's talents can be perceived to motivate students in a positive way, not only in the art classroom, but in all educational disciplines, this alternative certification program will become a real and popular option for artists.

Future A-I-E Funding

The federal government and most state governments feel that the art money granted to the A-I-E programs is money well spent, as it contributes to the betterment of the community and is therefore a tangible asset. In the future it is entirely possible that even more money will be allotted to these programs, as money might be shifted away from other arts programs like regranting or individual artist fellowships. Congress determines the

NEA funding appropriations and can institute legislative changes in how the arts monies will be spent.

The arts are often a low priority in education funding and the first to go when budgets need to be trimmed. Without a radical change in education and broad initiatives from the federal, state, or local governments, A-I-E appears to be in a crisis situation, since it is always dependent on funding, not curriculum. However, a change is underway as state art education departments mandate art in school curriculums. The prospects for more government A-I-E funding is favorable, because the NEA, either through congressional mandates or shifting priorities, is increasing the money given to state art councils. This money is given, in turn, to their A-I-E programs.

Governor's Schools for the Arts

Almost every state has a Governor's School for the Arts administered by that state's Department of Education (located in the state capital). These are summer art schools that usually run for six weeks and are held on various college campuses. The Governor's Schools have a selection process that offers sophomore and junior high school students the opportunity to learn and create with professional artist teachers and their peers. These selected students have demonstrated an artistic ability through a portfolio or demonstration of their artistic talents. This selection process takes the form of slide submission, videotapes, or an interview process.

Artists can be hired in one of two ways for these Governor's Schools. One, they are hired as teachers. The disciplines in the visual arts can be painting, sculpture, photography, ceramics, drawing, mixed-media, graphic arts, design arts, or printmaking. Artists are also hired in dance, music, theater, and literature. If an artist has a reputation and some teaching experience (A-I-E rosters), there is a possibility of being hired. In 1992, the starting Pennsylvania Governor's School salary for first year faculty (I was the photography instructor) was $2,500. If professional artists are unavailable then graduate students in art are hired.

The second way to be hired is to do an artist-in-residency in the visual or performing arts. Sometimes music or dance groups will do a single performance if their schedule does not enable them to do anything longer.

The working hours at the Pennsylvania Governor's School made for a long day, and are, I believe, typical. They try to cram as much information

as humanly possible into the students' schedule. The working hours are basically 8 to 11 A.M., Monday to Saturday; 1 to 3:30 P.M. Monday to Friday; and 6 to 8:30 P.M. Monday to Friday. From 8:45 to 10:30 P.M., films or student performances are held (the faculty is not required to attend). Occasionally a scheduled day off is arranged, as some of the classes can be rotated with other teachers. It can be very grueling, and often something comes up which requires additional hours.

The theory behind these schools is to have a working artist/teacher serve as a role model by creating their own work during this six week course. There is no testing or grades, however critiques, discussions, workshops, lectures on art history and recent trends in art are encouraged as part of the teaching process. Be prepared for normal educational bureaucracy, faculty meetings, art politics, personality differences, and student behavior all contributing to an exhausting pace.

Artists are hired for one summer, but it is possible to be rehired. Inquire about any faculty opening or artist-in-residency by contacting the Department of Education in your state. Notices for hiring usually appear during the winter, and the selection is made by the spring. If interviewed, be prepared with a course outline. In Pennsylvania, the instructor determines the direction of the course, which is dependent on the available equipment (such as in my experience, only black-and-white photography). The instructor decides on the projects and aesthetics to be explored, criticized, and exhibited. Usually at the beginning of the term, the artist/teachers have a group exhibition to introduce the students to their own work. At the end of the course, the students have a group show to demonstrate what they learned.

Partners of the Americas

Established in 1964 as the people-to-people component of the Alliance for Progress, Partners of the Americas is now the largest private voluntary organization in the Western Hemisphere engaged in international development and training. Partners links the citizens of forty-four U.S. states with those of thirty Latin American and Caribbean countries in partnerships.

Each partnership has volunteer committees on both sides, north and south, that work together at the grassroots level to carry out educational and development projects (including cultural programs). This can take the

form of an artist-in-residence or an exhibition. Proposals would have to be sent to the local cultural chair in your home state.

Funding for an artist might consist of a round-trip plane ticket and a stipend of $400 for one month's time (this is the Eastern Pennsylvania-Bahia, Brazil arrangement), or the artist might have to pay for their plane ticket and not receive a stipend.

If you wish to find out more information, contact Julieta Valls, Director of Cultural Programs, Partners of the Americas, 1424 K St., N.W., Washington, D.C. 20005; 1-800-322-7844; fax: 1-202-628-3306. She will let you know where to direct your proposal to your local state partner.

Sample Roster-Artist Profile

The following information about Gary Hassay is taken from the Pennsylvania Artist-in-Education artist roster directory. Gary J. Hassay is one of the approved artists in cross-disciplinary arts. He is a musician who collaborates with artists working in various media. His profile from the directory illustrates the professional presentation of an artist's credentials.

Gary J. Hassay

Artistic Work/Types of Residencies

What I have to offer through my residency is the experience accumulated through ten years of cross-disciplinary performance and the consequent knowledge gained by bringing together different artistic disciplines. What I actually do during a residency is first present my music, then discuss some of my thoughts on improvisation and how it applies to my musical concept and to life in general. Either an individual or a group situation can now be developed depending upon the number of participants. Through discussion, true reactions and real needs can be determined. Knowing these needs, a goal can be set (a performance, learning a new technique), and the purpose of the residency is then to find the means to reach this goal.

Biographical Sketch

I began playing music professionally in 1979. Since then I have performed with over forty internationally recognized artists from the United States and throughout the world (Germany, Japan, South Africa). I have received grants from Meet the Composer, The Painted Bride (NEA regional interdisciplinary), and the Pennsylvania Council on the Arts (Fellowship

and A-I-E). For the past ten years I have devoted my time to cross-disciplinary projects. In 1980 I co-founded "improvisationalmusico, inc." (improvco, inc.), an international nonprofit music presenting organization, of which I am president. My main expertise is musical improvisation and its ability to free the mind and to show new ways of seeing and thinking creatively. The central purpose of the residency is to develop an improvisational way of thinking within the participant, who need not necessarily a musician. Music is my particular language, but improvisation can be applied to any aspect of life.

Education/Training
I received a Bachelors degree in Sociology from Rutgers University in New Brunswick, New Jersey and an Associate degree in Science from Lehigh County Community College, where the main focus of my study was computers and mathematics. I have developed a group of artists (several poets, three painters, a dancer, a computer installationist, and a sculptor) who relate well to my music. Together we create projects based upon my specific improvisational techniques.

&

CHAPTER 10

Assembling a Resume and Portfolio and Other Helpful Tips

Once you begin to receive significant publicity, it is important to create a professional resume and a publicity portfolio. You will need to know how to cultivate professional relationships by using references and letters of recommendation. In addition, you should be on the right mailing lists (remember the press agency section in chapter 4), know how to catalog your artwork, and specifically identify material if it is lost or damaged. In case legal problems occur, you should be aware of Volunteer Lawyers for the Arts, an organization offering free or low-cost legal assistance. Finally, one of your goals should be having your artwork

exhibited in New York City. A number of practical techniques on how to tackle this premier U.S. cultural city are mentioned at the end of this chapter.

The Resume

An artist's resume, or curriculum vitae, is a summary of his or her achievements. It should include exhibitions in museums or galleries, both solo and group shows; grants received; major reviews and articles in newspapers or magazines; television and radio news items; book publications; lectures, workshops, demonstrations, master classes, and artist-in-education residencies; collections the work is present in; and commissions the artist has received. These should all be listed separately by category. Within each category, the items should be listed chronologically, with the most recent entry first.

An emerging artist can make a resume appear more significant by using the word "selected." The word "selected" should be used in this way: "selected group museum exhibitions," or "selected grants." It gives the impression that more is either being held back (minor insignificant shows or reviews) or the career is of such length that a lack of space requires one to select the most significant events. It makes the resume appear professional. Look at famous artists' resumes in museum catalogs and notice the different classifications and how items on the resume are categorized. Artists with numerous achievements can have a two-sided resume. This is the maximum length for resumes included with most grant and award applications.

Do not fabricate the resume. Since an artist is a public figure, it will come back to haunt you at a later date. Be prepared to document everything significant on the resume. Keep all announcement cards, reviews, grant award letters, publications, and video clips. The resume should be updated every year. Future information should be included, such as advance notice for articles and upcoming shows. If something falls through, just delete it the following year.

The NEA used to award individual artist fellowships in two categories, emerging and mature. The artist with less than ten years' experience on her resume was considered an emerging artist, and the one with ten years' or more experience, a mature (professional) artist. Artists in mid-career, applying for other grants using these categories, may find they have some

leeway in determining their status depending on what they consider the start of their career. For example, insignificant shows at the beginning of a career—such as in restaurants, open studios, or art festivals—could be included or left out to increase or shorten the official length of the career. It is hard to know exactly what to expect, some grants are specific for emerging or mature artists. In 1993, the Pennsylvania Arts Council panelists for the Individual Artists Grant decided only to fund emerging artists. Call or write the organizations offering grants to try to find out if they prefer emerging or mature artists.

If you are an interdisciplinary artist working in different mediums, you should create several resumes. For example, an artist working in sculpture and dance should have one resume for dance, one for sculpture, and one for performance art (combining the two). This is because there are often difficulties regarding acceptance (for grants, galleries, or publications) for interdisciplinary work that falls outside of official or perceived categories. The work can be classified as Conceptual, Visual-based performance, Video and New Genres, or it can fall between categories and sometimes understanding. This is one of the hardest disciplines in which to make a living. Documentation of the work is critical due to the often ephemeral nature of the art. Make sure to document this work in the most professional manner using slides or videos. The documentation sometimes becomes the art.

Another reason why interdisciplinary artists should create two or three separate resumes, one for each medium, is because they can be interpreted as scattered unless they have a major reputation. Panelists, curators, or gallery owners generally like to follow a single idea, theme, or project all stemming from one aesthetic. Deviating from this norm, and having it reflected on the resume, can dilute the perception of talent. Do not try to make the resume longer just to fill space requirements. The idea is to focus on one topic.

Publicity and Artists' Portfolios

Once articles or reviews begin to be published it is important to establish a publicity portfolio. This is different from a body-of-work portfolio, which should include great-quality photographs, sketches, and other materials that accurately represent the artist's actual work.

A publicity portfolio is a record of exhibitions and other events, which

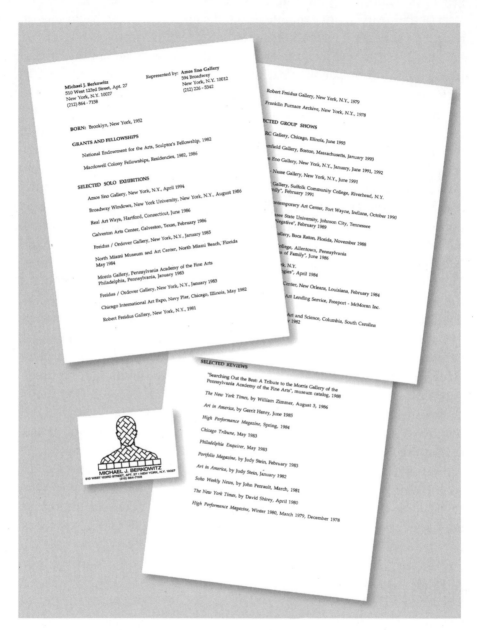

Figure 10: Artist's resume and business card

Courtesy Amos Eno Gallery

might include announcement cards, price lists, and reviews or articles. Many exhibitions can be included, in chronological order as they appear on the resume. It is best to obtain many copies of all published materials in case of lost or damaged portfolios. These materials have to be cut up (if necessary) and arranged in a visually pleasing form in the portfolio. The layout is important. It should include the masthead from each publication with the issue and date included. Use a glue stick to hold the elements in place. The review or article should be glued to a white or black sheet of paper (eight-and-a-half-by-eleven inches). These portfolio pages can later be reduced to fit a photocopy for mailings or leave-behinds. For longer articles make a two sided copy. It is important to use original material in the portfolio. If you only have one copy of a color article, get a color laser photocopy and cut that up. This is especially true for foreign magazines, which can be difficult or impossible to replace. Sometimes a feature article runs for several pages and the layout is peculiar due to ads. It is best to cut-up these articles and create a layout that fits the portfolio pages. It will look much better in the portfolio and will be easier to photocopy.

The publicity portfolio should be created to stimulate the eye. The best way to ensure this is to by grouping vertical and horizontal spreads and keeping the size of the materials consistent. Use a loose-leaf binder with eight-and-a-half-by-eleven inch plastic sheets in which to place the published material. The first page should be vertically formatted. The following two pages should also be vertical layouts. The next two-page spread could have a the horizontal format. It does not look "professional" to have a vertical layout on the left side of a two-page spread and a horizontal on the right side. If the viewer has to turn the portfolio constantly back and forth, it is not visually soothing. This indicates that minimal work has gone into professionally arranging the portfolio. It should take little effort to look at a portfolio, especially if it is a drop-off situation. Curators and art directors have to look at many portfolios, and if they constantly have to turn the binder due to poor placement of material, they might not look through the whole portfolio.

The same rules apply for the body-of-work portfolio. It, however, can be larger than eight-and-a-half-by-eleven inches. It might be eleven-by-fourteen or even sixteen-by-twenty inches. You may want to include high-quality color laser copies, which can commonly be made up to eleven-by-seventeen inches (the equivalent of two eight-and-a-half-by-eleven-inch pages next to one another).

Check prices and size availability for photocopies and color laser prints at the office superstores like Staples or Office Warehouse. They have low prices and excellent quality equipment. At Staples, the photocopy price can be as low as three cents a copy (black-and-white) for fifty or more copies. For two-sided copies, the total cost for fifty is only $3.00 plus tax—much cheaper than using your own photocopy machine. However, sometimes they are sneaky. If you give them an article laid out, that cannot be put through the feeder tray of the copier, they sometimes will show you the first copy which looks great. Then they photocopy the photocopy and the quality is almost useless. This is more true for photo-image quality rather than text. Make sure that they photocopy the original for every copy needed. Sometimes they complain about doing this, because it is time consuming. Do not leave material with them and come back later. The photocopies might be useless, and you might still have to pay for them.

Letters of Recommendation and References

In applications for grants, corporate support, job prospects, or even as part of a publicity package, include letters of recommendation and references. Letters of recommendation for fine artists are persuasive suggestions disguised as an objective critique to help one obtain a goal—either money, product, or publicity. Letters are required for artist-in-education grants, some private foundation grants, and emergency assistance. Some organization's applications request the name and address of all potential references. They will be contacted by the organization either by a telephone interview or for a letter of recommendation.

What are the best letters of recommendation, the ones that get you the grants? These are letters from people who are known nationally, regionally, or locally and who know your work on a professional level. These letters should be tailored to the particular project or grant and address specific issues (a general letter is almost useless). The letters should always be positive and mention the artist's strengths and should generally endorse the idea that "the artist gives a rigorous examination to his/her creative discipline." And remember, letterhead counts—the more prestigious the institution or author, the more significant the letter becomes.

Cultivating a group of critics, curators, collectors, and other artists who can be relied upon to write these letters will happen over time. In reality, more often than not, the letters people write for you come at a price.

Sometimes they will agree to it, then send you their letterhead and ask you to write the letter yourself and return it to them for their signature. Some people will do it out of respect, while others might want a favor out of you or some other barter in exchange for a letter (if only to be taken out to dinner).

What I have learned over the years is to stock the letterheads of the various institutions I have been associated with (galleries, alternative spaces, museums). This way they are readily accessible to write letters of recommendation or press releases. If you have not done this, ask them for their letterhead and explain why. Having blank letterhead on file saves a significant amount of time if you have to write the letter anyway or if you have received a grant application late and are under a deadline. It is important to tell the organizations what you are doing and to get permission whenever you use their letterhead. If you are on good terms with the organization's staff, you can save time and hassles (sometimes even forging their name as long as they know).

The consensus is that it is the letterhead that counts, since all letters say basically the same thing: "the preeminent oil painter of dashed hopes" or "is a good kid around the house and picks up his/her artistic toys."

Always get a copy of any letters of recommendation. These should be photocopied and used as part of a publicity package whenever you think it will help support the publicity. As an example, a press release could state: "The work created under the Big Fish in the Small Pond Grant was supported by Ms. Influential Position, the curator of The Little Peer Museum, whose letter of recommendation is included in this press package for the exhibition of Underwater Paintings by Red Herring."

Nom de Plume

Galleries, museums, arts councils, and magazines all sell mailing lists. If you want to try to track the sources of the mail you receive, utilize a nom de plume. Purposefully misspell or make an addition to your name, such as in my case: Julius Vitale, Julia Vitalis, Julius Vitali–Avante Disregarde. Or you can modify your address to include "Creativity Department." If you create a naming system for notated mailings, when something arrives in the mail, it can be traced to a specific magazine, art council, or gallery. Obviously, not every place sells a mailing list but as one requests information indicate your nom de plume or addition. Emerging artists

should try to be listed on many state art councils' mailing lists. States like South Carolina or New York offer free or inexpensive publications about various subjects. Applying for grants in your home state often puts you on another mailing list. Using a nom de plume will help you to understand how information is networked, which can help you access information and publicize yourself more effectively.

Cataloging Your Artwork

It is beneficial to number and catalog all of your artwork, sketches, slides, or photographs whether a computer is used or not. It is not the most creative activity but it acts as an historical record. Indicate the day, month, and year produced, materials used, and if the piece has been sold, who owns it (with name and address and phone number). This way the artwork can be traced for exhibition loans or to be rephotographed.

When artwork is loaned to museums or galleries for exhibitions, an invoice should be included giving the title and catalog number of the artwork with the condition noted. This will help to solve any problems such as lost or damaged artworks. When traveling shows are shipped, the receiving institutions must fill out a damage report for each artwork. This is a standard museum procedure.

How to Identify Returned Material

It is annoying to receive slides back from a museum or gallery via an SASE without a cover letter. Sometimes the postmark can identify the city but postmarks are not always reliable or readable. It can be impossible to determine where the materials were returned from. This could wreak havoc for your return filing system. One way to avoid this is to indicate all the necessary particulars somewhere on the SASE. Keep a list and indicate who received slides or artwork and when they were mailed. Then write this information, or a code referring to this information, someplace on the envelope or mailing flap. For double insurance (in case the return envelope is not used), indicate the significant information on one slide as well. This is a good back-up system, and it helps you avoid unnecessarily mailing out invoices for lost materials at a later date.

Lost Materials

It is beyond the scope of understanding how material is lost or even stolen. It does happen, however, and artists have some choices open to them about how to remedy the situation. To begin with, visit a stationery store and buy an invoice book. This is necessary to track lost materials as well as billing museums, galleries, magazines, or newspapers.

Whenever material leaves your premises, whether slides, photographs, or the actual art work, it should be notated and listed in your filing system (locate that system somewhere other than your memory). Make a photocopy of the slide sheet to know exactly what was shipped out. This includes any videos, black-and-white pictures, catalogs, or photocopies. If the material has been requested, try to send it out FedEx (since the requester might pay for it). FedEx insures their packages and has a sophisticated tracking system. If you have to send out original slides it is important to insure and/or register the package with the post office.

If the site loses the material and they acknowledge it, they should pay for the lost material. Tell the institution that lost the material that the going rate for each duplicate slide is three dollars to five dollars. (The N.Y.C. photo labs charge this amount as well as other custom labs.) You will be able to replace the slides for less, but this creates a significant mark-up that will cover phone calls, faxes, postage, and the time involved to either reshoot or duplicate the work. Usually the institution just asks for an invoice, not the receipts. If a videotape is lost, charge twenty dollars, the going rate for a duplicate video to be made at a commercial video business. Because you already know how to duplicate your own video cassette charging a commercial fee is a hidden way to recoup costs and pay for your labor.

Over the years, I've heard many excuses for lost material and noticed that it happens at every level. A majority of time the material is misplaced due to a new director or curator who changes the old filing system. If it is lost and they pay for it and then find the material, they usually will send it back to you without asking for the money back.

If on the other hand, the material is sent out cold, include with the original mailing a SASE postcard confirming that they have received the material. This insures an acknowledgement on their part which is necessary for future contact if they lose the material. They will understand that you mean business and will usually respond. It does not work all the

time. Invoices for lost material go to the billing department and accountants want to know what is being paid out. This then gets back to a curator or editor who is, hopefully, forced to track the material down.

If original material is lost, especially slides, restitution depends on the degree of loss. If it is just documented work and easy to reshoot, it is probably best to ask for a photographer's fee at $25 to $50 an hour plus cost of the film and processing. If it was an installation piece or art photography that is irreplaceable, seek out the ASMP guidelines for lost material. The value of original slides can be $250 a piece by ASMP standards. Stock photo houses sometimes value original slides as high as $1500 each. If originals are lost, prices can be negotiated. It is a serious situation of the sort that people sometimes lose their jobs over. Send out duplicates whenever possible to avoid these issues.

To recover loss for original artwork, one has to prove value. Insurance floaters from previous exhibitions are important to keep for this reason. If these are not available, use the price list from a gallery or a canceled check from a collector, which will establish the going rate for your work.

It might be helpful to carry your own insurance floater as part of a home owner's insurance policy. This is commonly available. It can be door to door coverage or just in the home. Consult an insurance agent for these types of coverage and how value is determined. If things get sticky, hiring a lawyer is another option.

Volunteer Lawyers for the Arts

Volunteer Lawyers for the Arts (V.L.A.) is a national organization of lawyers for the arts with forty-nine chapters in the U.S. and Canada. They provide low cost legal services (an initial fee is sometimes requested) besides basic business assistance and can help mediate lost or damaged artworks. (Other organizations offering emergency relief to artists in need are listed in chapter 8.)

The V.L.A. Directory provides updated descriptions of these programs. The directory is useful for artists and arts groups looking for legal assistance in their own communities or in places where their work is being performed or exhibited. Contact the New York or Philadelphia office to order the most recent directory or to find out the V.L.A. location nearest to you. In New York: One East 53rd St., 6th Floor, New York, NY 10022; 1-212-319-2787. In Philadelphia: 251 S.18th St, 19103; 1-215-545-3385.

The V.L.A. also sponsors classes and maintains an arts law library to publish and distribute legal guides such as: "Legal Guide for the Emerging Artist," "Artists Housing Manual," "An Artist's Guide to Small Claims Court." For quick answers, V.L.A. operates the Art Law Line: 1-212-319-2910.

In addition, there are two helpful books by Tad Crawford of Allworth Press: *Business and Legal Forms for Fine Artists* includes sample forms, contracts, with complete instructions; *Legal Guide for the Visual Artist*, revised in 1995, covers censorship, reproduction rights, contracts, taxation, estate planning, loft leases, museums, collecting, and grants.

Artists usually don't like to think about it, but differences do happen, and when legal issues arise it is best to be prepared by having as much written documentation as possible. Small claims court is an option in every state. Lawyers are not necessary as each party can present his or her case and judges or arbitrators hear the cases. The amount of the claims vary from state to state. In New York, a small claim is $1,500 or less. In Pennsylvania, it is up to $8,000. Make sure to know your rights!

Parking in New York City

Artists visiting New York City will find parking a vehicle as daunting as approaching galleries and museums. Especially if you are driving a van or pick-up truck in order to transport artwork, it is important to be familiar with the local parking laws. The situation is not as frightening as it appears, but New York City is notorious for the high prices of parking fines, towing, and parking lots.

If you own a small pick-up truck with either truck or commercial plates (this depends on the state policy), put three-inch or larger letters on the driver and passenger doors indicating the name and address of the business. This allows the truck to be parked in a designated truck loading and unloading zones. These zones exist all over New York City but are centralized in midtown Manhattan. Many magazines and galleries are located between the area just below Canal street and 90th Street, a distance of over one hundred blocks which includes TriBeCa, Chinatown, Soho, the East and West Village, the photo district, midtown, uptown, and Museum Mile. A commercial vehicle is able to park in a designated commercial parking zone for about forty-five minutes without receiving a ticket. There are a few designated four-hour areas in the east Forties.

Be patient, because it is entirely possible to drive around looking to park during business hours without success, since numerous trucks are actually loading and unloading merchandise. If you are not actually loading or unloading, this can be obvious to the traffic police. Write a note stating what time you left and where you are going (this is not necessary in the spots with a four-hour time limit). Place this note inside the car near the driver's side windshield. Sometimes the truck can be left unattended for an hour with a note and still receive a ticket for inactivity. This is usually a forty-five dollar fine. If this happens, get a letter from your appointment on their letterhead stating what caused the delay. Mail this explanation to the traffic court with the parking ticket. This should eliminate the fine for the ticket. Out-of-state vehicles have a bit more acceptance with the police and courts due to ignorance of the parking laws.

In New York State, it is possible to own a passenger car with commercial plates. (Inquire if this is possible in other states.) However, in New York, vehicles with commercial plates cannot be driven on parkways. Road signs will indicate no commercial vehicles allowed. If you have out-of-state plates and use these roads by accident, the police will usually just tell you via car microphone to get off the road at the next exit.

If the commercial vehicle does not have three-inch letters (which can be spray painted, stenciled, attached with stick-on vinyl letters, or by having a sign made and then attached) and is parked in a commercial zone, the vehicle will be issued two tickets. One for impersonating a truck and the other for parking in a loading zone. This happened to my truck and I was able to avoid the fine by putting these three-inch letters on the truck. Pictures of both sides of the doors had to be mailed with the tickets, within a specific time, to the city parking violations bureau.

Other parking tips regard alternate side of the street parking rules. On certain days, between either 8:00 to 11:00 A.M. and 11:00 to 2:00 P.M., it is not possible to park on these streets with or without commercial plates. If you do, the vehicle will receive a ticket or will be towed. The reason for alternate side of the street parking is for street cleaning. Due to the NYC budget crisis the Wednesday and Saturday alternate side of the street parking rules were suspended, even though the signs were not changed. Call the New York City branch of A.A.A. (1-212-586-1166, located at 1166 Broadway and W. 62nd St., New York, NY 10023), they will be able to give you up-to-date information regarding this. Alternate side of the street parking is used mostly in residential sections and midtown. If you

try to park in a spot just as it becomes available, it is advisable to get to the spot twenty minutes before the allowed time, since the locals are also trying to park. It can become a vicious game.

There is a parking lot on 60th Street and West End Avenue called Square Park and Lock (1-15 West End Avenue; 1-212-246-4256), which costs $9.00 for a twenty-four hour period and $7.25 up to twelve hours. This place has good lighting, a fence, security, and free shuttle bus pick-up and drop-off, Monday through Friday 7:00 A.M. to midnight, from West End Avenue to Fifth Avenue and 70th to 53rd Streets. It's a bit off the beaten path, but it is extremely reasonable; and if you are worried about leaving the vehicle on the street, this is not a bad location. Remember, this is the big city. Do not leave anything valuable in sight; it will be a magnet for thieves. Try to be street smart. Enjoy your visit.

&

CONCLUSION

Using Potential Resources

If you were to take all the newspapers, magazines, and television shows in the United States and log the allotted space and time on a chart recording what types of people received publicity, politicians would come out near the top and fine artists, near the bottom.

Politicians use the existing media to receive free publicity and establish a reputation. Imagine what would happen if an artist were to run for political office. In fact, one of the best ways for artists to receive publicity about themselves and their art would be to run for political office. Not only would they receive name recognition and publicity, but if their art was used

as a vehicle to promote their campaign, the artwork would increase in value due to its high visibility. The types of political ads that a truly creative thinker might develop would be unique and undoubtedly interesting. The campaign slogan would be "a picture is worth a thousand words." Politicians speak one-thousand words without saying anything concrete. A fine artist could run a political campaign by creating visual artwork on political topics related to the campaign and refuse to talk, letting the art work speak for itself. There would be two extremes at a political debate. The politician would talk for five minutes or one-thousand words (remember the art rap: thirty seconds or one-hundred words), and the art work(s) would be displayed the same amount of time. Then the political commentators would react to it, like a critic reacts to an exhibit.

The example might be far-fetched, but it illustrates the how little artists use the media to their own ends—a technique that politicians have refined to the level of fine art.

I remember viewing the "Primitivism in the Twentieth Century" exhibition at the Museum of Modern Art in September 1984. I was struck by some of the indigenous art of Oceania and Africa. The primitive artist was seen as the keeper of the culture and had a position of leadership and power in the community. The art objects had a utility and ritual function which was an integral part of the group's cultural and spiritual evolution. Although the "primitive" artists might not be the official ruler or leader of the group, they held tremendous influence on the inner workings of the community at large. Sometimes the maker of the masks, headdresses, and other ritual objects was also a shaman or holy person. It was not unusual for the "primitive" artist to be the spiritual leader of the group. Creativity meant the ability to foster a vision, not only to make art, but influence policy as well.

Today artists are perhaps seen as visionaries but never as leaders. There are a few exceptions. Vaclav Havel of the Czech Republic was a playwright and our own President Reagan, an actor. Usually the media portrays artists as bohemians or social deviants. They are sometimes portrayed as unwilling to work at traditional jobs or as con artists. Jeff Koons, a neo-Dada artist, is an example. His basketballs in plexiglass or his "readymade" vacuum cleaner seem like pure scam to the media. Artists take on the role of a cultural pressure valve. This is illustrated is by the last few minutes of the 6:00 P.M. or 11:00 P.M. television news. The soft news is usually a cultural item (which commentators often ridicule if given the opportunity),

which buffers the previous twenty-five minutes of ads and serious content. The soft news either makes you feel, think, or laugh, but is not to be taken seriously. This is the cultural pressure value letting off steam.

What has gone wrong with society? Artists are second-class citizens who have to fight for every nickel and dime. If "the collective artist" asks to be paid whenever they appear on television or every time a photo of their work is published, either the press will not run pictures or will have to pay to use them. As long as artists are willing to give away press photos and not be compensated, they will be taken advantage of.

Sometimes the events of the world stage inspire artists to create works that transcend aesthetics and become cultural icons. Picasso's *Guernica* is the best example. Its inspiration was the senseless bombing of that civilian town by the fascist general Francisco Franco during the Spanish Civil War in 1937. The painting *Guernica* was a protest—since Picasso was a refugee living in France—and that artwork had a tremendous effect on world opinion. While Picasso was alive one of his favorite comments was, *"I make a political statement every day in New York City."* At that time *Guernica* was on temporary loan to the Museum of Modern Art. Artists are inspired to create political art, but it sometimes seems the motivating factors have to be cataclysmic—like World War I for the Dada artists—to shock them into action.

The collective media rap for why artists are not paid for their services is "it's free publicity." If there were an artists guild or union with political power then there would be laws or regulations such as: every time a photo is used, a certain minimum amount has to be paid for its use; minimum pay standards for labor services such as lecturing, artist-in-residencies, or workshops; IRS deductions for the actual value of the work, not the material value if the work is donated to a nonprofit institution. As it stands now, a deliberate ambiguity exists when artists send out materials blindly to the print media. If an image is published, the artist has to phone the photo editor and ask what they pay for freelancers' photographs, if published. Then an invoice is mailed out. If only a few artists ask for payment, the invoice can be ignored. If many artists ask to be paid, something has to change.

Change is exactly the impetus of this book. If enough artists read the book and start to implement its concepts, something will happen. Artists need to use the resources available to them. Technological advances also create change. The Internet and E-mail are just beginning to offer

opportunities for artists. In a few years, in a revised edition, they will be covered.

I hope this books peels away the veneer regarding fame and reputations of artists. Artists, like politicians, have the ability to change society: the spiritual/aesthetic side for artists and the laws and regulations for politicians. Hopefully one day they will merge and the mask maker will be the leader of the clan.

APPENDIX 1

Photographing Your Art

The information in these appendices is geared for artists who have only a little knowledge of photography yet understand the necessity of photographing their artwork.

It is necessary for the fine artist to have a working knowledge of how to shoot their artwork in both indoor and outdoor situations. This information will be explained in this appendix. If, however, you decide not to shoot your own art work the second appendix will give specific information of the different types of color and black-and-white films. Armed with this information you can tell the photographer who will be shooting

your artwork specific films that will be for archival purposes, as well as for press releases.

Shooting Artwork Outside Using Daylight Slide Film

Although there are a variety of ways to shoot artwork indoors, shooting outdoors using natural light is a low-cost, low-tech way of achieving superb results. The materials needed are: a 35mm camera with manual settings, or an override of the automatic settings, a tripod, cable release, a non-distracting background, duct tape or push-pins, and possibly a light meter.

When documenting artwork, shoot it against a white, black, or grey background. This is considered non-distracting. It is possible to use twenty-by-twenty-four-inch construction paper if the artwork is small enough, or visit a photo store and buy photographic backdrops (sizes vary from four to ten feet) in white, black, or grey. Or use canvas primed white or painted grey or black. Use your creativity. If using cloth make sure it is ironed first.

If it is possible, shoot artwork outdoors in the shade or when it is evenly overcast. It is much less cumbersome than using studio lights. The best time of day to shoot artwork outdoors is between 10:00 A.M. and 2:00 P.M. as this is the time of day when the color temperature of the film will closely match the color temperature outdoors. First, test different films to find which give the best results. If this time period is too constraining, consider these options. The color of sunrise and sunset is blue and orange, and if documenting the artwork before 10 A.M. or after 2 P.M. then the possibility exists for either a blue or orange tint to show on the completed image. For an additional expense, this can be color corrected when duplicating slides. Many factors come into consideration. For example, time of year is an important factor. The summer sun enables an extended shooting time. A different type of light exists in Maine than in Florida. Pollution in the air affects overall tints (which is towards blue.) This is why testing is so critical.

Whether the artwork is flat or three dimensional will determine how to photograph it. A nail is put into an outdoor wall through the backdrop to hang two-dimensional work, such as painting, drawings, and photographs. It is necessary to use a table or sculpture stand for three-dimensional artwork. Be careful not to wrinkle the backdrop, cloth, or canvas, as one wants it to look pristine. Do not shoot on a very windy day; this can wreak havoc.

If the camera has a meter, put it on the manual setting and take a light reading about one foot away from the artwork. If the work has a wide tonal range, take a few meter readings and determine an average exposure. Remember this meter setting, because if you are shooting against a white or black backdrop, the meter can give a false reading, as it will be reading the backdrop instead of the artwork. Do not accidently put the automatic setting back on as this will result in a wrong reading. The backdrop does not need to be metered, just the work. If unsure of the exposure, then bracket these exposures, by taking one frame higher than, and another frame lower than, the indicated f/stop. An example: Kodachrome 64 film, thirty-six exposures, in normal light exposes correctly with a shutter speed of one-fifteenth of a second, at f/8. To bracket this exposure, shoot at one-eighth of a second at f/8 to overexpose one f/stop, and then one-fifteenth of a second at f/11 to underexpose one f/stop. It is important to have the f/stops set at least at f/8; this allows for a greater depth of field, or area in focus. When shooting sculpture and wall reliefs where there exists more than two feet of height by width by depth, it is important to achieve full focus by having a maximum depth of field. All lenses have a critical aperture. This is the sharpest aperture based on the lens construction. Test patterns are sold in order to do fine line comparisons. To find out the critical aperture, shoot the pattern at all the f/stops and compare the pictures for line sharpness. Without doing this fine line testing, you can assume that the critical aperture usually is either one or two f/stops from the highest aperture of the lens. If a lens has its highest aperture at f/32, then either f/22 or f/16 would be the sharpest f/stop. Depth of field is, of course, critical for sculpture but not for a flat painting.

Some lenses indicate the depth of field by color coded marks. On a 55mm Nikkor macro lens, the f/stops from f/32 to f/11 are color coded (f/32 blue, f/22 white, f/16 yellow, and f/11 red). When focusing on a sculpture you can determine the depth of field (or focusing range) by looking at the colored coded ranges indicated next to the focusing ring.

If a sculpture is three feet long and it is six feet away from the camera, with this lens at f/22 the range of depth of field is from four-and-a-half feet to twelve feet, therefore set the focus at seven-and-a-half feet. The camera will then bring anything in to focus from four-and-a-half to twelve feet. At f/16 the range is from five to ten feet. At f/11 the range is six to eight-and-a-half feet. The minimum f/stop would be f/16, allowing for five feet to be in focus. (Use a tape measure to find out exact distances.) If a

depth of field preview button exists on the camera body, depressing the button while looking through the lens will darken the image, but also show the area of the focusing range. In this way, the sculpture can be viewed through the lens and seen to be in full focus. Slight focusing adjustments can be made if it appears to be out of focus. The shutter speed would then change to one-fourth of a second at f/16.

Your slides should show all of your artwork in perfect focus. Even if only parts of a sculpture are out of focus, the slides will be unacceptable for publications and grant panels. Therefore, it is important to take exposure notes for each frame of film until you feel confident about the equipment. Later on it will be possible to take copy originals by this method.

When shooting a number of oil or acrylic paintings try to keep the color of the background the same. This is important for grant application but not for publishing. Publishers will crop out the background and just use the sized image of the work. The image size of a 35mm camera is a rectangle and not all work conforms to this size. Therefore, crop as close to the artwork as possible and leave a safety zone around the top edges of the frame to allow for no loss of image when duplicating. The photo labs do not take the original slides out of the mounts when duplicating. They shoot the originals in the mounts and it causes 5 percent (or less) of the image to be lost around the top edges.

Try to shoot all artwork without glass in front of the image, as it is another plane that light has to pass through and it might make it necessary to use a polarizing filter to minimize reflections. The polarizing filter has a ring which moves in a 360 degree arc and it is necessary to look through the lens to see how the reflection is minimized. Sometimes, the filter decreases the amount of light reaching the film, changing the correct exposure by as much as two f/stops. When using polarizing filters, a Kodak Gray Card (showing the 18 percent reflectance) will help you determine which exposure is necessary for achieving superb results.

Depending on how the film is loaded into the camera, it is possible to get thirty-seven or even thirty-eight frames on a roll of thirty-six exposure film. The film length is constant, however, if the film is loaded in a changing bag or near total darkness, the film's leader will not be exposed, and it is possible to start exposing the film before the numbers begin on the camera. This might not be possible with automatic cameras if they are self-loading. Again test to find out if an extra slide can be squeezed out

of a roll. It will save approximately one cent per exposure, besides giving you an extra slide.

Shooting Work Indoors and in a Gallery Situation

Artificial light has a different color balance than natural light. To shoot artwork under incandescent lights it is necessary to use 3200K or 3400K tungsten film. An 82A filter will reduce the speed of 3400K film, making it compatible with 3200K lights. This is more convenient and cost-effective than having two sets of lights. Always shoot a test roll and take notes.

If shooting sculpture indoors with the existing tungsten lights (3200K), try a long (one-second) exposure to achieve the necessary depth of field. Some of these tungsten films are fine for eight-second exposures. Before buying film, you can check the lighting conditions with the camera meter to determine the shutter speed necessary to maintain at least an f/11 aperture. For shooting flat art, such as a painting, the depth of field is not as critical since the film plane is without depth. Choose the best film based on the needs of the art and the features of the camera. For 3200K use 300-watt or 500-watt bulbs. These get very hot and might have only a four-hour life. Make sure the housing for the bulbs can handle this additional wattage, since ordinary clamp-on lights are rated at 250 watts or less and will overheat during long shoots.

Attachments are available for clamp-on lights, such as barn doors, diffusion screens, and flood reflectors which cut down glare. Mount the lamps on stands, and, to reduce glare, direct the light at 45 degree angles to the artwork's surface. Keep the lights back at least a few feet in order to have a wider arc of light illuminate the work. Sometimes two lights will be adequate but at other times four lights are necessary to achieve even illumination. (B&H [see Appendix 2 for address] offers a beginners Flood Light Kit for about $162 with tax). Take light readings from each of the four corners and the center of the work. Adjust the lights to achieve the same exposure at all five points. It might be a wise investment to buy a light meter if the one in your camera is not to be trusted. The cost of a new light meter ranges from a Gossen Pilot 2 at about $75 to a Sekonic 318B Digilite at about $195. Older used models are available; check for prices.

If possible, to achieve consistency from one documentation to the next, set up a permanent space for photography, where lights and backgrounds

are not constantly being moved, requiring re-metering. This will also enable you to document your work quickly, and minimize the likelihood of mistakes.

Sculpture and installations pose lighting problems, since there are many different sculptural materials such as ceramic, stone (marble), cement, Dry-Vit, various metals (copper or stainless steel), Lucite plastic, fiber, and hair. Different lighting possibilities include direct, flat, back, and cross-lighting, the choice of which depends on the materials' reflective properties, texture, transparent quality, and size. Photograph sculpture at an angle to show its volume. Shooting it straight away flattens the perspective. Many views might be necessary and each might require different lighting. Installations might require a wide-angle lens and track lighting as well as clamp-on lights.

Shooting close-ups might require either a telephoto or normal lens with a macro attachment. Getting too close to the art work might interfere with the lighting, so set the camera on its timer and get out of the lights' way.

You will achieve the best results if you always keep the plane of the film (determined by the angle of the camera) and that of the artwork parallel, and use a white fill card to reflect the light. The fill card is placed as close to the artwork as possible without it being in the picture. Move it around to see how it best fills in the light. If you run into problems, the local camera store will always offer advice. Take a picture of the set-up and show it to a photographer if you just can't get it right.

Many books are available to help you with documenting your work, depending on your level of experience. The book *Caring for Your Art* by Jill Snyder (Revised Edition 1996, Allworth Press) has a helpful chapter on photographing artwork. Read and practice; after a while this will become second nature.

‿

APPENDIX 2

Color and Black-and-White Slides

This appendix explains the various types of color and black-and-white slide films that are currently available and why it is important to know which films are recommended for archival purposes and/or press releases.

All prices are based on the September 1995 *B & H Photo-Video Catalog*. B & H is located at 119 West 17th St., New York, NY 10011; 1-800-947-9970. Please note that the prices are used for comparison only.

Manufacturers have two divisions of film: *amateur* and *professional*. This is true for Kodak, Agfa, Fuji, and Konica films. Professional films usually have to be bought at, and

return-mailed to a photolab or professional photography store for processing. They are either the same price or slightly more expensive than the amateur/consumer film, and each film has certain characteristics whether neutral colors, long exposure time (less than one-fifteenth of a second), or flesh tone reproduction.

Kodak offers a hot line and a free professional catalog that can be ordered by calling 1-800-242-2424, ext. 19. This catalog is a must to explain all Kodak products as well as some photography techniques. Through talking with the technicians about the difference between amateur/consumer verses professional films, I discovered some important facts. When consumer film is brought to the market it has a very slight green tint and a two-year shelf life. As the film ages, its color shifts slightly to magenta over the course of six months to one year. Over the next year, the color stabilizes, but after the second year the film will begin to deteriorate if it is not refrigerated or frozen.

The professional film has testing done to it and it is aged or "ripened" before it appears on the market. The film is first refrigerated while at Kodak or Fuji, and it is supposed to be refrigerated at the professional photo store. Fuji has an interesting approach to their films made in Japan. The films are shipped in refrigerated containers via boat. The delay allows the film to fully "ripen" before it reaches the photographers. Once the film is in the United States, it is stored in refrigerated distribution warehouses until it is sold. The photographer/artist is also supposed to refrigerate professional film until use. Freezing stops the aging process and as long as the film is defrosted before use there will be no problem. As a result of the ripening and cold storage, the color will not shift. Since accurate color is essential to the artists documenting his or her work, the slightly higher price of this film (at about three cents per exposure) is well worth the price.

If the artist buys consumer slide film while it is fresh on the market, it has a slight green tint and when it ages it shifts to neutral colors. This is true for Kodachrome, all E-6 Kodak, Polaroid, Fuji CR-56, and equivalent films. If the consumer slide film is kept in the camera for a year at an optimum temperature of sixty-eight to seventy degrees, the unexposed film is fine. The exposed film in the camera will have a *latent image shift*, causing an overall color change (most likely to orange). This might explain how and why film reacts as it does, and why artists should use professional film; especially if the work is to be produced in a magazine or a catalog "where color separations are needed." Do not hesitate to call Kodak, Fuji,

Scotch, or other manufacturers about any of their products. They have free literature, which can be mailed to you upon request.

Toll-free numbers for film companies that offer technical information are:

Polaroid: 1-800-343-5000; technical assistance: 1-800-225-1618
Consumer Fuji: 1-800-800-FUJI or 1-800-659-3854
Scotch 3M Photo Assistance Line: 1-800-695-3456
Ilford: 1-800-426-0781
Consumer Agfa: 1-800-243-2652
Konica: 1-800-285-6422

All the Scotch slide film is considered non-professional or consumer film. It is not refrigerated until after it ages.

The Polaroid technicians advise not to freeze their films and especially the separate developer unit. The slide films have a separate film and developer which are married when processed. They explained that the chemicals might separate and cause an uneven development.

Film is like a perishable vegetable or food. After a certain point it wilts, which in photographic terms means its quality will deteriorate. The color will not be as vivid or brilliant. Polaroid film will tend to have an overall blue/green tint if used out of date.

Color Slide Film

Wilhelm and Brower, authors of *The Permanence and Care of Color Photographs*, make some interesting recommendations regarding slide films, whether they are projected or kept in dark storage. Many color transparency (slide) films are available and the standard for comparison is Kodachrome 25 or 64 daylight film or 40 type A Professional (since it requires 3400° Kelvin or K flood lights) tungsten film. Kodachrome films require seven chemical developing steps, five washes and two light exposures. Thus, only a limited number of photo labs worldwide offer this service. In the United States only seven labs can process this film. Four of them are Kodalux and three are independents. The Kodalux labs that process Kodachrome film are: Dallas, TX, 1-800-345-6971; Findley, OH, 1-800-345-6975; Fairlawn, NJ, 1-800-345-6973; and Rockville, MD, 1-800-345-6974. The three independent labs are A & E in Los Angeles, CA; Grand Canyon Photo in Tucson, AZ; and BWC in Miami, FL, 1-800-292-3664. Processing costs about $8.47 a roll.

Kodachrome film tends to last the longest if frozen or refrigerated. In fact, all professional films should be refrigerated before being used and then processed as soon as possible after use. Film should be kept in the refrigerator for storage and not left in the camera for long periods of time. This way the color dyes remain stabile longer. Even though the consumer film tends to be made with camera storage in mind, if film is left in the camera over one year the color stability might be affected.

If film is stored in a low humidity freezer it effectively stops dye stability deterioration. (For more information about this see Wilhelm book.) No manufacturer will say for how long after the expiration date the film's colors remain stable, since they do not recommend using it after expiration date. However, from my own tests, one roll of film frozen four years after expiration date yielded results with no deterioration. It is recommended not to keep out-of-date film in the camera. Use this film as soon as possible and process immediately. It is not recommended to buy out-of-date film unless it was properly stored.

Projecting slides affects the film's color stability. If Kodachrome film is not projected, then, in terms of stability of the color dyes, it will last the longest. It is the best for duping slides as it has the best sharpness, contrast, and fine grain. One of its drawbacks, according to Wilhelm's book, is that after twenty minutes of continuous slide projection, the magenta color dye begins to fade. It is not recommended to use projected copy originals for grant applications as after continuous usage the image will deteriorate. Sometimes in the final round of the grant evaluation, slides are viewed for a long time. You do not want the image to begin to fade or the color to shift at this time.

If copy originals are to be used for projection, then Fujichrome Sensia 100 ISO, as well as Fujichrome duplicating films, last the longest during projection and on the light table. When sending out slide duplicates to magazines or agencies, this information becomes especially important. For E-6 processed film, Fujichrome Velvia has the best recommendation for storage as long as it is not projected. It is very close to Kodachrome quality. A good rule is to never project your originals due to image deterioration and possible scratches. Project only the duplicates unless you have plenty of copy originals. The Ektachrome duplication films (E-6) hold up about half as long as the Fuji films.

Kodachrome Film

Kodachrome is a slow speed film, which means that it is best used with a tripod. Fuji Velvia can be substituted for Kodachrome. If the slides are to be looked at on a light table for only short periods of time, Kodachrome copy originals will be the best for creating quality slides without duplicating. This is done by shooting the same work many times. Testing will determine if this is realistic for your needs.

Slide films have a much smaller exposure latitude than color negative film—usually one f/stop, either over or underexposed. However, underexposing slide film by half to one f/stop yields a much richer and color saturated result.

The underexposed slide can actually look better than the original art work due to these characteristics. Do tests before shooting a lot of film.

Without a working knowledge of film and equipment, you may find that a majority of images per roll might not be useable. All the characteristics need to be understood: camera body and lens, meter, shutter speed, and film. Do not be discouraged. Note taking is essential. Indicate film type, shutter speed, lens aperture, time of day, and number of the camera's frame counter.

Kodachrome film should not be push processed. When duplicate slides are made, however, underexposed slides even two f/stops darker will often yield good results since the information is there. It is dark but it can be brought out in the duplicate slide. Overexposed slides may be salvageable if the image information is still there to be saved. There is a point of no return when the slides are too light or too dark. This is not the case for color correction as color can be filtered correctly in duplication. However, if the slide has incorrect color and is over or underexposed, it is much harder for the lab to correct.

Ektachrome and Other E-6 Films

Many E-6 films (E-6 stands for the six chemical processing steps) for both indoor and outdoor use are available. You must consider these factors: whether you should use consumer or professional film; whether duplicates or originals will be used; what your time constraints are; and, always, consider cost. These will ultimately determine what type of film is used.

If it is inconvenient to use Kodachrome film due to slow turn around

time, and you decided to send out copy originals or make duplicates, there are many superior-quality films (daylight and tungsten) in both professional and consumer categories. Remember, these films all can be processed through photolabs, sometimes in a few hours. It is not uncommon for professional labs to offer four-hour service at the same price. This includes the processing and mounting. (In Europe, mounting the film might not be done automatically and might cost extra.)

Film is balanced for daylight or tungsten lights, so be sure to buy the right film for shooting indoors or outdoors. Filters are available to correct color when using film balanced for one type of light in the other. Since these filters affect the speed of the film, it is much simpler to buy the correct film for the task at hand. If you are shooting in a gallery and the light source is unknown—a mixture of natural and artificial light—daylight film might turn blue, green, or purple and indoor film, orange. The slides will not be suitable as copy originals. Do not worry, they can be color-corrected in the duplicating process.

Comparison of Daylight Slide Films

There are over twenty different types of daylight film available rated at fifty, sixty-four, or one hundred ISO. Since quality of image is the issue, I would recommend using films in this range. This is especially true when it comes to duplicating slides.

Kodak has a new line of films called Lumiere-100 and 100X ISO. These use a new technology called T-Grain emulsions. The films contain special sensitizing and filter dyes that improve color reproduction and make it possible to achieve whiter whites and cleaner neutrals. Kodak claims it is on par with Kodachrome as the Lumiere 100X incorporate a warming factor (toward orange) which means it is good to shoot in the shade. Most E-6 films tint towards blue, while the Kodachrome tints toward orange. If shot near noon, this should all but disappear. One of the benefits is that it can be push processed one stop.

Daylight films available include Kodak Ektachrome and Lumiere, Agfa Agfachrome, Fuji Fujichrome, Konica Konica Chrome, Scotch Scotchrome, and Polaroid Polachrome. Most of these films are available in several speeds and grains.

Based on my own tests, conversations with professional photographers and the companies themselves, and Wilhelm's book recommendations,

Fujichrome Velvia ISO 50 seems a good choice and Kodak's Lumiere seems superb for shooting daylight film outdoors in the shade.

Fujichrome Velvia is setting a new standard for E-6 processing with a price similar to Kodachrome 64. Since these are professional films, the standards are higher and the color reproduced will closely match the original work. Polaroid film has the benefit of instant results, but I would only use it for grant applications where the slides are projected (when one does not have the time or available film to do otherwise). To make duplicates from Polaroid slides is a bit senseless. Just shoot the work again. The film grain is considered medium, due to the filter stripes laid into the film emulsion.

These films were selected for use with a tripod on daylight, with the intention of having either copy originals or duplicate slides made. If you intend to send out copy originals for press releases with the understanding that these images might not be returned, use low priced slide film. The quality of these originals will be comparable with duplicated professional slide film. 3M/Scotch is the world's largest supplier of store brand film, serving more than 125 major retailers worldwide including Sears, Pathmark, and Fays. Scotchrome is probably the least expensive slide film and is also sold under these store's private labels.

35mm Polaroid Color Slide Films and Processing

When using 35mm Polaroid film it is necessary to buy either a manual or automatic processor to develop the instant film. The manual processor costs about $103 and the automatic $258 if bought at B & H in New York City. An Illuminator Mounter is also needed to cut and mount the film. This costs about $45, including 500 plastic slide mounts. This is a substantial investment for instant results, unless you plan on shooting many slides. The cost of Polachrome color film is about $20 for thirty-six exposures, or 55 cents per exposure. Polachrome is also available in a twelve exposure roll for about $14, or $1.13 per exposure.

35mm Polaroid Black-and-White Slide Films

Polaroid makes two types of 35mm black-and-white slide films: Polapan daylight 125 ISO and tungsten 80 ISO come in twelve and thirty-six exposures; Polagraph daylight 400 ISO and tungsten 320 is only available in twelve-exposure rolls.

Polapan costs about $18 for thirty-six exposures, or 49 cents per exposure. The twelve exposure roll is about $11, or 90 cents per exposure.

Polapan is a continuous tone film, and the grey scale can vary by bracketing the exposure. Processing time is one minute. Polagraph produces high-contrast black-and-white slides and it is good for line drawings. When using Polaroid film, remember that the temperature affects the processing time and, consequently, consistent results require testing. It is cost effective for an arts group with many members to assemble artwork and then do Polaroid film testing. Then Kodachrome or E-6 films are used for permanent documentation as a result of the Polaroid lighting tests. It is especially useful when using an electronic flash (either studio flash or on top of the camera) as it will show where shadows will fall in, for instance, a gallery situation.

Indoor (Tungsten) Slide Film

If you are shooting artwork indoors, tungsten films such as Kodachrome 40 type A, Fuji 64T, Ektachrome 160 and 320 are good choices. Approximate film prices, including mailer processing, tax, and postage, are: Kodachrome 40, $14 or 38 cents per exposure; Fuji 64T, $11 or 30 cents per exposure; imported Ektachrome 160 is $12 or 34 cents or per exposure, and domestic 160 is $15 or 40 cents per exposure; imported Ektachrome 320 is $15 or 40 cents per exposure, and domestic 320 is $16 or 43 cents per exposure. Scotchrome has the fastest tungsten film on the market at 640 ISO, costing $11 or 31 cents per exposure. If using Scotchrome 640 it is best to have a test duplicate made to insure quality as the film grain might be too noticeable.

Black-and-White Films

It is possible to shoot both color and black-and-white films at the same time. Keep the same ISO numbers for both films. This way when the film is changed you will not forget to re-set the film speed. Automatic cameras that can read the bar code on the film will automatically adjust but you will have to change the speed on the older manual cameras.

Kodachrome 25 color can paired with Agfapan 25 or Kodak Technical pan 25 ISO black-and-white; Fujichrome Velvia for color ISO 50 and Ilford Pan F Plus 50 for black-and-white; Kodak Lumiere 100X or Ektachrome,

Fujichrome, Agfachrome 100 with black-and-white Kodak T-Max 100, Agfapan 100, Fortepan 100, Ilford Delta 100, or Kodak Ektapan 100.

Obviously, there are many choices. If press photographs are necessary, the image will be reproduced in newspapers, a low-resolution medium. However, stick to the ISO rating at 100 or less to insure the highest standards. The quality of newspaper printing of photographs is lacking due to the low dpi (dots per inch); however fine grain films will enhance the printed photographs that are reproduced in newspapers.

These films can either be processed in the home darkroom or through a lab or supermarket. Get a contact sheet first, if you decide not to develop your own film. This can be used to choose which photos should be printed. For a single roll of film it might be easiest to have the film sent out for processing and then make prints at home, or get the local supermarket to make three-by-five-inch or four-by-six-inch machine prints to use for press releases.

Processing Film

What is the difference between professional and amateur photolabs? Professional labs are much smaller operations and are careful with handling the film chemistry, mounting, etc. Their customers demand this high standard, but their prices are usually higher than the supermarket or department store. The amateur labs usually run twenty-four hours in a mass production situation. These labs have toll-free numbers and it is possible to talk with the technicians and ask about standards.

Film Mailers

If using a Kodalux mailer (prepaid processing of twenty-four or thirty-six exposure Kodachrome, Kodak Ektachrome, or any E-6 film), a one week turnaround is standard. However, if you include a check for $1.80 per roll, the service can be speeded up. Call the Kodalux hot line, 1-800-456-3258, to find out which professional labs will accept the mailer in lieu of payment. If the lab is close to one of the four Kodachrome processing labs, twenty-four hour service might be available. Otherwise, this film can be dropped off at a supermarket for processing, as it will end up going to one of the labs that process Kodachrome anyway.

Fuji offers a film mailer for thirty-six exposures costing $3.77 with tax.

The lab is in Phoenix, AZ. Turnaround time is a few days longer that Kodalux but the price is lower. The lab number for tracking slides is 1-800-283-3658.

Duplicate Slides

For duplicate slides, a lab called World-in-Color, 39 Caledonia Ave., P.O. Box 170, Scottsville, NY 11546-0170; 1-800-288-1910, provides very consistent results with no sales tax for out-of-state residents. The prices are very reasonable, and are best if you send in a large order. Unless you order twenty-five duplicates of the same image, it is less expensive to shoot Kodachrome copy originals, which will also be best for archival purposes. It costs one dollar extra to color-correct the master slide (this is a set-up charge), the same charge applies to cropping the image.

World-in-Color uses Ektachrome duplicating film and if you are not projecting it and know how to store it, it will not deteriorate. However Wilhelm recommends using Fujichrome Duplicating film. This is usually only available at professional labs, therefore the cost of the duplicates is much higher (up to $3 per image). Wilhelm writes that Fujichrome is superior to Ektachrome in projector/fading stability.

The only way around this dilemma is to order enough duplicates at the lower price and understand that they will fade faster when projected. Never project originals, if you do they become throw-away items. If you order ten dupes from World-in-Color it is almost the same price as one dupe from a professional lab. So my advice is to order twenty-five. Fifteen can be projected or given away to magazines for press release material. The rest can be archivally stored and used as needed.

Write or call for the World-in-Color catalog. They offer other services, plus they have a free slide test run offer. If you send them one or two of your original 35mm color slides, they will be returned together with two duplicates of each at no charge and with no obligation. If there are any problems, they offer a money back guarantee.

Archival Storage

Do not use PVC or polyvinyl chloride slide sheets to store slides. They can (according to Wilhelm), contaminate, stick to, or even destroy films and prints. Use surface-treated polypropylene, which is acceptable for mounted

slides, or high-density polyethylene, a naturally slippery plastic with little tendency to cling to the slides. High-density polyethylene is preferable to surface-treated polypropylene because it is less likely to cause scratches when sliding film in and out of the plastic enclosure. A company called Clear File makes slide and negative sheets and puts out a newsletter which explains how temperature and relative humidity play a major role in the safe storage of photographic materials. Contact them at 1-800-423-0274. There are many other manufacturers as well. Consult the Wilhelm book for a more definitive analysis.

&

Index

About the Author

Julius Vitali is an interdisciplinary artist working with oil paint, photography, video, computer imaging, and experimental music. *The New York Times* has said of his work, "with his modern technology and bold innovation, Mr. Vitali stands apart as a kind of one-man frontier for the avant-garde. It has been easy to regard him as someone who is pushing the very limits of art in a very positive way."

While working with techniques that are often considered "experimental," Vitali has consistently received coverage in the mainstream media. His "Puddle Art," which uses the reflective qualities of water as a liquid canvas, has been featured on *The David Letterman Show*, network television news, and in national and international magazines as articles and illustrations.

Vitali's "Visual Surgery," a montage technique using found materials made into paper sculpture and then photographed; his "Photographic Windows," a method using cut and contact-printed photographic negatives to create a progressive narrative; and his work in other art forms have been featured in forums such as CNN, *The Village Voice*, and the prestigious *British Journal of Photography*. This same work has been supported by grants from the NEA, NYFA, Pennsylvania Council on the Arts, Polaroid, Kodak, and the Experimental TV Center.

Julius Vitali's intelligent use of the media has bolstered his career, helping him to secure numerous artist and educational residencies, receive corporate support, exhibit in the United States and Europe, and place artwork in public and private collections.

❧

Allworth Books

Allworth Press publishes quality books to help individuals and small businesses. Titles include:

Arts and the Internet by V. A. Shiva
(softcover, 6 × 9, 208 pages, $18.95)

Fine Art Publicity: The Complete Guide for Galleries and Artists
by Susan Abbott and Barbara Webb
(softcover, 8½ × 11, 190 pages, $22.95)

Artists Communities by the Alliance of Artists' Communities
(softcover, 6¾ × 10, 208 pages, $16.95)

The Artist's Complete Health and Safety Guide, Second Edition
by Monona Rossol (softcover, 6 × 9, 344 pages, $19.95)

Legal Guide for the Visual Artist, Third Edition by Tad Crawford
(softcover, 8½ × 11, 256 pages, $19.95)

The Business of Being an Artist, Revised Edition by Daniel Grant
(softcover, 6 × 9, 272 pages, $18.95)

The Artist's Resource Handbook by Daniel Grant
(softcover, 6 × 9, 176 pages, $12.95)

Licensing Art & Design, Revised Edition by Caryn R. Leland
(softcover, 6 × 9, 128 pages, $16.95)

Business and Legal Forms for Fine Artists, Revised Edition
by Tad Crawford (softcover, 8½ × 11, 144 pages, $16.95)

The Laws of Fésole: Principles of Drawing and Painting from the Tuscan Masters by John Ruskin, introduction by Bill Beckley
(softcover, 6 × 9, 208 pages, $18.95)

Lectures on Art by John Ruskin, introduction by Bill Beckley
(softcover, 6 × 9, 224 pages, $18.95)

Please write to request our free catalog. If you wish to order a book, send your check or money order to Allworth Press, 10 East 23rd Street, Suite 400, New York, NY 10010. Include $5 for shipping and handling for the first book ordered and $1 for each additional book. Ten dollars plus $1 for each additional book if ordering from Canada. New York State residents must add sales tax.

If you wish to see our catalog on the World Wide Web, you can find us at Millennium Production's Art and Technology Web site:

http://www.arts-online.com/allworth/home.html

or at **http://www.interport.net/~allworth**